THY BROTHERS' KEEPER

APRIL 22ND—JULY 30TH, 2006

FLINT INSTITUTE OF ARTS, FLINT, MICHIGAN

THY BROTHERS' KEEPER

APRIL 22 - JULY 30, 2006

FLINT INSTITUTE OF ARTS,

1120 EAST KEARSLEY STREET,

FLINT, MICHIGAN, 48503.

TEL: 810-234-1695.

WEBSITE: FLINTARTS.ORG.

FAX: 810-234-1692.

THY BROTHERS' KEEPER IS A PHOTOGRAPHY EXHIBITION THAT EXPLORES THE COMPLEX MULTI-DIMENSIONAL ISSUES RELATED TO GLOBAL JUSTICE. IT PRESENTS THE STORIES OF PEOPLE WHO HAVE ENDURED AND ARE ENDURING CONDITIONS OF HISTORICAL AND SOCIAL EXTREMITY.

THIS PROJECT IS ORGANIZED BY THE ALTERNATIVE MUSEUM, AN INSTITUTION WITH A 25-YEAR HISTORY OF PRESENTING ART THAT FOCUSES ON THE PRESSING ISSUES OF OUR TIMES AND IS PRESENTED AT THE FLINT INSTITUTE OF ARTS.

RESEARCH AND PRESENTATION OF THY BROTHERS' KEEPER AND ITS ANCILLARY PROGRAMMING WAS MADE POSSIBLE BY THE GENEROUS SUPPORT OF THE CHARLES STEWART MOTT FOUNDATION.

JOHN B. HENRY III, DIRECTOR
FLINT INSTITUTE OF ARTS, FLINT, MI.

GENO RODRIGUEZ, DIRECTOR
THE ALTERNATIVE MUSEUM, NEW YORK CITY, NY.

PROJECT DIRECTOR/SENIOR CURATOR:
GENO RODRIGUEZ.

ASSISTANT PROJECT DIRECTOR: JANICE ROONEY.

CONTRIBUTING CURATORS:

DIANA EDKINS, DIRECTOR, EXHIBITIONS & LIMITED-EDITIONS PHOTOGRAPHS, APERTURE FOUNDATION, NEW YORK CITY, USA.

KATHY GRUNDLINGH, CURATOR, MICHAEL STEVENSON GALLERIES, CAPE TOWN, SOUTH AFRICA.

WU JIABAO, DIRECTOR/FOUNDER, FOTOSOFT INSTITUTE OF PHOTOGRAPHY, TAIWAN, CHINA

KATHERINE SLUSHER, INDEPENDENT CURATOR, BARCELONA, SPAIN.

NISSAN N. PEREZ, SENIOR CURATOR OF PHOTOGRAPHY, THE ISRAEL MUSEUM, JERUSALEM.

CURATORIAL CONSULTANTS:

RICARDO VIERA, CURATOR, ZOLLNER GALLERIES, LEHIGH UNIVERSITY, BETHLEHEM, PENNSYLVANIA, USA.

BAS VROEGE, CURATOR, PARADOX EXHIBITIONS, AMSTERDAM, THE NETHERLANDS.

ESSAYISTS:

HOWARD BOSSEN, CURATOR, KRESGE ART MUSEUM, EAST LANSING, MICHIGAN, USA.

COLIN BOSSEN, COFOUNDER OF THE CHIAPAS PEACE HOUSE PROJECT, CHIAPAS, MEXICO.

WILLIAM BOWLES, EDITOR, INVESTIGATING THE NEW IMPERIALISM (INTERNET SITE), LONDON, U.K.

RICHARD GOTT, AUTHOR/JOURNALIST, LONDON, U.K.

JAY MURPHY, DIRECTOR/FOUNDER, SOUL CITY (INTERNET SITE), NEW YORK CITY, USA.

NIYATEE SHINDE, FOUNDER/DIRECTOR, TURMERIC EARTH, INDIA.

CHARLES T. SALMON, DEAN, COLLEGE` OF COMMUNICATION, MICHIGAN STATE UNIVERSITY, EAST LANSING, USA.

VERED SEIDMANN, INSTRUCTOR COLLEGE OF SOCIAL SCIENCE, MICHIGAN STATE UNIVERSITY, EAST LANSING, USA.

EDITOR:
JOHN B. HENRY III.

PHOTOGRAPHIC EDITOR:
GENO RODRIGUEZ.

CATALOGUE DESIGNER:
JAN ROONEY, NEW YORK CITY.

WEBMASTER AND CD ROM DESIGNER:
MARCUS PINTO, JOMA DESIGN, NEW YORK CITY.

PROOFREADER:
SUSAN CICCOTTI, NEW YORK CITY.

PUBLISHER:
FLINT INSTITUTE OF ARTS, FLINT, MICHIGAN.

PRINTED BY:
WALSWORTH PUBLISHING COMPANY, MARCELINE, MISSOURI.

ISBN # 978-0-939896-26-4
LIBRARY OF CONGRESS CONTROL NUMBER:
2006921225.

10 FOREWORD: JOHN B. HENRY III

12 INTRODUCTION: GENO RODRIGUEZ

7 UNITED NATIONS DECLARATION OF HUMAN RIGHTS

14 HOWARD & COLIN BOSSEN: WITNESS AND MEMORY

19 WILLIAM BOWLES: LISTEN TO YOUR ANCESTORS

185 RICHARD GOTT: LATIN AMERICA AT THE DAWN OF THE 21ST CENTURY

178 JAY MURPHY: VISITED LAST SUNDAY. IT WAS THE HEART OF DARKNESS

25 VERED SEIDMANN & CHARLES T. SALMON:
 SHOOTING WAR: REALITY, REPRESENTATION, AND RESPONSIBILITY

30 NIYATEE SHINDE: CAN CONTRADICTIONS WITHIN BE SKIRTED?

32 DIANA EDKINS, CONTRIBUTING CURATOR

 NINA BERMAN: PURPLE HEARTS / BACK FROM IRAQ
 ANDREW LICHTENSTEIN: BEHIND BARS
 STEPHEN SHAMES: UGANDA'S CHILDREN OF WAR

52 KATHY GRUNDLINGH, CONTRIBUTING CURATOR

 FANIE JASON: MAPOGO A MATAMAGA / PEOPLE'S JUSTICE
 GUY TILLIM: MAI-MAI / LITTLE SOLDIERS

64 WU JIABAO, CONTRIBUTING CURATOR

 WANG YISHU: TSUNAMI HOLIDAYS 2004

72 NISSAN N. PEREZ, CONTRIBUTING CURATOR

 NOEL JABBOUR: PALESTINIAN STRUGGLE FOR EXISTENCE
 ILAN MIZRAHI: FALASHMURA IN ISRAEL
 SHARON PAZ: MINOR PROTEST

86 GENO RODRIGUEZ, SENIOR CURATOR

 DAVID BINDER: WILL THE CIRCLE BE UNBROKEN?
 ALEXANDRA BOULAT: AFGHAN REFUGEES
 HEIDI BRADNER: CHECHNYA / A DECADE OF WAR
 CUBAN COLLABORATIVE: RAUL CANIBANO / HUMBERTO MAYOL: LIFE IN RURAL CUBA
 PETER ESSICK: KILLING US SOFTLY / U.S. NUCLEAR WASTE
 PHILIP JONES GRIFFITHS: VIETNAM TODAY
 CAROL GUZY: IN MEMORIAM / FDNY
 GEERT VAN KESTEREN: WHY MISTER? WHY?
 GARY KNIGHT: A TRAGIC DIVIDE
 FERNANDO MOLERES: CHILDREN AT WORK
 LUCIAN PERKINS: FAR FROM HOME
 JOHN STANMEYER: OUT OF SIGHT OUT OF MIND
 VIDA YOVANOVICH: IN THE SHADOW OF TIME

164 KATHERINE SLUSHER, CONTRIBUTING CURATOR

 ANDRES CARRASCO: UNINVITED GUESTS
 ENCARNA MOZAS: DREAM HOME

ACKNOWLEDGEMENTS

On behalf of The Alternative Museum, I would like to thank the officers of the Board of Trustees of the Flint Institute of Arts and in particular, John Henry, the Institute's Director, for providing The Alternative Museum with the opportunity to present *Thy Brothers' Keeper*. Their willingness and ability to realize the need for an exhibition that provides compassionate insight into the pressing issues of our times is courageous and speaks of their awareness and sensitivity to the global plight of the many people we can, in biblical terms, refer to as our global "Brothers."

I am, of course, indebted to all the participating photographers for the generous use of their images, as well as the project's curators and catalogue essayists who were so generous with their professional skills, advice, and time. Their creative insights and suggestions were right on the mark every time and made the execution of this project a seamless and successful experience. In addition, their contributions also provided an international perspective to the content and urgency of this project.

I also wish to thank the Flint Institute of Arts' curatorial staff members Lisa Baylis Ashby, Curator of Collections and Exhibitions; Monique Desormeau, Curator of Education; Jill Johnson, Assistant to the Curator; Charles Gentry, Assistant Curator of Film and Video; and Michael Martin, Registrar, for their significant efforts in coordinating and helping to produce the exhibition, catalogue, film series, and related interpretive materials and programs. Special thanks goes to Development Officer Tracey Stewart who assisted in securing funding for the project. Also, Preparators

Bryan Christie, Don Howell, and Jeffrey McLaurin must be commended for their creation of a beautiful exhibition installation at the FIA.

Local, regional, and even global outreach was important to this project and I want to acknowledge the following individuals for their contributions to the development and implementation of programs to further stimulate discussion of the issues raised in *Thy Brothers' Keeper*: Howard Bossen, Ph.D., Professor, School of Journalism, Michigan State University; Fred Wagonlander, Art Education Visiting Lecturer, University of Michigan-Flint; Mara Fulmer, Associate Professor and Program Coordinator, Graphic Design Degree Program, and Lillie McCain, Professor of Social Science, and Paul Rozycki, Professor of Political Science, Mott Community College; Bruce Edwards, Staff Photographer, *The Flint Journal*; Richard Ramsdell, Flint Central High School; and Cheryl Pell, Michigan Interscholastic Press Association. A global reach was the objective for the cyber catalogue and the exhibition's accompanying DVD that was produced with the significant efforts of Marcus Pinto, The Alternative Museum's Webmaster.

We extend our most sincere thanks to the Charles Stewart Mott Foundation, its Chairman, President, and Chief Executive Officer William S. White for his vision and encouragement, and his staff for their assistance and support, including Patrick N. Naswell, Program Officer. We especially wish to thank Ann F. Richards for her insight and kind advice toward the development of this project.

Geno Rodriguez
Director, The Alternative Museum
New York City, 2006.

UNITED NATIONS UNIVERSAL DECLARATION OF HUMAN RIGHTS

ON DECEMBER 10, 1948 THE GENERAL ASSEMBLY OF THE UNITED NATIONS ADOPTED AND PROCLAIMED THE UNIVERSAL DECLARATION OF HUMAN RIGHTS THE FULL TEXT OF WHICH APPEARS IN THE FOLLOWING PAGES. FOLLOWING THIS HISTORIC ACT THE ASSEMBLY CALLED UPON ALL MEMBER COUNTRIES TO PUBLICIZE THE TEXT OF THE DECLARATION AND "TO CAUSE IT TO BE DISSEMINATED, DISPLAYED, READ AND EXPOUNDED PRINCIPALLY IN SCHOOLS AND OTHER EDUCATIONAL INSTITUTIONS, WITHOUT DISTINCTION BASED ON THE POLITICAL STATUS OF COUNTRIES OR TERRITORIES."

PREAMBLE

Whereas recognition of the inherent dignity and of the equal and inalienable rights of all members of the human family is the foundation of freedom, justice and peace in the world,

Whereas disregard and contempt for human rights have resulted in barbarous acts which have outraged the conscience of mankind, and the advent of a world in which human beings shall enjoy freedom of speech and belief and freedom from fear and want has been proclaimed as the highest aspiration of the common people,

Whereas it is essential, if man is not to be compelled to have recourse, as a last resort, to rebellion against tyranny and oppression, that human rights should be protected by the rule of law,

Whereas it is essential to promote the development of friendly relations between nations,

Whereas the peoples of the United Nations have in the Charter reaffirmed their faith in fundamental human rights, in the dignity and worth of the human person and in the equal rights of men and women and have determined to promote social progress and better standards of life in larger freedom,

Whereas Member States have pledged themselves to achieve, in co-operation with the United Nations, the promotion of universal respect for and observance of human rights and fundamental freedoms,

Whereas a common understanding of these rights and freedoms is of the greatest importance for the full realization of this pledge,

Now, Therefore THE GENERAL ASSEMBLY proclaims THIS UNIVERSAL DECLARATION OF HUMAN RIGHTS as a common standard of achievement for all peoples and all nations, to the end that every individual and every organ of society, keeping this Declaration constantly in mind, shall strive by teaching and education to promote respect for these rights and freedoms and by progressive measures, national and international, to secure their universal and effective recognition and observance, both among the peoples of Member States themselves and among the peoples of territories under their jurisdiction.

ARTICLE 1.
All human beings are born free and equal in dignity and rights. They are endowed with reason and conscience and should act towards one another in a spirit of brotherhood.

ARTICLE 2.
Everyone is entitled to all the rights and freedoms set forth in this Declaration, without distinction of any kind, such as race, colour, sex, language, religion, political or other opinion, national or social origin, property, birth or other status. Furthermore, no distinction shall be made on the basis of the political, jurisdictional or international status of the country or territory to which a person belongs, whether it be independent, trust, non-self-governing or under any other limitation of sovereignty.

ARTICLE 3.
Everyone has the right to life, liberty and security of person.

ARTICLE 4.
No one shall be held in slavery or servitude; slavery and the slave trade shall be prohibited in all their forms.

ARTICLE 5.
No one shall be subjected to torture or to cruel, inhuman or degrading treatment or punishment.

ARTICLE 6.
Everyone has the right to recognition everywhere as a person before the law.

ARTICLE 7.
All are equal before the law and are entitled without any discrimination to

equal protection of the law. All are entitled to equal protection against any discrimination in violation of this Declaration and against any incitement to such discrimination.

ARTICLE 8.
Everyone has the right to an effective remedy by the competent national tribunals for acts violating the fundamental rights granted him by the constitution or by law.

ARTICLE 9.
No one shall be subjected to arbitrary arrest, detention or exile.

ARTICLE 10.
Everyone is entitled in full equality to a fair and public hearing by an independent and impartial tribunal, in the determination of his rights and obligations and of any criminal charge against him.

ARTICLE 11.
1. Everyone charged with a penal offence has the right to be presumed innocent until proved guilty according to law in a public trial at which he has had all the guarantees necessary for his defence.

2. No one shall be held guilty of any penal offence on account of any act or omission which did not constitute a penal offence, under national or international law, at the time when it was committed. Nor shall a heavier penalty be imposed than the one that was applicable at the time the penal offence was committed.

ARTICLE 12.
No one shall be subjected to arbitrary interference with his privacy, family, home or correspondence, nor to attacks upon his honour and reputation. Everyone has the right to the protection of the law against such interference or attacks.

ARTICLE 13.
1. Everyone has the right to freedom of movement and residence within the borders of each state.

2. Everyone has the right to leave any country, including his own, and to return to his country.

ARTICLE 14.
1. Everyone has the right to seek and to enjoy in other countries asylum from persecution.

2. This right may not be invoked in the case of prosecutions genuinely arising from non-political crimes or from acts contrary to the purposes and principles of the United Nations.

ARTICLE 15.
1. Everyone has the right to a nationality.

ARTICLE 16.
1. Men and women of full age, without any limitation due to race, nationality or religion, have the right to marry and to found a family. They are entitled to equal rights as to marriage, during marriage and at its dissolution.

2. Marriage shall be entered into only with the free and full consent of the intending spouses.

3. The family is the natural and fundamental group unit of society and is entitled to protection by society and the State.

ARTICLE 17.
1. Everyone has the right to own property alone as well as in association with others.

2. No one shall be arbitrarily deprived of his property.

ARTICLE 18.
Everyone has the right to freedom of thought, conscience and religion; this right includes freedom to change his religion or belief, and freedom, either alone or in community with others and in public or private, to manifest his religion or belief in teaching, practice, worship and observance.

ARTICLE 19.
Everyone has the right to freedom of opinion and expression; this right includes freedom to hold opinions without interference and to seek, receive and impart information and ideas through any media and regardless of frontiers.

ARTICLE 20.
1. Everyone has the right to freedom of peaceful assembly and association.

2. No one may be compelled to belong to an association.

ARTICLE 21.
(1) Everyone has the right to take part in the government of his country, directly or through freely chosen representatives.

(2) Everyone has the right of equal access to public service in his country.

(3) The will of the people shall be the basis of the authority of government; this will shall be expressed in periodic and genuine elections which shall be by universal and equal suffrage and shall be held by secret vote or by equivalent free voting procedures.

ARTICLE 22.
Everyone, as a member of society, has the right to social security and is entitled to realization, through national effort and international co-operation and in accordance with the organization and resources of each State, of the economic, social and cultural rights indispensable for his dignity and the free development of his personality.

ARTICLE 23.
1. Everyone has the right to work, to free choice of employment, to just and favourable conditions of work and to protection against unemployment.

2. Everyone, without any discrimination, has the right to equal pay for equal work.

3. Everyone who works has the right to just and favourable remuneration ensuring for himself and his family an existence worthy of human dignity, and supplemented, if necessary, by other means of social protection.

4. Everyone has the right to form and to join trade unions for the protection of his interests.

ARTICLE 24.
Everyone has the right to rest and leisure, including reasonable limitation of working hours and periodic holidays with pay.

ARTICLE 25.
1. Everyone has the right to a standard of living adequate for the health and well-being of himself and of his family, including food, clothing, housing and medical care and necessary social services, and the right to security in the event of unemployment, sickness, disability, widowhood, old age or other lack of livelihood in circumstances beyond his control.

2. Motherhood and childhood are entitled to special care and assistance. All children, whether born in or out of wedlock, shall enjoy the same social protection.

ARTICLE 26.
1. Everyone has the right to education. Education shall be free, at least in the elementary and fundamental stages. Elementary education shall be compulsory. Technical and professional education shall be made generally available and higher education shall be equally accessible to all on the basis of merit.

2. Education shall be directed to the full development of the human personality and to the strengthening of respect for human rights and fundamental freedoms. It shall promote understanding, tolerance and friendship among all nations, racial or religious groups, and shall further the activities of the United Nations for the maintenance of peace.

3. Parents have a prior right to choose the kind of education that shall be given to their children.

ARTICLE 27.
1. Everyone has the right freely to participate in the cultural life of the community, to enjoy the arts and to share in scientific advancement and its benefits.

2. Everyone has the right to the protection of the moral and material interests resulting from any scientific, literary or artistic production of which he is the author.

ARTICLE 28.
Everyone is entitled to a social and international order in which the rights and freedoms set forth in this Declaration can be fully realized.

ARTICLE 29.
1. Everyone has duties to the community in which alone the free and full development of his personality is possible.

2. In the exercise of his rights and freedoms, everyone shall be subject only to such limitations as are determined by law solely for the purpose of securing due recognition and respect for the rights and freedoms of others and of meeting the just requirements of morality, public order and the general welfare in a democratic society.

3. These rights and freedoms may in no case be exercised contrary to the purposes and principles of the United Nations.

ARTICLE 30.
Nothing in this Declaration may be interpreted as implying for any State, group or person any right to engage in any activity or to perform any act aimed at the destruction of any of the rights and freedoms set forth herein.

FOREWORD

THY BROTHERS' KEEPER

In 1999 The Alternative Museum, while still at its location on Broadway in New York City, presented an exhibition of photographs titled, *The Pursuit of Happiness*, which I was able to see. The exhibition featured several photographic essays made at different times and in different places around the world depicting incidents of man's inhumanity to man. The photographs portrayed man's seemingly inexhaustible compulsion to inflict hardship and suffering on others. Each picture was a reminder that even in this age of visual overload, a single static photographic image has the power to elicit a reaction. The message in each essay was clear: whether motivated by jealousy, greed, or power, there are people in this world who cause others to lose in order that they might gain. Some of the images revealed the consequences of acts of violence and force on individuals while others seared the mind with unthinkable atrocities.

I was so moved by the experience of the exhibition, I asked my friend and colleague, Geno Rodriguez, the Director of The Alternative Museum, if I could borrow the collection to exhibit in Flint, but unfortunately, the loan period for the works could not be extended. For the Flint Institute of Arts, this became an opportunity to create a new exhibition, larger and broader in scope, curated by Geno and several other guest curators from around the world.

The FIA project began with enthusiastic support from the Charles Stewart Mott Foundation, which felt the objectives of the exhibition were in line with the Foundation's interests. The Foundation first provided a planning grant in 2002, followed by an implementation grant received in 2003. With offices in Flint, South Africa, and Russia, and its stated vision of "a world in which each of us is in partnership with the rest of the human race—where each individual's quality of life is connected to the well-being of the community, both locally and globally," the Foundation expressed interest in the exhibition reaching audiences globally as well as locally. To that end, Geno developed a website for the project and planned for a cyber catalogue while the FIA staff worked on local collaborations within the Flint community. Originally scheduled to open in the winter of 2004, the exhibition was postponed twice as the FIA underwent an extensive renovation and addition to its facility. Despite the delays, Geno continued to refine the exhibition with edits and selections of new works by some of the most recognized and respected photographers in the world.

It has always been Geno's professional nature to organize exhibitions that stimulate and challenge the viewer to react and respond, however, the job of curating an exhibition of disturbing imagery can be especially difficult because photographs in a museum are viewed very differently than when they are surrounded by headlines and subtexts in newspapers or magazines. As Curator, Geno had the responsibility to create a balance in his selections between the subjective narrative of the photo-essays and the aesthetic success of the photograph. To this point, Susan Sontag wrote in her last book, *Regarding the Pain of Others:*

> Transforming is what art does, but photography that bears witness to the calamitous and the reprehensible is much criticized if it seems aesthetic; that is, too much like art. The dual powers of photography—to generate documents and to create works of visual art—have produced some remarkable exaggerations about what photographers ought or ought not to do.

Additionally, as Curator, Geno had to demonstrate impartiality in selecting the photographer and the images, and not simply choose those that support his own personal point of view. Photographs are unique among other art forms, like paintings

or sculpture, because they are perceived to be a picture of reality. In their article in this catalogue, Vered Siedmann and Charles T. Salmon address this issue:

> The photograph is real, but not necessarily authentic; it is a sampling of experience, but not necessarily representative; it is subjective, but still captures a piece of what has transpired.

So, the curator also must be sensitive to the fact that photographs can be deceptive but still be taken as fact, and can make images of disasters attractive, even beautiful.

As Project Director and Senior Curator, Geno has done an outstanding job of balancing the exhibition's aesthetics and subjective messages. Using his years of experience, he has found highly qualified curators from around the world to assist in selecting the twenty-five photographers represented in this exhibition. By seeking photographers from different regions, the exhibition has become diverse in location, subject matter, and cultural experience. The contributing curators are to be commended for acquiring outstanding work from some of the world's most renowned photographers and for the pictorial stories they have chosen to represent their region. Geno arranged for the curators to be joined by researchers and scholars to provide insightful interpretations of the images and issues for the catalogue, and for the photographers, themselves, to prepare statements about their work to accompany the photographs on the gallery walls.

The Flint Institute of Arts' exhibition is like the one Geno presented in New York in its presentation of images that attract attention and elicit a response from everyone who lays eyes on them. In his words written for this catalogue, Nissan N. Perez, Senior Photography Curator at the Israel Museum, describes the photographers in this exhibition as:

> trying to raise the level of awareness of injustices of all sorts, and through their work incite the viewer to reconsider opinions and attitudes, and eventually take action toward creating a better and more just society.

The title of the exhibition, *Thy Brothers' Keeper,* is a quote from the Book of Genesis in the Bible, which refers to Cain's deceitful response to God when asked about his slain brother Abel's whereabouts. In his attempt to cover up the murder of his brother, Cain replied, "*Am I my brother's keeper?*" We know that throughout the ages, mankind has continued to inflict acts of violence and treachery on his fellow man. It is the nature of some men to resort to such methods in order to gain what they want but do not have. The exhibition considers this and other kinds of calamities that can cause human suffering such as poverty, sickness, and loss from natural disasters like earthquakes, fires, and storms. The exhibition is a reminder that there have always been and will always be human suffering but that we must not use that as an excuse to become passive and assume there is nothing we can do to alter the course of events. The essays in this exhibition and its accompanying catalogue certainly will not change events in the world but it is hoped that they will raise awareness among those who view the images and read the texts. Colin Bossen and Howard Bossen aptly summarize the FIA's intentions in presenting these photographs:

> They remind us that no matter what our conditions, by merely being human, we have more in common with each other than not. We are all our *brothers' keepers*, the photographs whisper to us, if we'll listen.

John B. Henry III
Director, Flint Institute of Arts
Flint, Michigan, 2006.

INTRODUCTION

THE HUMAN CONDITION: CONNECTING THE DOTS

Although we live in the 21st century, a century that should be filled with advances for mankind throughout the world, we are instead living in one that is increasingly divided by religious, economic, and ethnic strife. It is also a world where too many of its inhabitants are living in abject poverty, hunger, and isolation, while ethnic and indigenous populations are suffering disenfranchisement—often by their own governments—through unspeakable violence and torture with no accountability. At the same time, large swaths of populations are dying from epidemics that have no cure—despite medical advances; as well as epidemics that could have been avoided if the wealthier nations of the world had cared enough. These consequences are all the more tragic because the basic tenets of global human rights have gone unfulfilled, a betrayal that not only affects wealthy nations but has devastating consequences for the poorer ones that are unable to take any solace from the economic, technical, and medical advances of the 21st century.

Thy Brothers' Keeper presents a story of diverse peoples who have endured, and continue to endure, intolerable conditions that violate the basic principles of humanity. This exhibition, shows us, through photographs, that we are all citizens of the world, not just a country, a state, or a neighborhood—and the hope is that it will encourage us all to take greater responsibility to ensure that the conditions under which our fellow citizens live are humane on all levels, and to remind us that we are all interconnected—we are, in biblical terms "Our Brother's Keeper".

The photographs in *Thy Brothers' Keeper* chronicle the complex multidimensional issues related to global justice and human rights transgressions. Why is the moral-ity of torture an issue today? What are the political motivations behind the many atrocities committed on a daily basis against civilians? Who profits from the many wars for peace? Are we responsible for the actions of our government? Where does the blurring begin between our image of who we are versus how we act, and does God take sides as religious extremism is driven backwards into the Middle Ages?

The images in *Thy Brothers' Keeper* will, we hope, give viewers reason to pause and think about the causes and effects that bring about such human calamity. In a way, we are all perpetrators of injustice, although most of us don't know how or why and, if we do know, we are unwilling to claim our part in it, for fear that we might uncover answers that are at odds with our political, economic, or military interests. Although it is more comfortable to rely on simplistic answers, we can no longer avoid the profound questions that are exposed by this exhibition, because in the long run we cannot remain immune from the suffering of others—their pain, loss, disenfranchisement, and anger will eventually burst into our lives in ways we least expect. The events of September 11 did not occur in a vacuum. Whether we like it or not, to the perpetrators of that attack, there was a cause.

The men and women who took these photographs are compassionate individuals. They are deeply committed to global justice and the pursuit of happiness. We hope that through their powerful images viewers will engage more earnestly in the evolution of just and peaceful societies.

Most of these photographers have received international recognition and awards from prestigious humanitarian foundations as well as respected art museums and cultural institutions worldwide. Many have gone beyond their job "mandate" and put their lives on the line, donating personal time and effort to the very communities they have photographed.

The intention of presenting these thought-provoking images and the questions they pose within the context of art, instead of politics, is to open up new avenues of discourse within both the arts and education communities, as well as to provoke and invoke a sense of personal responsibility by stimulating a desire to become more involved in the creation of equality and justice throughout the world.

Thy Brothers' Keeper cannot provide the answers to the many issues represented in this exhibition, however, the overriding goals of the project are to urge viewers to see beyond their own lives, beyond being a citizen of one country and instead become "one" with the rest of the world. *Thy Brothers' Keeper* asks the viewer to join the photographers as partners in the essential and urgent need to advance the cause of human rights worldwide, and prove that art can be an effective voice in resolving conflict and promoting peace.

Geno Rodriguez
Director, The Alternative Museum
New York City, 2006.

WITNESS AND MEMORY colin bossen and howard bossen

"Photography is a weapon against forgetting."
—Czech photographer Markéta Luskacová

In today's world speed is important. The innovations in communications and transportation technologies have created a rapid-fire environment where for the vast majority immediacy trumps contemplation. This is reflected in politics, economics, and culture. Information that a mere 200 years ago would have taken months to move from one part of the world to another, can be seen today in real time almost anywhere on the globe. The speed with which information is transmitted and the amount of information received today couldn't have been imagined even 50 years ago. At times, the amount of information, especially visual information, reaches a saturation point. This is evident in events such as the coverage of September 11, the dash to Baghdad, and Hurricane Katrina. Yet, while the amount of information received has vastly increased, critical questions about the information are not often asked. Headlines and sound bites substitute for insight. In most media, the visual record of events takes precedence over the visualization of complex issues.

Located within the tradition of social documentary photography, *Thy Brothers' Keeper* seeks to explore and uncover the depth of social and political conflicts in a way that the media usually does not. The exhibition is less about news and more about the human experience. Most of the photographs aren't about the big events of battle nor the large sweeping view of history as it unfolds. These images are about the little moments of life lived in difficult places, during tough times and frequently under horrible circumstances.

The photographers featured in *Thy Brothers' Keeper* understand the difference between recording an event and examining an issue. Their photographs stand in sharp contrast to the dramatic attention-grabbing imagery that frequently appears in the evening news or the morning newspaper. These are not the still images of burned bodies dangling from a bridge in Fallujah nor the videotape of American soldiers being blown up by a roadside bomb as shown on television. Instead, they tell the story of what happens after much of the media goes home or moves on to cover other events. Some capture the horror of war, revealing how long the consequences linger after the conflict ends. Nina Berman's photo-essay of returned Iraqi war veterans shows who pays the price for political decisions to go to war. The mutilated face of a veteran sitting in solitude reminds us that those who fight a war must live with its physical and emotional scars, while the generals and politicians who send them to battle retire in relative comfort.

Berman's photographs juxtapose neatly with Carol Guzy's of memorials for New York City firemen killed on September 11, 2001. These two series are ultimately about who makes the sacrifices to keep civilization running. They contain images of ordinary people thrust into extraordinary situations and what happened to them. Both the Iraqi veterans and the New York City firefighters paid high prices trying to do what they understood to be their duties.

Alexandra Boulat's and Ilan Mizrahi's work shows moments of quiet dignity amid desperate poverty. Boulat's photographs of Afghanistan depict people living in a centuries-old tribal culture where many are trying to cling to their traditions; but the people of Afghanistan have been caught in the crosshairs of global politics. In Boulat's photographs the ancient dominates although small elements of modernity, such as a child's tiny red rubber boots demand our attention. Life is defined not just by poverty, but also the violence of war. A desolate land where fundamentalist interpretations of Islam require women to be fully cloaked is presented. Almost paradoxically there is a sensual lyricism seen in the way the wind catches the fabric. Her photography seems to belie the symbolism inherent in traditional Muslim female dress. The strength of the burka-clad women is apparent despite their veils.

Ilan Mizrahi's series on the Falashmura, Ethiopian Jews, presents people who don't conform to the stereotypical view of being Jewish and who are largely invisible to the rest of the world. In one piece, a family huddles closely together in a small, squalid room while the photographer takes their picture. Looking at this image, one almost senses the love that the family members feel for each other. It suggests that the family bond is something that transcends material conditions as well as national and ethnic boundaries.

The work of Cuban photographers Raul Canibano and Humberto Mayol focus on the Cuban countryside. In the context of *Thy Brothers' Keeper* the photographs become politically charged. They subvert the popular conception of Cuba by revealing that human happiness can be found there and that happiness is much the same as happiness found anywhere. The boys who Canibano depicts playing in a river might as well be boys in rural Iowa, South Dakota, or Mississippi. These images remind us of the diversity of human experience and culture. They cause us to ask the question: Is the highly consumer-oriented industrialized way of life the best way or only way to find happiness? This is an important question for those of us who live in an increasingly market-driven culture.

Much of the work in *Thy Brothers' Keeper* explores what life is like when the larger society isn't interested in the well-being of all, and through neglect—and as part of the structural system itself—its citizens are stripped of hope, dignity, and a chance for a better life. Yet even with all the misery these photographs depict, glimmers of hope are seen, the strength of the human spirit is present, and the message that human beings are not reducible to their material conditions is revealed. They remind us that no matter what our conditions, by merely being human we have more in common with each other than not.

The format in which we experience an image changes our relationship to it and may alter our understanding of what we see. In the newspaper and magazine, photographs are surrounded by words and usually appear as single images rather than as a visual essay. We read our newspapers and magazines while drinking our morning coffee, often surrounded by the competing sounds of television, radio, or family. Newspapers and magazines provide information, but do not invite contemplation. By moving these photographs into the museum context—an environment where one goes for both contemplation and inspiration—the relationship between the photographer, the image, and the viewer is altered. With the newspaper or magazine, the experience is quick. In the museum, one studies and reflects. In the quietude of a museum, reflection may lessen the desensitization that often accompanies the constant assault of violent imagery in the day-to-day media environment. The manner of presentation creates an intimacy between the object viewed and the viewer.

An image that appears in a museum has the status of art object conferred upon it and thus is given greater cultural value and a more lasting place in the collective memory than the ephemeral images that are found on the television or in the print media. Their social location inside the institutions that determine what the elite culture holds of lasting value means they frequently receive closer attention than images that appear elsewhere.

These photographs serve as the evidence and the collective memory that will help people remember what we did to each other, at a moment in time, in a specific place. By presenting us with their view of the issues that they've captured in both descriptive and empathetic terms, these photographers are creating the historical record to judge the behavior of governments, movements and the people who lead them, fuel them, and are a part of them. While they are reflections of a moment, they cannot show us what preceded that moment nor what moves past the moment toward possible solutions. They can, and do, enable us to bear witness. To bear witness means to be present with the suffering of others. It is to preserve

them and their suffering in our collective and individual memories and make sure that their cries of pain are not completely unknown. This act of witnessing is a small one but sometimes it can cross cultural and social barriers and force people to pay attention to things they'd rather ignore.

Stephen Shames' photograph of a teenage girl whose face was mutilated for refusing sex with a soldier of the Lords Resistance Army in Congo is an example of how photography can serve as an act of witness. His work is a portrait of unimaginable brutality visited upon the innocent. Some photographs, like this haunting portrait, are so horrific that once seen can't be forgotten. It is quiet and dignified. And yet, as with Nina Berman's portraits of maimed American soldiers, it is nightmarish because it is confined within the conventional boundaries of the portrait where the expectation is to see the body beautiful. In this image while we are presented with the ghastly wounds to the body we are also shown the soul, the strength of the human spirit, hurt, betrayed, but not destroyed. This image is just one of the many small voices in *Thy Brothers' Keeper* that doesn't let the viewer forget. It is one thread in our collective memory that is woven into our collective history and shows how complicated the human experience can be by showing that beautiful art can sometimes be drawn out of pain.

It is a strange assumption that the complexities of human life should be examined in a bifurcated manner. Both sides aren't always equal. Sometimes there aren't even two sides. Many issues have multiple points of view and are highly nuanced. Event-centered journalism doesn't capture that complexity; only in-depth issue-centered journalism that isn't afraid to challenge the idea that all sides are equal and deserve equal space and consideration is capable of dealing with the complexity of life and responsibility of speaking truth to power. As Edward R. Murrow knew, it is the responsibility of the journalist to expose what is unfair, unjust, and injurious to the fabric of civilized life.

The power of the images in *Thy Brothers' Keeper* is a function of the union of both form and content. While the content of a large percentage of the images is without question disturbing, many of these images are also beautiful to look at. Some like Peter Essick's series on nuclear waste present a beauty that is surreal. The quality of light and color in these images suggest a nightmarish dream, while his photograph of an alligator being tested for Cesium-137, grounds the dream in sobering and disturbing reality.

While the general public frequently views photographs as objective records of reality, they are in fact personal interpretations influenced by the photographers' choices. These choices are philosophical, political, and cultural as well as technical. To argue that one is purely objective and apolitical is in itself a philosophical and political position that requires a critical examination of the premises that form each photographer's worldview.

Whether they acknowledge it or not, photographers and journalists work from specific points of view. They, along with their news organizations, decide what is worth documenting and what is not. The perspective of a correspondent embedded with U.S. troops is different than that of a colleague who covers the same conflict without a military escort, if for no other reason than the sources the two correspondents will have access to. The embedded correspondent will go where the troops go and mostly see what they see. The point of view is limited. The need to provide additional viewpoints is great if multidimensional understanding rather than propaganda is the journalist's or photographer's goal.

Social documentary photography has a long tradition. In America it goes back to the work of photographers such as Jacob Riis who photographed the slums of New York at the end of the 19th century and Lewis Hine who spent more than a decade making pictures of child labor at the beginning of the 20th century. Both

saw documentary photography as a catalyst for change. They viewed their job as one of persuading through the presentation of fact, of using the photographic record and the words linked to them to build the case for social transformation. In the 1930s, in the United States, photographers associated with the Farm Security Administration (FSA) carried on this tradition. The Roosevelt administration created the FSA to document the plight of those hurt by the Great Depression. It was to serve as a tool to help enact social policy to alleviate poverty and deprivation. While the images of the FSA and Hine were often published in newspapers and magazines, they were not news photographs. They were an earlier incarnation of the kind of work presented in *Thy Brothers' Keeper*. They attempted to examine issues, not events, provoke debate and through the presentation of the social problems they focused on, to move people to act.

The documentary work of Riis, Hine, and the FSA photographers made the public as well as policymakers more aware of the problems they depicted. Most important, they demonstrated that photography could play a significant role as a catalyst for change. Although Hine's moving photographs spurred public policy that lessened the abusive practices of child labor, those practices have not been eliminated. Today child labor still exists in many parts of the world, and many multinational companies use it to produce their products. One hopes that photographs of child laborers around the world like those of Fernando Moleres and Guy Tillim's of child soldiers in the Congo will have an effect similar to Hine's and bring about an increased global awareness of the exploitation of children. At the very least, they show that humanity is still wrestling with the same issues it was almost 100 years ago and that photographers still try to make us aware of what we would otherwise ignore.

Point of view is explicit in documentary photography. In the daily newspaper or news show, there is a point of view, but we're led to believe that what we see and hear is objective, without bias—a simple record of what's happening in our world. But it is never that simple. All news organizations have finite resources and exist within larger political and social structures. It simply is impossible for the media to cover every war, conflict, disaster, social wrong, and injustice. So decisions must be made. How those decisions are made, how those resources are allocated, how the news agenda is set determines what images are made and which ones receive space to be seen. Time, resources, and the primarily event-centered approach to news means that only rarely does the media allow a photographer the time to examine beneath the surface of events, to explore the spaces of existence that may move us from acknowledging that bad things happen to understanding what they mean and what the viewer might do in constructive response.

David Perlmutter, in his book *Photojournalism and Foreign Policy: Icons of Outrage in International Crises*, argues that the foreign policy decisions of the U.S. government drive the decisions of news organizations about what does and doesn't get covered. For example, writing about the coverage of Somalia, he said, "It was not until late November, 1992, in response to policy balloons of the Bush administration [the first President Bush], that *Newsweek* began to focus on the Horn of Africa. This is significant: policy formation spurred visual focus." This observation highlights just how interdependent are the press and the government. For a time we saw many photographs of Somalia because it was part of the government's foreign policy concerns. Yet, just a couple of years later, we didn't see the horrendous atrocities being committed in Rwanda as they unfolded because Rwanda was not yet a foreign policy imperative. It was up to the courageous documentary photographers working largely outside the confines of regular media channels to make the pictures that allowed us to bear witness, to understand through historical hindsight the violence and the depravity that caused over 800,000 deaths and left 95,000 children orphaned in a three-month period of time.

"It is always the image that someone chose; to photograph is to frame, and to frame is to exclude," wrote the late author and essayist Susan Sontag in her book *Regarding the Pain of Others*. This simple statement contains a powerful observation that leads to a critical question all viewers need to ask to fully understand what they are looking at in any photograph. One needs to ask what is not seen, what is outside the frame, and to come to an understanding of why one isn't seeing something. With much of the work in *Thy Brothers' Keeper*, one needs to know not just what isn't pictured but why. It isn't sufficient to know that we aren't shown compassionate treatment of the mentally ill in John Stanmeyer's study of mental institutions throughout Asia or of prisoners in Andrew Lichtenstein's photo-essay on prisons and inmates in the United States. The photographs demand an answer to the question of why people are treated that way. What are the competing values in a particular society, culture, or government that finds stripping people of all dignity and hope acceptable? These images not only show us what was recorded in a tiny slice of time, but also challenge us at a moral and philosophical level to come to grips with what is outside the frame. It is often what we don't see that links the image depicted and the true reality of circumstance. It is what photographs provoke, and not what they contain, that sometimes enables us to question and to understand.

Each photo-essay in *Thy Brothers' Keeper* presents a specific point of view and tells a unique story about the consequences of conflict, neglect, ignorance, prejudice, poverty, and greed. In doing so, one photo-essay builds upon another. Collectively the vision of these photographers and the power of these photographs give voice to the voiceless, make visible what most don't want to see, and allow us to bear witness to the suffering of the defenseless, the downtrodden, and the repressed.

But above all, the photographs in *Thy Brothers' Keeper* call us to remember. They want us to remember the consequences of the systems we live in, of the decisions of world leaders, and of our own choices. They remind us that in the early 21st century we still live in a world where the exploitation of children is common, where civilians are the primary victims of wars, and forced migration is ever present. And at the same time, they call us to understand that, despite all of our flaws, much of the human experience is beautiful. If we can remember that, then we might be called to action and do something to stop the horrors that surround us.

Colin Bossen and Howard Bossen—January 2006.

Colin Bossen is the Intern Minister, Unitarian Universalist Church of Long Beach, Long Beach, California; cofounder of the Chiapas Peace House Project, Chiapas, Mexico; and Managing Editor, *Journal of Liberal Religion*. Howard Bossen is a professor of journalism, and the adjunct Curator of Photography, Kresge Art Museum at Michigan State University, East Lansing.

LISTEN TO YOUR ANCESTORS william bowles

I am a big fan of history. Ever since I was a kid, history has fascinated me and perhaps in another life I might well have become a historian. And, in an age where history gets rewritten by the corporate media hour by hour, day by day, understanding where we come from and how we got here is a critical issue.

This essay was triggered by a play on the radio by Margaret Buzby about the Ashanti rebellion in what is now Ghana, at the turn of the 19th century, seen largely through the eyes of Queen Asentewas who led the rebellion. At the end, defeated and old, she is exiled to the Seychelles along with all the other leaders of the rebellion, where she spends her time telling the children all the tales of her struggle and that of her ancestors, so that the tradition and history of the Ashanti could be carried on.

It's not so long ago that Kwame Nkrumah came to power in 1957, in Ghana, the first African country to achieve independence from the British. From then on, one after the other, by ballot or bullet, African countries achieved independence, at least nominally. And by 1975, with the exception of South Africa, Namibia, and Zimbabwe, Africa was no longer a colonized continent. All were in one way or the other products of the changing fortunes of the principal former colonial empires of England, France, Portugal, and the Cold War and the clash of ideologies and economics that mostly took place in what was called the Third World.

When the Portuguese vacated Mozambique following the overthrow of the dictator Salazar in 1975, they left behind a single railroad leading to a mine, and destroyed everything else of value in a fit of ex-colonial pique. Within a short space of time, the Apartheid regime, fearful of the rise of a professed Marxist government right on its borders, financed the terrorist organization Renamo, which systematically destabilized and terrorized the country, which led to a vicious "civil" war that lasted until 1990. But its legacy lives on and the same can be said for many African countries.

Mozambique was pretty typical for post-independence Africa in broadly following (with local variations), the socialist model in one form or another, either of the Russian, Chinese, or Indian variety. All were underdeveloped with most of the population engaged in subsistence farming and little or no industrial infrastructure. Most of the post-independence governments believed in "modernism," which translated into rapid industrialization, land redistribution, education, health and housing, and holding the major means of production and distribution in state hands.

All things being equal, which of course they are not, there is no reason to believe that independent Africa could not have, by now, achieved many of its goals. This was the optimistic feeling that permeated Africa of the 1960s and into the '70s, in spite of all the obstacles, setbacks, and mistakes. But unlike Europe, which had built its fortunes on the slave trade—the wealth systematically stripped from its colonies, and its domination of world trade—Africa struggled to build modern nation-states, either on the wreckage left behind by the departing colonizers or attempted to utilize systems of government built by the colonizers, with precious little else except the raw materials they possessed.

All had to submit to the reality of an international trading system that was skewed in favor of the West. Trading with the Soviet Union, China, or India may well have been cheaper, but rubles were worthless on the international currency markets; the world traded in the U.S. dollar or the British pound. Most important of all, the prices of all the major commodities that Africa produced were determined in London, Chicago, or New York. Caught between two fires, they were forced into taking sides and depending upon which side, depended the nature of the development process, or lack of it.

And while it was typical in the West to talk of Nkrumah's corruption and his grandiose and "unrealistic" modernization schemes, the West completely ignored

the brutal dictatorships of Mobuto Sese Seko in the Congo and the like, many of whom were installed and supported by the Western Powers, depending on whether they possessed valuable natural resources or had some strategic value in the Cold War.

Starting in the 1970s with the rise of the so-called neoliberal economic agenda, there has been a concerted attempt in the West to shift the blame for the "failure" of African states back onto Africa itself. Predictably, most of the blame has been laid on the doorstep of "aid" and on the "inefficiency" of state ownership. "Aid" made them dependent, code word for lazy, and "inefficiency" carried two messages, one was ideological and the other was corruption, as if Western states are not also corrupt and inefficient? But of course, corruption in a poor country has a far greater impact than corruption in a rich one, and in any case, Western countries encouraged corruption through the use of kickbacks in order to obtain lucrative contracts.

But perhaps even more insidious and racist messages underlay the counterattack by the West on independent Africa, the most common of which are the labels "tribal" and "ethnic," both of which imply backwardness. Thus the racist preconceptions of the West are justified by the collapse of the central state in countries like Rwanda, Liberia, or Somalia, predicated on the essentially "backward" nature of the African that led, according to the West, to genocide and the rise of the "warlord," and the current buzzword, "failed state."

Laughably, if it wasn't so tragic, the industrialization of genocide carried out by German Fascism or that of the "ethnic" war in Northern Ireland, now in its second century, or indeed the ongoing war against black Americans, is conveniently forgotten. I could go on, but the point is we operate a double standard that Robert Cooper, the former British proconsul to Afghanistan has unashamedly made into de facto official British foreign policy, the "double standard" theory.

The challenge to the postmodern world is to get used to the idea of double standards. Among ourselves, we operate on the basis of laws and open cooperative security. But when dealing with more old-fashioned kinds of states outside the postmodern continent of Europe, we need to revert to the rougher methods of an earlier era—force, preemptive attack, deception, whatever is necessary to deal with those who still live in the nineteenth century world of every state for itself. Among ourselves, we keep the law but when we are operating in the jungle, we must also use the laws of the jungle.

—Robert Cooper, "The New Liberal Imperialism," *The Observer*, April 7, 2002.

Cooper goes on to define this "new liberal imperialism" as:

a new kind of imperialism, one acceptable to a world of human rights and cosmopolitan values. We can already discern its outline: an imperialism which, like all imperialism, aims to bring order and organisation but which rests today on the voluntary principle.

Acceptable to "us" in the West, that is. Cooper wrote this essay in 2002 and it spells out the ideological framework for the re-establishment of a New World Order, virtually a "bible" for the invasion of Iraq and it is one of many documents that form part of an array of weapons that the so-called neoconservatives—from Bush to Blair—use as a justification for re-conquering the world.

And while not wanting to turn Africa into one giant, defenseless, and helpless "victim," aka the despicable "Live 8" phenomenon, the reality is that of a world with all the rules loaded in favor of the West. We need only look at the Anglo-American corporations involved in the sleight of hand called debt cancellation and "aid" to Africa, that overnight, appear to have acquired a startling "change of heart" concerning Africa.

A closer examination of the figures being bandied about reveals however, a very different story, for when you break down the numbers, which sound so enormous, not only is the "debt cancellation" a small fraction of the total owed by African countries (estimated to be on the order of $300 billion), it amounts to something like 5¢ per day per person, at most, hardly likely to make a difference. Compare the "aid" to the amount extracted from Africa by the multinationals, which according to the International Monetary Fund (IMF), at current prices the value of the goods and services Africa produces in a year is $773 billion. And to "benefit" from "debt cancellation" they will have to open their markets completely to Western capital; guarantee that the "free market" operates without let or hindrance; reduce their governments to little more than branch offices for the multinationals in the name of fighting corruption and in the case of the United States, agree to become forward bases for U.S. military penetration of Africa in the "war on terror."

While it is a fact that the leaders of the "free world" have been forced to recognize the reality that the poor are poor because we are rich, the problem for the West has been how to sideline exposing the real cause of Africa's problems and how to deal with this reality. Enter "Live 8," Make Poverty History, etc., and of course, Blair's much lauded but illusory "debt relief."

To become eligible for help, African countries must bring about "a market-based economy that protects private property rights," "the elimination of barriers to United States trade and investment," and a conducive environment for U.S. "foreign policy interests." In return they will be allowed "preferential treatment" for some of their products in U.S. markets.

> "Africa's new best friends"—George Monbiot, *The Guardian*. Tuesday, July 5, 2005.

Just how deeply entrenched the racism is that determines the Western view of Africa is revealed by the following:

> Africa's winner-takes-all politics lies at the heart of everything that has gone wrong with Africa.... It is the reason why it has fallen behind the rest of the world economically, the reason for its wars and poverty.
>
> —Richard Dowden, Director of the Royal Africa Society and former Africa editor of *The Independent*, London.

Dowden's article, which was written in the context of "Sir Bob Geldof's 'Live 8'" roadshow goes on to tell us:

> Imagine a united European state—united by force not by referendum—which has to elect one president, one government. A Europe in which the French are Muslim, the Germans are Catholic, the British Protestant and there is only one source of income, oil, and it is under the Germans.

But of course, a mere 50-odd years ago, Europe was united by force—it was called WWII—albeit into two blocs that faced each other down, armed to the teeth with nuclear weapons, and Dowden's comments (made about Nigeria) are patently nonsense as a mere 150 years ago, Europe was a motley collection of states and statelets (Germany didn't become a country until 1848, Italy a few years later) that had constantly been at war with each other for over 500 years!

The major difference, of course, between Africa and Europe was that the colonial powers grew powerful precisely because they colonized Africa and exploited it for some 500 years, accumulating literally trillions of dollars of capital at today's prices that powered the industrial revolution. Dowden goes on:

> With a few exceptions African states have no common understanding or experience of nationhood. Their flags, their national anthems, their identities were created by outsiders. Patriotism in the good sense is in short supply.

While it is true that most modern African nations came about through the colonial division of Africa after the 1889 Berlin Conference that divvied up the continent according to a pecking order of power (with Britain getting the proverbial lion's share), to say that the newly independent African countries had no understanding of nationhood is not only insulting to the liberation struggles that led directly to independence, but is a lie of grand proportions.

To say that the struggles of Kwame Nkrumah and Eduardo Mondlane were devoid of an understanding of the importance of nationhood in the struggle for independence reveals the dual standard that the West uses when dealing with Africa.

Dowden's uninformed comments also ignore the pre-colonial history of Africa, a history that it shares in common with the rest of humanity, one of empires, artistic and technological innovation, as well as that of pre-national formations. The fact that Dowden makes a "special" case for Africa reveals more about the bankruptcy of thought in the West than it does about Africa.

That the countries of Africa were forced into a world capitalist order in the space of a few decades, a process that Europe took hundreds of years to arrive at (accompanied by endless religious, ethnic, and "tribal" wars), is simply ignored.

That the national politics of many African countries are powered by patrimony, merely illustrates the complexity of the struggle between tradition and modernity within which Africa seeks to develop. Again, these are battles that were also waged in Europe, some not so long ago for example, the "rotten boroughs" of English politics of the late 19th century, or the unequal voting system in Northern Ireland that existed until the late 1960s (based on property), illustrates. Or indeed, the civil rights struggle in the United States that still sees black Americans deprived, through political chicanery, of the right to vote.

And for contemporary examples of comparable processes, we need look no further than the corrupt nature of local politics in Europe, with the equivalent networks of patrimony based upon political, business, and "club" connections such as in Italy, with the power of the Mafia or the Catholic church, or indeed in the most corrupt state of them all, the United States and its network of business, political, and family connections, i.e., Bush–Saudi–Bechtel–Halliburton.

To suggest that African networks are essentially any different just illustrates the kind of thinking that powers the alleged intelligentsia of the West, mired as it is in generations of domination.

Most African economies are still at the subsistence stage of economic development, with agriculture being the primary source of income, hence political networks reflect the connections between village, clan, and family rooted in the countryside and an agrarian economy, and a political order based in the cities that reflects the dichotomy between city and country, again something that Europe went through (and which it is still going on in the UK, France, and other European countries) in a period that lasted some several hundred years, culminating with the enforced migration of millions of agricultural workers from country to city that made the industrial revolution possible.

The irony of the West's racist approach to African politics is revealed when we realize that over the past 20 years, Africa has been deliberately impoverished through the economic policies of the developed world. That for every dollar given to poor countries in aid, they lose two dollars to rich countries because of unfair trade barriers against their exports. That Africa has lost 85¢ for every $1.75 it receives in "aid" because of the falling prices it gets for its commodities.

And now the new imperium has exhumed yet another invention from a previous age, the rehabilitation of the colonial empire, by promoting the works of historians

such as Niall Ferguson, blue-eyed boy of the latest revision of British history. Ferguson's book, *Empire* (also turned into a BBC television series), described British colonial rule in Africa as "nation-building."

And in line with current Western propaganda, asserts that the British Empire laid "the foundations of . . . [the] rule of law, non-corrupt administration, and ultimately, representative government." Ferguson also claims that a period of "relative world peace" and a global order within which economic development was unquestionably easier as a result of the British Empire. Ferguson goes further, stating that poverty in Third World countries is not a product of colonialism or globalization, but is rooted in the fact that those "areas of the world have no contact with globalization. It's not globalization that makes them poor, it's the fact that they're not involved in it." An amazing claim considering the devastation caused by the policies of the World Bank and the International Monetary Fund.

In a later book, *Colossus: The Rise and Fall of the American Empire*, Ferguson, now a professor of history at Harvard University, has been calling on U.S. officials to take on their role as the new colonial master, as inheritors of the British empire. He even talks of an "imperial gene," no doubt an Anglo-Saxon one.

Coincidence? I think not, for it fits perfectly into the assault on the past that justifies the present and in doing so, ramps up the current onslaught on the poor of the world.

One of the most insidious aspects of this current rewriting of the past is that because it is so far in the past, the genocidal policies of colonialism are blunted and softened by time. Hence, the current revisionist histories are able to implant the idea that we have changed but "they" haven't in spite of all our attempts to "civilize" them. Hence the need to reimpose "our" values on "them" as they have proved incapable of doing when supposedly left to their own devices.

When we look at the words of Tony Blair, we see the transmission of the Ferguson version of history translated into the world of vox pop, where the struggle is that of "civilization" against the "dark forces" reigned against us. The "virus" that will "infect" us unless we reimpose our control. Who said which? The medical reference is interesting as it implies that invasion and occupation are in actuality, more like an "inoculation," a preventive measure that neatly links up to the idea of "pre-emptive strikes."

> [In] another part of the globe, there is shadow and darkness where not all the world is free, where many millions suffer under brutal dictatorship and poverty.

Or,

> Iraq; another act; and many further struggles will be set upon this stage before it is over. We are bound together as never before.

These are the words of Tony Blair to the joint houses of the U.S. Congress in 2003. Note that "we are bound together," that is, the "civilized" world, as elsewhere it's a world of "shadow and darkness." These deeply racist images strike a chord in populations long raised on a diet of being citizens of empire and reinforce the idea that the "dark hordes" are at the gates, hammering to get in, either to destroy us or take what is rightfully ours because it is ours by might.

One of the things I learned during my time living in Africa, was the importance of acknowledging the existence of the ancestors, although for me it translated into being connected to the past rather than believing in them literally. For through a connection to the ancestors, the past becomes solid ground rather than shifting sand. The ancestors are a transmission line to the past that remains stubbornly unbroken. Through the ancestors, a different history is preserved and carried down, not by education, books, or TV. It is both a private conversation and a collective memory, as in speaking to one's ancestors you are also speaking to their time, calling upon their experience, their wisdom.

I know it's a bit of cliché that history is written by the victors, and I know it sometimes seems like pissing in the wind, as the saying goes, but that is no excuse for us not to take the victors to task. Language, and through it, control of our collective and individual histories, is the only weapon we have in the struggle that we can call our own. And I know we all make the mistake of reducing the "struggle" to clichés, I suppose it is an inevitable product of the nature of struggle. All I can say is that I was raised by folks who carried with them a sense of the importance of their own history and their place in it and that thankfully, it was communicated to me.

So while the victors ensure that their transmission line to the past remains firmly under their control, we need to re-establish the fact that we are part of a continuum that embodies our struggles, our experiences of lives we have lived and continue to live. Thus rather than surrender to a world reordered, reconstructed by the Coopers, the Dowdens, and the Fergusons in their image, it is for us imperative that we reconnect ourselves, here in the West to our common heritage, our humanity, to our ancestors.

William Bowles—September 2005.

William Bowles writes for and publishes an online political journal, Investigating The New Imperialism (http:// williambowles.info), and has lived and worked in the U.S. and Africa as well as his hometown, London, where he resides once more. Recently published work includes a chapter for *Devastating Society—the Neo-Conservative Assault on Democracy and Justice*, (Pluto Books, 2005).

SHOOTING WAR: REALITY, REPRESENTATION, AND RESPONSIBILITY
vered seidmann and charles t. salmon

Wars, conflicts, and disasters are magnets for photojournalists. Because of the variety of their assignments, few photojournalists covering regional/ethnic conflicts can develop a deep understanding of any single conflict. They often are experienced travelers, moving from one site of human suffering to another; Yugoslavia, El Salvador, Sudan, Chechnya, Israel, Rwanda, Afghanistan, and Iraq are only a few of the stops on the international journalism circuit since 1990. Although a certain mystique has grown up around the culture of photojournalists, the reality of the job is often anything but glamorous. In the words of one seasoned veteran,

> You have to take the airplane, to take a jeep, work for three weeks, meet the right people, shit on yourself—I mean no food, no water, you don't know if you are a hostage or a friend. Suddenly hell breaks loose, and you're trying to survive and take pictures. Then it takes three weeks to go back. That's for one photo! If it's good. And it may not be good, too.

While many photojournalists covering conflicts internationally consider themselves "war photographers," photojournalists covering conflicts in their own countries are less likely to define themselves as such. They don't travel to a foreign country to cover wars, but merely the local reality. If the conventional wars of a previous era occurred in these journalists' "backyards," many of the contemporary conflicts in the current era of asymmetrical warfare and terrorism are occurring in their "living rooms" as well as in their backyards.

Correspondents are in the center of the journalistic world, while photographers often construct marginalized identities. The photographers are often free of the professional norms that obligate the correspondents, and free as well to express themselves in ways that others would call "crazy" in order to take the ultimate photo. Correspondents can report a war from a city, a neighborhood, or a hotel room, but photographers need always to be in the center of the action.

In his study of foreign journalists covering the conflict in El Salvador, the anthropologist Mark Pedelty identified the following three types of war photographers:[1]

THE ADVENTURER: Photographers of this type have many of the characteristics of the "manly" myth of the war photographer. The adventurer sees the war as "fun," and develops a kind of addiction in her or his quest for the perfect photo, the most authentic image that will show the real drama of the battle. He or she (but usually "he") is looking for graphic images and is often frustrated with the editors for censoring the photos and limiting him from showing more blood and violence.

THE ANTHROPOLOGIST: This photographer is characterized mostly through an interest in people and issues regardless of their news value, and through a keen motivation to understand and interpret the meaning of specific situations. Pedelty describes this type of photographer as a humanist who is constantly frustrated by the editor's appetite for violent photos. He or she usually works alone.

THE CONCERNED PHOTOGRAPHER: This photographer is most readily identified through a need to depict the war and to constantly look for ways to present the photos that couldn't be shown in the course of routine journalistic work. The concerned photographer usually finds the way to show these images through books, articles, or exhibitions of his work.

Regardless of their role, all photojournalists face several fundamental questions when practicing their craft: Where should the photographer, who is both an objective professional and subjective participant, position himself? How much distance should a photojournalist have from the story being covered? Should the role be one of critic, artist, interpreter, or witness?

These questions are closely linked to two major, interconnected issues that pertain to responsibility. The first has to do with the degree to which a photograph can and actually does represent a situation, and the photographer's role in constructing this representation. The second issue deals with the responsibility of the photographer to function as a witness of the events and to transfer testimony to the viewer, while simultaneously factoring into account personal viewpoints, professional culture, situational contexts, and aspects of aesthetics. Both issues reflect the photographer's choice of point of view—what to shoot versus what not to shoot, what to publish or not, and how the subjects will be perceived in the photos.

To illustrate these issues, we use the example of Israel, a center of international news coverage since the 1940s. We draw on the experiences of two photojournalists, one a European and one an Israeli, who between them, covered conflicts throughout the world. The European photographer has moved from one war zone to another and photographed most of the major international conflicts for 30 years. The Israeli photographer worked for different domestic newspapers at different stages in his career. From the beginning, he knew he was interested in the Israeli-Palestinian conflict, and that he wanted to focus on the Palestinian perspective. Although these professionals do not necessarily represent all photojournalists, they do provide a glimpse into the world of photojournalism and the complex decisions that can arise therein.

* * *

The Al-Aqsa Intifada, which began in 2001, occurred after the regional ethnic conflicts in former Yugoslavia, as well as the first Intifada in Israel, had taken place. In the context of these international ethnic conflicts, the Al-Aqsa Intifada was viewed differently from Israel's traditional wars in 1948, 1956, 1967, and 1973, in terms of world perceptions and media coverage. Wars are often viewed as having clear-cut aggressors and victims and identifiable and morally defensible values. Contemporary ethnic conflicts are more ambiguous and are often linked to struggles sometimes dating to antiquity. They often occur within civilian populations, and combine "legitimate" war activities with "illegitimate" terrorist acts. They are framed in the press either as idealistic manifestations of struggles for national identity and autonomy or as senseless and morally indefensible slaughter. Whereas news coverage of traditional wars concentrated on battlefields and armies, coverage of ethnic conflicts, such as the Al-Aqsa Intifada, occurs in neighborhoods and businesses. Suicide bombings in concentrations of civilian populations, involving women, children, and the elderly, are covered pervasively. Related issues such as "the Wall" and the pullout from Gaza are also given prominence.

The Palestinian side is covered in the Israeli press through Israeli eyes. Israeli newspapers will not show graphic photos of bodies or the badly wounded. They show "softer" photos of the wounded, results of the events and mostly visual metaphors that symbolize the event—shoes left in the area, the remains of a bombed bus, or soldiers crawling in the sand looking with their hands for the remains of their friends. They show an angry Palestinian funeral crowd after an Israeli attack; the ruins of houses in the West Bank or Gaza; or a sandal of the Sheik Yassin, the former leader of the Hamas, a fundamentalist political party, after he was assassinated by the Israeli Defense Force (IDF). Rarely will mainstream Israeli newspapers show the faces or tell the stories of suffering Palestinians.

The photographer Oded Yeda'aya, who studied the work of well-known Israeli photojournalist Micha Bar-Am, claims that the origins of the Israeli news photographers are different from those of the foreign photographers.[2] While the stereotypical war photographer is a person who will sacrifice everything for the ultimate photo, the Israeli photojournalist traditionally has been willing to sacrifice everything for his country. The Israeli photographer was a fighter in the army, a man with a cause who

sometimes was on the battlefield as a soldier and other times as a professional news photographer. He was totally committed to the ideal of Israel's existence and the need for a strong defense. The photographic work of the Israeli hero photojournalist has, therefore, usually been an extension of what he did during his military service. But the hero photographer's status is not as clear today as it used to be; the status of the photographer as a hero witness is in conflict today because the reality has changed and the values have become ambiguous. Defining the bad versus good, the weak versus strong, and the justification of the conflict is more complex today. As a result, today's Israeli hero photojournalists concern themselves less with the former ideals of Zionism and more with issues of professionalism within the culture of photojournalism, according to Yeda'aya.

One of the major questions asked about news coverage is whether what is shown or reported accurately represents a situation or context of a conflict. The two photographers interviewed answer this question in different ways. To the Israeli photographer, photogenic events do not necessarily convey depth and meaning of the situation at hand:

> . . . when I started working as a photographer, I was very attracted to photo events . . . often confrontations between [Israeli] soldiers and Palestinians, being beaten. Suddenly, in the past few years I realized that the suffering is not expressed there. The real suffering is not there. The real suffering is found in some kind of an intolerable, humiliating, restrictive daily situation, and in recent years I'm trying to photograph this. Not events, I mean. I'm less interested in them. I'm more interested in the barriers[3] series I was working on for the past three years. Because the barrier is not an event; it's a routine, a way of life . . . and it is a continuing restriction and humiliation. If your husband or your partner slaps you in the face it's a terrible thing. I think it's worse to live every day with someone that will potentially slap you.

The Israeli photojournalist does not seek objectivity. His work has a clear political agenda and he acknowledges it as political. His work also is subjective and he refers to the events from a personal point of view. He won't send photos that don't "properly" represent the relationships between the Israelis and the Palestinians. For example, he refused to use a photo of Israeli soldiers playing soccer with Palestinian children because even though it was a real event, he thought it didn't reflect the situation authentically.

The European photographer does not come with as clear a political agenda as the Israeli photographer. Nevertheless, when he shoots a news event he asks himself the same question, i.e., whether a photo of some slice of reality is representative of the overall situation or at least does justice to it. The following story is illustrative of this mindset:

> One day I'm on a frontline on a hill in southern Lebanon. And there is a priest . . . in the old way, you know, in a robe. . . . Suddenly he gets to this hill, and he sees on the other side of the valley his church burning. The village he just left, his church burning. The Arabs have just taken off, and he takes a machine gun of the Falanga and he opens fire, in his robe, and he is shooting. Great picture! I react as a photographer. I take the picture. I send the film. And the next day he finds me. I'm sleeping with the army guys down in the house. And he says, 'I want to talk to you.' And he lights a candle and he speaks and he says, 'I'm a young priest . . . I'm a priest but I'm young. And I reacted to my church. It was the devil that was talking. I don't like the Muslims, but in our villages they have always respected the priest. They have never killed a priest. If this picture is shown around the world, they'll kill every priest. . . .' So I called *Newsweek* and I said: 'You can use any picture I have except that one,' and they answered me: 'It's a great *fucking* picture! You're gonna lose $10,000 if we don't use this picture.' I said:

'Fuck the $10,000. It represents the act of one man for about three minutes. It doesn't represent the general idea of the whole conflict. So *cut* that picture. Take it off.'

Whereas both photographers are concerned about the representation of their works, they differ in terms of the degree to which they see themselves as "witnesses" at a scene of conflict. The European photographer we interviewed sees his main goal as telling the stories of others:

I'm just a witness that uses any means possible to tell the story. I shouldn't say this but I don't really care about photography. I just use a camera. Like I use a pen. Like I use a movie camera. I . . . I don't really care about photography. . . . So . . . for me it's just a way of telling the story. . . . *They* use me, *they* see me as a witness . . . the soldiers, the civilians, the kids, the old people. When I'm in Ramallah and this house has been destroyed and they see the camera, the woman will rush to me and . . . talk! When I see an Israeli soldier wounded, his friends will talk to me! They need to talk to somebody. So it's *known* to other people. So first it's them, and then maybe me through my . . . through being their witness. But for that you have to be very careful. You have to put aside your own feelings. You can't be emotional. You can be sensitive but not emotional. Because otherwise *they* are emotional. If you are emotional then you lose your perspective. Then you are just like *them*! You know.

The Israeli photographer, on the other hand, refuses to see himself as a witness and resents attempts to treat photographers as professional witnesses or the camera as an objective tool to capture reality:[4]

The subject of witnessing is very problematic when we refer to photos. Because . . . first of all, this testimony is so stammering and so partial that nobody in the world would accept it as testimony. I mean, if some-

one would come on the stand and say: yes, I saw him shooting the guy. Then the judge or the lawyer that would have had this dialogue with him, or that interrogation, would tell him: and what happened a moment earlier? I don't have that 'moment earlier.' What I have is 1/125 of a second! Don't ask me about a moment earlier and don't ask me about the moment later! I don't have it. Which means that in terms of witnessing, it's already very problematic. . . . My camera is part of the event and in that sense I'm part of the crime . . . the event always changes because of the camera's presence, so I'm part of the crime and part of the crime planners. And sometimes I'm the reason for an event. . . . I mean, it's possible that some event wouldn't happen without the press. . . . As unpleasant as it is, you take part in a game that is too big for you in the sense that you can't control much of it . . . or what you do or what you are used for.

* * *

The experiences of war photographers who have worked in Israel are unique in some ways, and universal in others. Regardless of locale, the job of a war photographer is a daunting one, both in terms of the potential for physical harm as well as the burden of responsibility. A war photographer has a responsibility to capture fleeting images that will, over time, become the definitive historical record of an event and potentially influence public policy decisions on the other side of the world. He or she is responsible for providing firsthand visual accounts to editors and media consumers who have only secondhand access to information. He or she must sift through a potentially infinite set of possible images and, through an internal calculus, select only those that are congruent with a personal worldview and expectations of a professional culture.

But the notion of responsibility does not end with the photojournalist; media consumers have a responsibility to understand that the "visual bites" that they are see-

ing are not statistically faithful representations of some faraway reality. In the words of one of the photojournalists we interviewed:

> How many photos do you remember from the Vietnam War? After we try to remember how many photos, we will talk about 50 photos, and I am including movie posters in that. The average shooting speed is 1/125 of a second, which means we remember half a second from a war that lasted how many years—12? 13? And you want to talk to me about the relation between photography and reality? There is no relation. You are part of an event that lasts for a long time, but you perceive in parts of a second. You shoot a very narrow angle of an event that has 360 degrees. You shoot a very colorful event in black and white, an event that has noises to which you are completely deaf, an event with smells that you can't convey. The photo is some kind of reference to an event, but not more than that. It is some kind of reminder, a trace.

The photograph is real, but not necessarily authentic; it is a sampling of experience, but not necessarily representative; it is subjective, but still captures a piece of what has transpired.

Vered Seidmann and Charles T. Salmon—December 2005.

NOTES

1 Pedelty, Mark. *War Stories: The Culture of Foreign Correspondents* (New York and London: Routledge, 1995).

2 Yeda'aya, Oded. "The Rhetoric of the Mythology: On the Photography of Micha Bar-Am," *Studio*, 2000, Vol. 113, pp. 21-33 (in Hebrew).

3 The photographer does not refer here to the Wall. Unlike the Wall, barriers can move from one location to another, according to the army's needs.

4 See the discussion at: Peters, J. D., "Witnessing," in *Media, Culture & Society*, 2001, Vol. 23, pp. 707-723.

Vered Seidmann is an instructor at the College of Social Science, Michigan State University, East Lansing. In Israel she taught at Tel-Aviv University, the Open University, Sapir College, and the College of Management. Charles T. Salmon is Dean of the School of Communication Arts & Sciences at Michigan State University.

CAN CONTRADICTIONS WITHIN BE SKIRTED? niyatee shinde

About two and a half decades ago news reporters busied themselves with extensive coverage on demonstrations in New Delhi. The demonstrations, which began in north India, were mostly peopled by women provoked by a sense of (misplaced) religious fervor, who were demonstrating the "right to *sati*." (*Sati* is self-immolation of a widow by burning on the funeral pyre of her husband.) According to Hindu mythology, Sati, the wife of King Dakhsha was so overcome at the demise of her husband that she immolated herself on his funeral pyre and burnt herself to ashes. Since then, her name has come to be symptomatic of self-immolation by a widow.

Propagating this "cause" soon spread into various pockets of the country, ironically, by several women's organizations demanding a woman's right to commit *sati*. What sparked off these demonstrations at the capital, followed by similar protests all over the country, was the prime minister's withdrawal of a grant to build a *sati* temple in the old parts of the city. In Delhi the well-known Rani Sati Organization, which already owned several *sati* temples in the city had been granted land to build yet another commemorative shrine celebrating *sati*, by the local municipality. It was a relatively innocuous news item to this effect in one of the dailies that caught the attention of an NGO (nongovernmental organization) that dealt with women's issues. Their efforts in thwarting the local municipality boomeranged into a shocking all-India support from like-minded fanatics. However, it was only after a cataclysmic response intensified by agitations from feminist groups and supported by then-prime minister Mrs. Indira Gandhi, that the land grant was withdrawn. Concerted efforts were initiated to cull the "*sati*-glorifying preaching and educate the believers." However, one can imagine the resistance to such efforts within a religiously oriented state.

Decades later the practice, though curtailed, continues in distant remote villages. The memory of those who commit *sati* is kept alive till today by bards and songs, which glorify their act. The halo of honor granted supposedly by their supreme sacrifice is burnished by several even today.

To quote Dr. Veena Das, the well-known Krieger-Eisenhower Professor of Anthropology who has researched extensively on collective and domestic violence in everyday life and social suffering, "The glorification of a particular social or religious practice however, is open to a greater range of freedoms and merges with the right to practice one's religion. Interference with this custom raises the question of whether the state has a right to control the future or whether it can also redefine, and in this sense control, the past." Rumblings of *sati* occurrences continue and on July 22, 1999, *The Hindustan Times* reported about a woman forced to commit *sati*, stating "Family members of a man who had killed himself allegedly forced his wife to commit *sati*. They forced her to first drink poison and later made her sit on the pyre of her husband even though she was alive. According to reports, the *chowki-dar* [guard or watchman] of the village connived with the family members and made arrangements to prepare the pyre of the deceased beside a small canal in the village. It was then that the family members reportedly put the woman on the pyre. Since the body of the woman was only partially burnt, members of the family buried her body." In March 2004 it was reported that in Samatipur, north India, an 80-year-old widow decided to "join her demised 90-year -old husband on his last journey."

The reasons why this practice could have come into being are many. But the principal among them could be identified in the same setting, which has also given birth to the dowry (compulsory cash and valuables given to the groom at the marriage by the bride's family). Closer examination of this practice of immolation supports this inference. Immolation as a widely prevalent practice can be seen only since the medieval period, but there are reasons that trace its origins to antiquity.

Incidentally, this practice of self-immolation is more prevalent among the higher marital castes. Among the lower castes and aboriginal tribes it is nearly absent. *Sati* among the higher castes is no coincidence.

As mentioned earlier, among the higher castes, a bride was looked upon as a burden as she represented a drain on the family's income while not contributing anything toward it. If this was her status as a bride, it is not surprising that if she had the misfortune to become a widow, her presence in the family was dreaded. And apart from being considered the harbinger of ill omens, her very presence after her husband's demise was like an albatross to her in-laws. The country owes the first attempts at the abolition of this deplorable practice to the crusading efforts of Raja Ram Mohan Roy, the 18th-century crusader of social reform and women's issues.

In a country that worships womanhood as an embodiment of *shakti* or power, where the woman-goddess rules in a pantheon of a million gods, where in her image of a woman she is venerated daily, such barbaric rituals come undoubtedly as ruthless contradictions. And if *sati* and the dowry system makes one baulk, take the long-prevalent customs of the Devadasis (literally meaning god's girl-slaves) wherein young girls are rigorously trained in *nritya* or temple dance, and then as virgins, dedicated to the temple either to appease the fiery Goddess Yellamma for a misfortune that may have befallen them or to plead the goddess's blessings and goodwill. Staunch believers of the Yellamma cult furiously defend their belief in the power of this goddess and the sanctity of being devoted to Yellamma and the temple. However, the reality is that the young virgins who are dedicated by their families to the temple, live in unspeakable misery with a life riddled with disease and poverty "serving and appeasing" the desires of the temple priests and rich male patrons. They eke out a living through prostitution and begging. Over the years spirited exchanges have taken place between the believers of this centuries-old tradition and various NGOs. The latter's attempts to redeem the Devadasis and alter the practice have met with very little success. The practice is now carried out in great secrecy. The embarrassed local authorities, under the spotlight of international media, have off and on made reluctant attempts to curtail the custom. Religious sentiments ride on frail steeds. Coupled with rampant ignorance such rituals and customs are assured a heady survival.

However, several NGOs and citizen groups have with missionary zeal taken up the task of reforming these customs. Traditions, especially in a country like India, die hard and though it is undoubtedly an uphill task, what with government apathy and a nation's religious fervor at stake, small inroads have been made to change the way people interpret and translate religious myth and scripture.

The work of the NGOs is indisputably aided by the work of several young photojournalists and filmmakers. Armed with their lenses and a refined sense of vigilance they make forays into the deep pockets of religious and social practice. Largely these photographers are part of the rapidly expanding media industry, their rousing images shake the apathetic stupor not only of those in power, but more important, of the average reader.

Inherent contradictions are now being addressed with a realization that perhaps these can no longer be skirted.

Niyatee Shinde—2006.

Niyatee Shinde is the founder and director of Turmeric Earth—curatorial assistance, Mumbai, India.

NINA BERMAN purple hearts: back from iraq

ANDREW LICHTENSTEIN behind bars

STEPHEN SHAMES uganda's children of war

Diana Edkins: Curator

PHOTOGRAPHS FROM THE HEART

The work of Nina Berman (Purple Hearts—Back from Iraq), Andrew Lichtenstein (Behind Bars), and Stephen Shames (Uganda's Children of War) deeply touch and reflect my concerns in a floundering moment of world uneasiness. Each body of work provides social commentary through photography. Photography has the power to persuade. These photojournalists however, have probed the psychological depths created by human conflict and have observed and fleshed out new understandings through their images. Each of these photographers has been compelled to photograph those whose voices were not being heard.

In Nina Berman's work Purple Hearts—Back from Iraq she makes seemingly simple portraits of American soldiers wounded in the Iraq War. Berman wanted to better understand the soldiers and their war, so she photographed them in spaces each veteran personally chose. Berman also conducted interviews to accompany the images so we could better understand the soldiers and the war. Nina reflects: "Before I met any wounded soldiers, I imagined that what would distress me most would be the physical injuries, the ones I could immediately see. As I got to know them, the physical damage receded and the emotional devastation took over. Now when I look at my images, I don't really see the prosthetics or the burns or the wheelchairs, except as signs of a deeper internal trauma, which I can feel and which is lifelong, and for some soldiers relentless."

In Stephen Shames' 2004 photographic exploration of the children in Uganda he has delved much further into the nether regions of youth forced to live adult lives while still being children. Shames has always observed and beautifully rendered the life of the alienated youth in a number of different photographic series. He looks for those young kids who are outsiders but also survivors. He loves to watch

the transformation. In his work Outside the Dream he captured the dance of the youthful life of children of the streets. He showed how these outsider kids found moments of play even in the most dangerous and outrageous places. In Uganda he shows the life of child soldiers placed in harm's way—children who are more familiar with guns and killing than most adults will ever be. Stephen Shames remarks: "My photographs show youth on the edge: young people embracing life in a world of menace and danger. My work concerns peril and sensuality; chaos and joy; life amidst death. I try to convey pure emotion. My goal is to capture private, inner moments where things are ambiguous, less rational. These images explore our concealed fears and hopes. They investigate the boundaries of the ordinary: the edges of experience, the place where public meets personal. Though seemingly based on reality, my photographs are dreams."

Andrew Lichtenstein's prison work was begun around 1996 or '97. He received an assignment for a death row story in Texas from a Swiss magazine. Lichtenstein says of his prison work: "This would be a pattern that would end up repeating itself many times because while the death penalty, especially in Texas, which kills more prisoners than all the other states combined, is an important story, I immediately realized that less than one percent of the nation's prisoners were on death row, but received about 99% of the media attention. I asked myself what about all the people locked away forever, 99 or 200 years, or all the people who die in prison from awful medical care, or the ones released with permanent mental scars? I wanted to tell their story as well." He received a grant from the Open Society Institute to make prison stories; for six or seven years, on two- to three-week breaks from work, he would photograph in many different prisons. Through the previous stories he had done he had gotten to know some people who worked inside the system. "They would point me in the direction of wardens who they thought would not be put off by my presence—enlightened souls. Since I worked within very set ground rules—no violence, model releases—I got to be trusted." Lichtenstein adds, "I began to photograph in prisons as a way to give these wasted lives a human face."

At first glance each photographer's work seems simple. However, upon closer regard and serious consideration one sees the imperfections, the incontrovertible fact, and lastly the tragic flaw. These photographers balance indignation and consolation with a sense of reverence.

Since the Vietnam era the most dramatic or newsworthy incidents like 9/11 are generally derived from moving images rather than from still ones. This shift in emphasis has not eliminated the role of the photojournalist, but it has clearly altered the nature of his or her work. Instead of the more topical subjects photographers have chosen subjects with greater complexity and depth. They have also devoted their energies to the expressive and narrative potential of the picture story. Beautifully rendered, Nina Berman's portraits unveil the vestiges of war where their experiences are etched on a person's face and their soul. Andrew Lichtenstein's seemingly quiet pictures of prisoners are grounded in people caught at unguarded moments conducting seemingly simple tasks—passing and/or sharing a sandwich or cleaning the floor. Here these tasks are elevated to seem celebratory. These artists have made pictures, which are highly subjective as a medium of invention and expression. Pictures certainly worthy of serious contemplation.

Diana Edkins—New York City, USA.

Diana Edkins is Director of Exhibitions and Limited-Edition Photographs, Aperture Foundation, New York City, USA.

NINA BERMAN purple hearts: back from iraq

In October 2003, I started making portraits of American soldiers who were wounded in the Iraq War. I began the project because I needed to see what I wasn't seeing. Each day I would hear reports of soldiers being injured, but there were no images. The human cost of war seemed conspicuously absent from public view.

There are no lists of the wounded, unlike the dead. In newspapers, the names of the dead are published every day along with their ages, hometowns, and command units. I read these names and feel sorry for the soldiers' families and friends. But the dead tell no stories. It is the wounded who survive and present us with our own complicity.

I found my subjects by going on the Internet and plugging in certain words: brain damage, blind, wounded, arm, leg, and amputee. I then tracked them down in their hometowns after they had been discharged from military hospitals. I avoided photographing them at public spectacles like welcome home parades or purple hearts ceremonies. I wanted to see the soldier in private and alone as each confronts his or her loss and considers the experience of war and life ahead.

When I started the project there were a thousand wounded. Now there are tens of thousands. They have lost eyes, ears, and pieces of their brain. The damage is wrenching and at first I was not prepared. Then I became obsessed. I couldn't stop the project. I had to find more soldiers.

Looking back, I now understand how desperate I was to carve out a place of truth amid the spectacle of Shock and Awe and Mission Accomplished and the Hunt for Saddam and the yellow ribbons and freedom fries.

The soldiers made it real.

Nina Berman—New York City, USA.

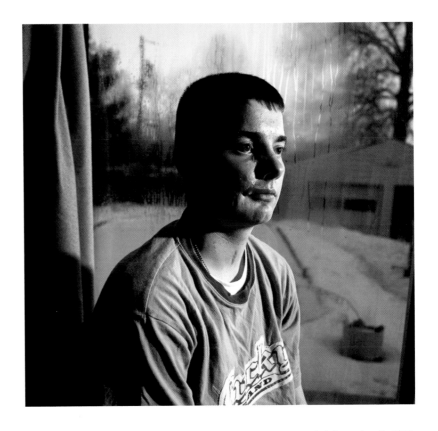

PFC. RANDALL CLUNEN, 19 years old, 101st Airborne, was wounded December 8, 2003, when a suicide car bomber broke through security lines and exploded himself. Chunks of shrapnel ripped into Clunen's face and jaw, requiring multiple surgeries. Photographed at his home in Salem, Ohio, USA.

"I liked it. The excitement. The adrenaline. Never knowing what's going to happen. I mean you could walk in the house and it would blow up, or you could go in and get fired at....

"Now it's nothing. You just watch the news or you watch the war movies on TV. I want to find Hamburger Hill, that's a good one about the 101st. My dad, we'd sit there and watch them. A lot of John Wayne movies, too."

FEBRUARY 14, 2004. ©NINA BERMAN.

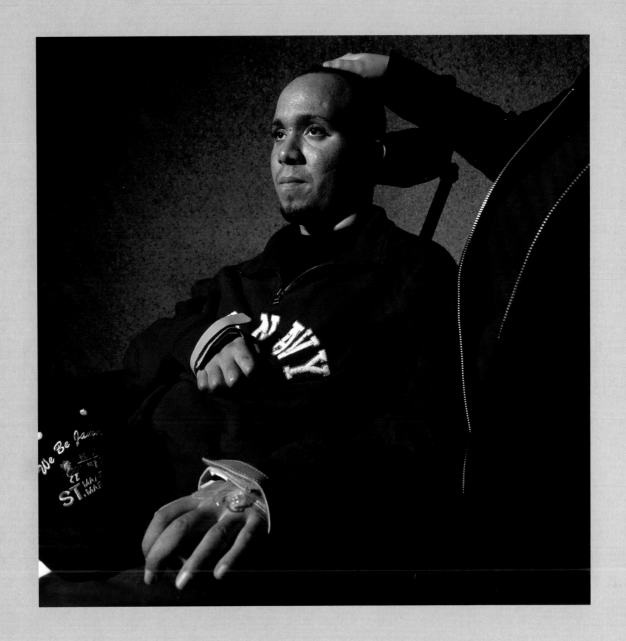

SPC. SGT. LUIS CALDERON, 22 years old, 4th Infantry Division, was wounded May 5, 2003, in Tikrit, when a concrete wall with Saddam's face on it, which Calderon had been ordered to destroy, came crashing down on him, severing his spinal cord and leaving him a quadriplegic. His entire family moved from Puerto Rico to south Florida to take care of him. Photographed at the Miami Veterans Hospital, Florida, USA.

"From my neckline down, I cannot feel anything. . . . I got an Army Commendation Medal. I didn't get a purple heart. I feel like I deserve one. It would make me more confident that I really did something."

DECEMBER 17, 2003. ©NINA BERMAN.

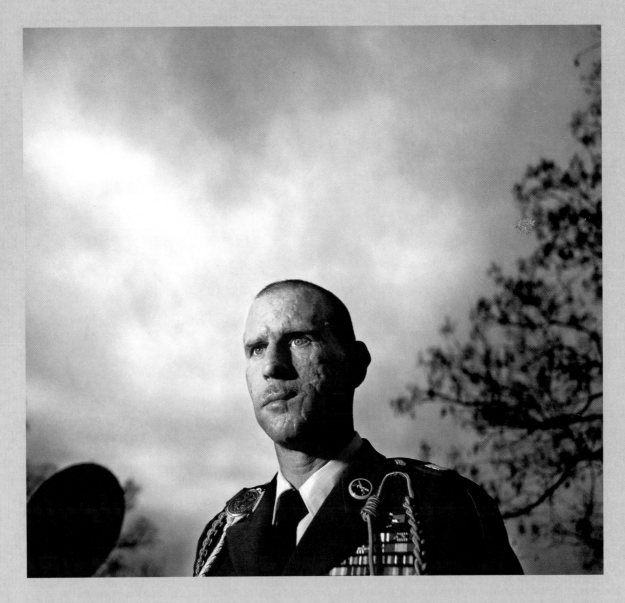

SGT. JOSEPH MOSNER, 35 years old, 1st Infantry Division, was wounded December 16, 2003, in Khalidya when a remote controlled bomb planted in a side of a building exploded, sending metal into his face and injuring two other soldiers. Photographed at his home on base at Ft. Riley, Kansas, USA.

"It took off my scalp, left side of my face, my ear was hanging off, my left ear. I got shrap metal in the chest, shrap metal in my legs from the knees down, and both my legs were broken."

"We had a good time. We made it fun. After we got hit we'd give each other high fives and laugh about it. So it was OK, you know getting to do the real thing. It's like playing a sport, you practice, practice, practice and then game-time comes, you know, you want to play."

APRIL 9, 2004. ©NINA BERMAN.

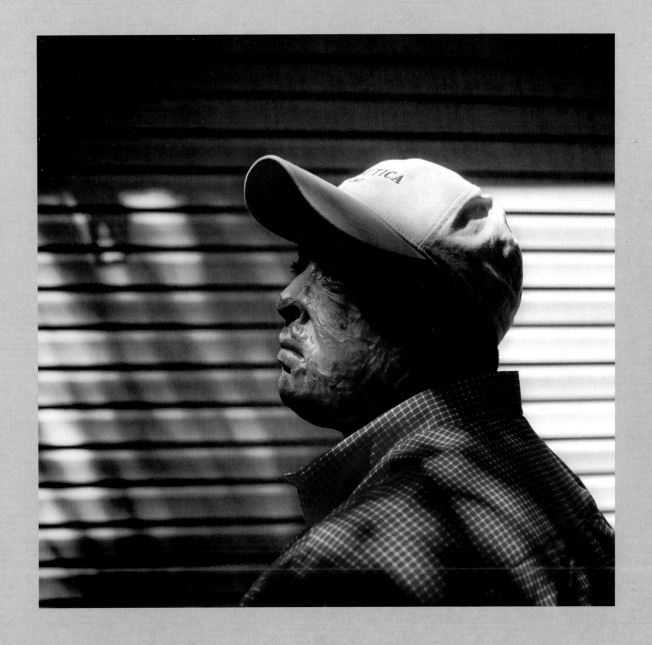

SPC. JOSE MARTINEZ, 20 years old, 101st Airborne, was wounded April 5, 2003, in Karbala when his humvee hit a land-mine and exploded. Martinez suffered extreme burns to his head, face, and body. He has spent the last year in surgery and recovery at Brooke Army Medical Center in San Antonio, Texas. Photographed at his home while on brief hospital leave. Dalton, Georgia, USA.

"I had this dream where everything was going to work so good and everything would be fine. Three years in the Army. I'll be in and out. Now I look back on my thoughts and I think, all it was, was a fantasy. That's kind of what it was."

APRIL 3, 2004. ©NINA BERMAN.

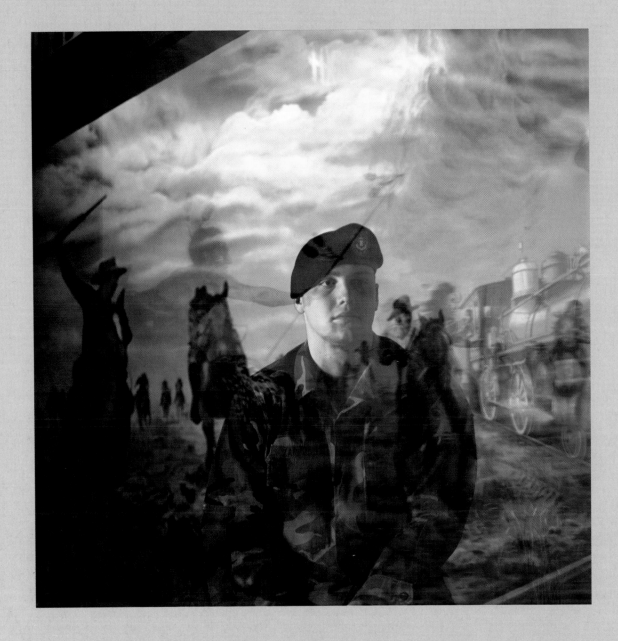

SPC. ADAM ZAREMBA, 20 years old, 1st Armored Division, was wounded July 16, 2003, while guarding a bank in Baghdad. A mine exploded, blowing off his left leg and sending shrapnel into his head, right leg, arms, and hands. The explosion also killed an Iraqi child. Photographed on his base at Ft. Riley, Kansas, USA.

"I joined in high school. The recruiter called the house. He was actually looking for my brother and happened to get me. I think it was because I didn't want to do homework for a while and then I don't know, you get to wear a cool uniform. It just went from there. I still don't even understand a lot about the Army."

APRIL 9, 2004. ©NINA BERMAN.

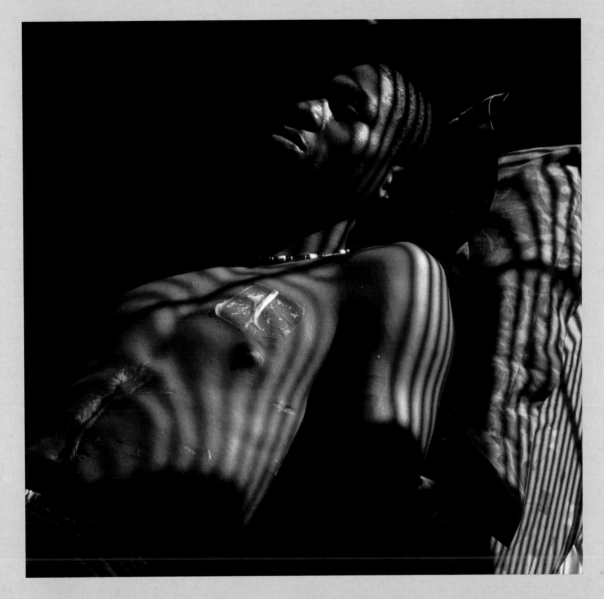

CPL. TYSON JOHNSON, 22 years old, 205th Military Intelligence Brigade, was wounded September 20, 2003, in a mortar attack on the Abu Ghraib prison. He suffered massive internal injuries and is one hundred-percent disabled. Photographed at his home in Prichard, Alabama, USA.

"Most of my friends, they were losing it out there. They would do anything to get out of there, do anything. I had one of my guys, he used to tell me, 'My wife just had my son, I can't wait to get home and see him.' And you know, he died out there. He sure did and I have to think about that every day."

"I got a bonus in the National Guard for joining the Army. Now I have got to pay the bonus back and it's $2,999. The Guard wants it back. It's on my credit that I owe them that. I'm burning on the inside. I'm burning."

MAY 6, 2004. ©NINA BERMAN.

ANDREW LICHTENSTEIN behind bars

Photographing in prisons was, above all else, a balancing act. In order to get behind the walls with a camera, I had to be an invited guest of the warden. But I never wanted to be perceived by the prisoners themselves as working for the prison administration. To be considered fair-minded and professional by suspicious prison officials, and at the same time, be honestly interested in the lives of the prisoners, required a lot more diplomacy than photography.

Almost all of these photographs were taken while a guard as an escort accompanied me. Whether I admitted it or not, I was dependent upon the guards for my own safety. But wherever I went in America, prisoners treated me with kindness and respect. They were eager to tell almost anyone about the injustices of a criminal justice system where money buys your freedom, of the beatings they had received from guards, and of the latest corruption scandal in the prison. When they were done, I'd have to turn to my escort and ask to be taken to see and hear more. Immediately, I would realize the only reason that I was able to take these pictures was because the prisoners had already been tried and convicted. Their stories are trapped with them behind the bars, accessible to any visitor willing to listen.

As a visitor, there is no way to experience what life in prison is really like. Several hours after being escorted past the razor wire and sliding doors, I would be ready to leave. Not being able to walk away is the only way to understand prison, and each time I left out the front gate, I was thankful that I had not come to terms with the claustrophobia, idleness, boredom, and fear, that dominate the prisoners' lives. Most prisoners, seeing my camera, were very concerned that I was being given a propaganda tour by the guards. I'd never be allowed to be there when they were being beaten or gassed, or if there was a riot or stabbing, they challenged. When I

Andrew Lichtenstein—New York City, USA.

replied that I took it for granted that I would never see the real truth about their lives, and that the only way would be to be locked up with them, without the cameras, they relaxed. Which is more than I could say for a few of the wardens, who on two separate occasions seized my film.

Over the past decade, America's prison population has doubled. There are now over one million convicted felons sitting in American prison cells. Laws that impose mandatory drug sentences, and a general hardening of attitudes toward criminals, have put a whole new generation of young Americans behind bars. Attempts at reform and rehabilitation for people convicted of crimes have been abandoned, giving way to an honest admission of prison's real role, as a place to punish people.

With that punishment has come the inevitable dehumanizing of the prisoners. America has collectively turned its back on anyone convicted of a crime, regardless of how petty the original offense, or how ridiculously long the sentence they were given. While visiting different prisons, I certainly met some people who I was glad were locked behind bars. Sadistic murderers, violent robbers, career criminals, and repetitive child molesters are in some of these photographs. But the vast majority of prisoners I met were people who had fallen on hard times, made some bad decisions and with few financial resources to defend themselves, had been caught in the tremendously powerful wheels of America's criminal justice system. Convicted of a nonviolent offense like drug possession, they had to learn how to survive in a world run by professional prison gangs and prison officials who could not help but view them as just another number.

It was to give all of these wasted lives a human face that I began taking these pictures.

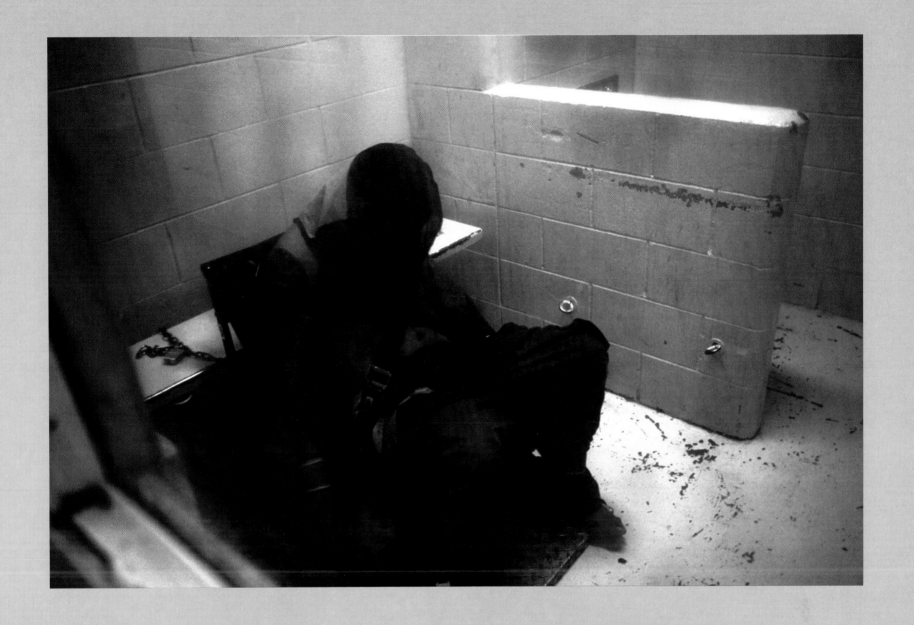

A man, who was arrested and came into the Maricopa County Jail fighting sheriffs' deputies, is placed in a restraining chair, in a single cell after being hog-tied and maced. The mask is on his face so that he cannot bite or spit on his jailers. Phoenix, Arizona, USA.

SEPTEMBER 1, 1994. ©ANDREW LICHTENSTEIN/AURORA PHOTO.

A prisoner peers out of his administrative segregation
cell in the Hughes Unit. Gatesville, Texas, USA.

JUNE 1, 2000. ©ANDREW LICHTENSTEIN/AURORA PHOTO.

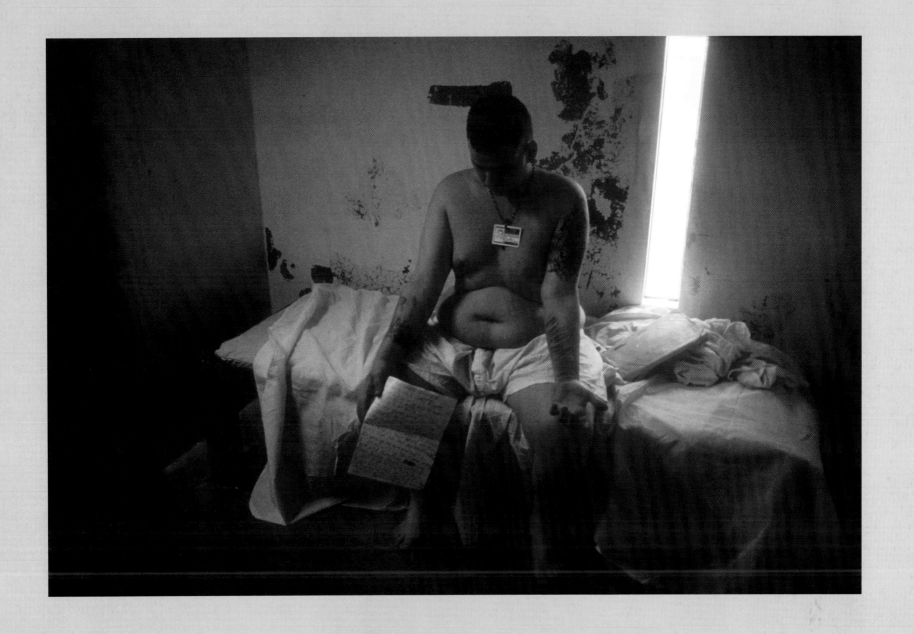

A young prisoner holds a letter pleading to the warden for a transfer to a different section of the prison. Like many scared and unstable prisoners, he has recently slashed his wrists in an attempt to be moved. Unfortunately, that will only work if the wounds are life threatening. Beaumont, Texas, USA.

JUNE 1, 2000. ©ANDREW LICHTENSTEIN/AURORA PHOTO.

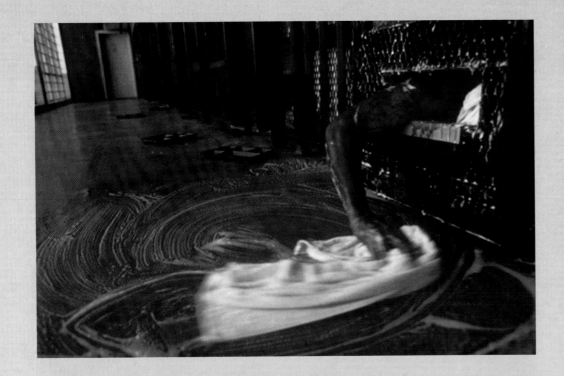

ABOVE LEFT: In a desperate attempt to keep his cell clean, a prisoner on the administrative wing of the Collfield Unit in Palestine, Texas, washes away the sewage left from a flooded toilet on the tier above him. With no access outside of the cell, blocking up toilets is a common form of protest in prison.

LEFT: Gang members housed on the same wing of the Collfield Unit in Palestine, Texas, exchange a peanut butter sandwich made from commissary supplies while the prison is on lockdown and kitchen services have been suspended. Palestine, Texas, USA.

JULY 1, 2000. ©ANDREW LICHTENSTEIN/AURORA PHOTO.

At a wing of a prison reserved for the mentally ill, a prisoner sleeps away the day in the corner of his cell. Over sleeping is a typical symptom of depression in prison. Psychiatric Wing of the Montford Unit, Lubbock, Texas, USA. JUNE 1, 2000. ©ANDREW LICHTENSTEIN/AURORA PHOTO.

STEPHEN SHAMES uganda's children of war

"I killed five children in Teso, one in Gulu, and four in Lira. . . . You don't feel anything. You don't feel yourself. You get confused and very depressed about it. I never got used to killing people. Every time I killed people, I felt very bad about it. I even have bad dreams about them. Last night . . . I [woke up] screaming."

—Olee, 12-year-old former child soldier

Of all the horrible things this world has to offer, abducting children and forcing them to kill has to rank at the top. Young boys and girls are snatched by the Lords Resistance Army from their homes in the middle of the night. They are immediately brutalized, required to beat another child or a baby on their heads with a club until they die. Or they are forced to kill their parents. Boys become soldiers. Girls are given to commanders to be their "wives." If they refuse to have sex, their lips are cut off. This has been going on for 18 years in northern Uganda, while the world continues about its business.

In 2004, I met Els De Termmerman, a Belgian writer who used the proceeds from her book on child warriors to finance the Rachele Rehabilitation Center in Lira, Uganda. I asked if I could take photos. The staff and children welcomed me. As I wandered around freely snapping, I saw dedicated Ugandan men and women rehabilitate traumatized children with love and sheer will power (and very little money). Later I returned and conducted video interviews with the children and staff. The quote leading off this statement comes from Olee, who was abducted at ten and lived for two years in the bush.

I was privileged to be there when a large group of adolescents arrived—just out of the bush—with four LRA commanders who walked out with them, the largest defection in the war. The next day I accompanied them to Gusco Center in Gulu.

The photo of the boy and the soldier took place at this emotional reunion of 12-year-old Ojok with the commander who saved his life. This slight boy was a squad leader, commanding other children on raids—until one day he saw his chance to escape and made his way home. Months later, he was abducted again and was about to be killed, when the commander on the left of the photo saved his life and helped him escape again. This tough kid, who led others into battle, breaks down and cries frequently—at the smallest provocation. His body shakes. He only calms down when he is held.

This is some of what I have seen. I am a photojournalist. Photojournalists are on the front lines of evil, everyday. It is impossible to remain unaffected by what we see. Some, many of us, do something about it besides taking photographs.

On my next trip to Uganda, I flew up to Kitgum—the roads are unsafe—to an Internally Displaced Persons (refugee) camp to ask Ojok's grandparents if I could put him into a good school. He came down to Kampala, learned English in a few weeks, and attends third grade at Katikamu Primary School. Ojok does not get upset as often anymore. He is one of 40 vulnerable children and traumatized youth attending good boarding schools in Uganda, including two who go to St. Henry's Kitouvu, one of Uganda's elite schools. They are looked after by half a dozen volunteer moms and a part-time local director

Four years ago, I started paying school fees for one child; one depressed AIDS orphan in Uganda, who had no hope of going to school. Michael was but one of the thousands of the AIDS orphans, children with AIDS, child soldiers, and street kids I have photographed during the past five years in India, Brazil, Bangladesh, Honduras, Vietnam, Thailand, Kenya, and Uganda.

Well, his brother needed to go to school also, and then there were the 15 children living in child-headed families in a rural village in Rakai, who were out of school

because they did not have money for pencils and paper, or enough food, so even when they manage to get to school, they can't study. "Sometimes at school when I try to sing, I am so hungry the words can't escape," is how one boy expressed it.

I couldn't afford to help them all by myself. So I started Outside the Dream Foundation and asked my family and friends to contribute. Outside the Dream pays school fees for AIDS orphans, street kids, and other vulnerable children in Africa and Asia. We find highly motivated, intelligent children living "outside the dream"— children without parents to take care of them, food to eat, or money for school fees—and enroll them in school. We help our students graduate from high school, and, if possible, college by paying their school fees; buying them school supplies like books, pens, paper, and uniforms; making sure their basic needs for food, clothing, and shelter are met; and providing emotional support.

One or two individuals might not change the course of human history. However, you and I can transform a child's life. We can educate one youngster. Knowledge provides opportunity. It can make the difference between a child who becomes a doctor or computer whiz and one who ends up in the "swamp of ignorance" that provides fertile breeding ground for criminals, prostitutes, and terrorists.

As you look at the photos in this exhibition, remember that for 85¢ a day, one of those kids could escape their "fate." That's right—85¢ a day—a cup of coffee, a small order of fries. Scores of individuals contribute $10, $25, $50 a month—and a few give considerably more. They do this to help African children achieve their dreams and to create a safer world for their own children.

Why don't you join us?

Stephen Shames—New York City, USA.

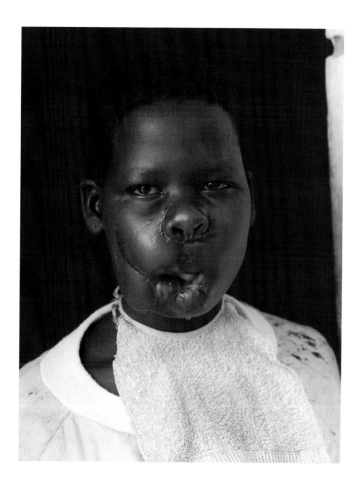

A Teenage girl who had her lips cut off for refusing to have sex with a rebel soldier. The Rachele Rehabilitation Center for child soldiers who were abducted and forced to kill by the Lords Resistance Army.

The center was started by Els De Temmerman, a Belgium woman who wrote a book on child soldiers. Lira, Uganda.

May 26, 2004. © Stephen Shames/Polaris Images.

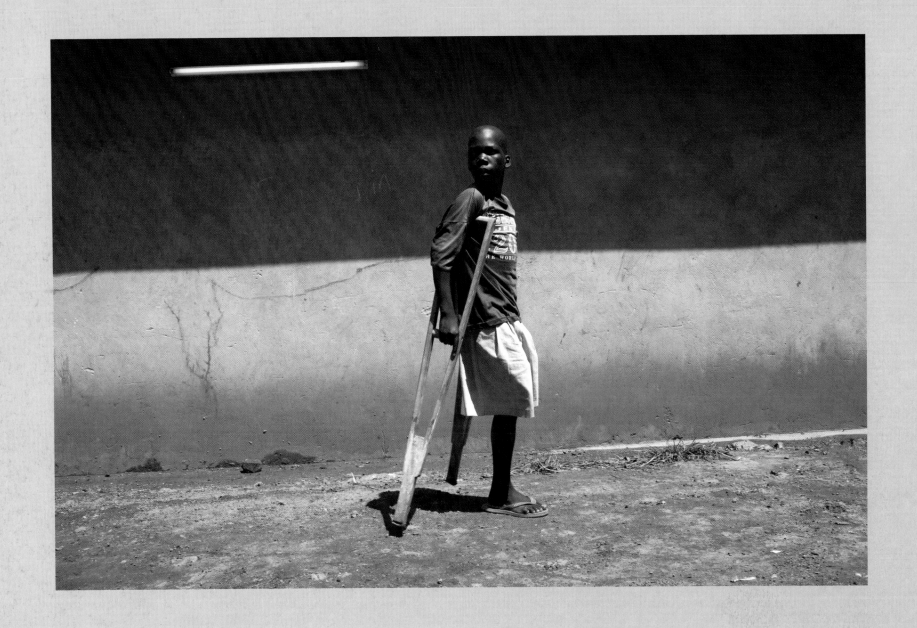

A teenager who lost his leg in the war. The Gusco Child Rehabilitation Center helps children abducted by the Lords Resistance Army to re-integrate into society. These child soldiers were forced to kill or be sex-slaves. Now they can become children again. Gulu, Uganda.

MAY 28, 2004. ©STEPHEN SHAMES/POLARIS IMAGES.

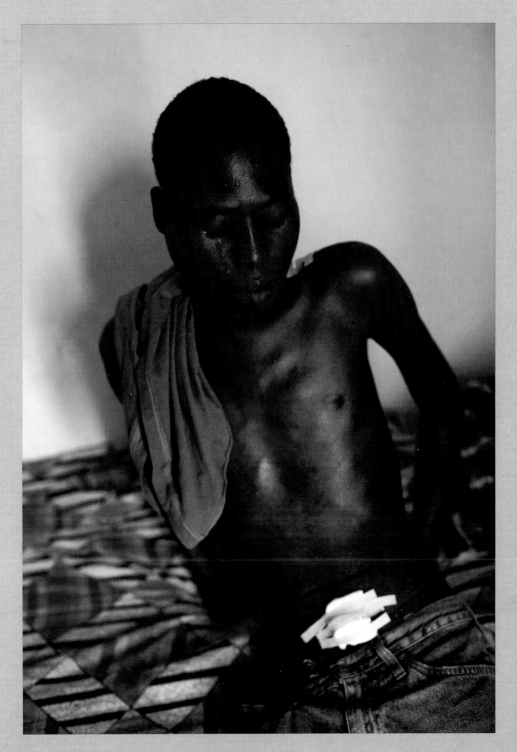

ABOVE: A counselor at the Gusco Child Rehabilitation Center holds the hand of one of 130 child soldiers who defected from the Lords Resistance Army. Gusco helps children abducted by the Lords Resistance Army re-integrate into society. These child soldiers were forced to kill or be sex-slaves. Gulu, Uganda.

MAY 28, 2004. ©STEPHEN SHAMES/POLARIS IMAGES.

LEFT: A teenager recovering from a bullet wound in the stomach he received during a battle. This boy is at Rachele Rehabilitation Center for child soldiers who were abducted and forced to kill by the Lords Resistance Army. The center was started by Els De Temmerman, a Belgian woman who wrote a book on child soldiers. Lira, Uganda.

MAY 26, 2004. ©STEPHEN SHAMES/POLARIS IMAGES.

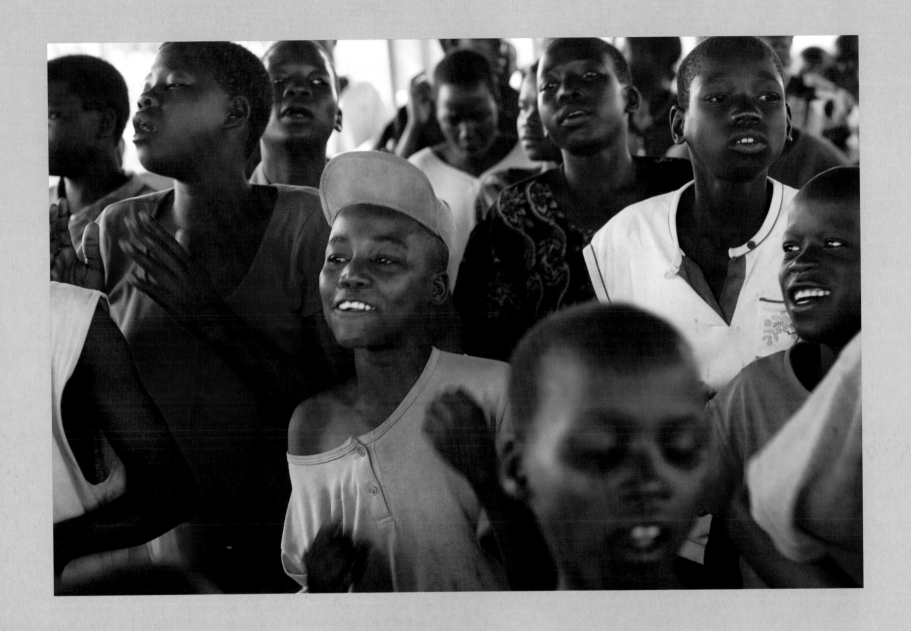

Former child soldiers sing at the Rachele Rehabilitation Center. "We want them to experience joy and to be children again," says Els De Temmerman, a Belgian woman who wrote a book on child soldiers and started the center for child soldiers who were abducted and forced to kill by the Lords Resistance Army. Lira, Uganda.

MAY 26, 2004. ©STEPHEN SHAMES/POLARIS IMAGES.

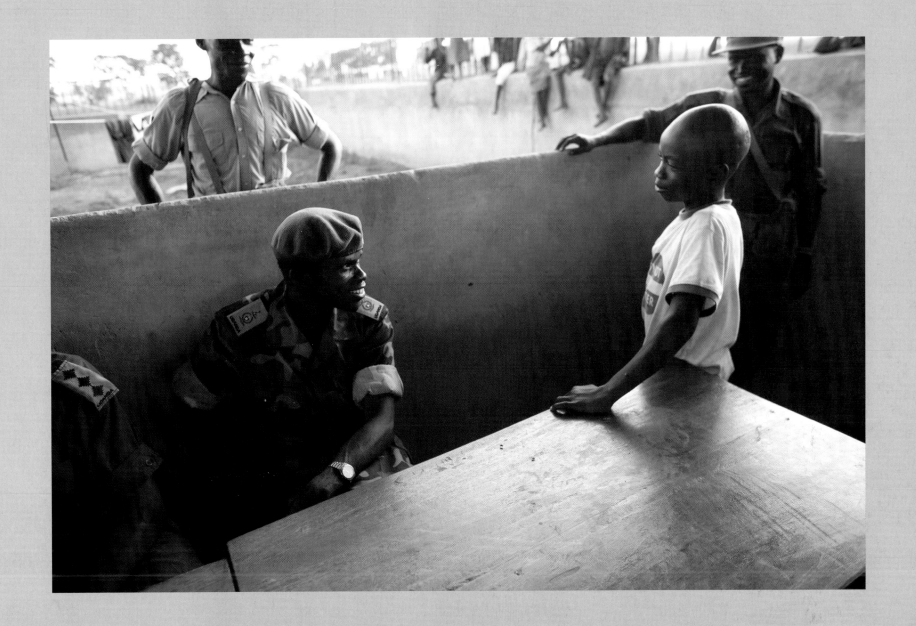

Reunion between LRA commanders and former child soldiers who were under their commands at the Rachele Rehabilitation Center—12-year-old Ojok Charles with Major Okot Ayol Silvio. Ojok was a bodyguard to Major Okot, who later saved Ojok's life when the LRA tried to kill him. Four senior commanders of the Lords Resistance Army defected with 130 fighters in the largest defection of top leaders. Uganda.

©STEPHEN SHAMES / POLARIS IMAGES.

FANIE JASON mapogo a matamaga: people's justice
GUY TILLIM mai-mai: little soldiers

Kathy Grundlingh: Curator

Fanie Jason was born in Cape Town, South Africa, in 1953. In 1960, following the promulgation of the Group Areas Act, his family was forced to move to the township of Guguletu. He attended high school in the nearby "colored" area of Mannenberg. Jason is a self-taught photographer who started taking photographs to supplement his income as a bible salesman and he has worked for most South African newspapers, including *Drum* and *Pace* over the last 20 years. His images have appeared in many international publications, including *Time Magazine*, *Globe*, and *Star* (U.S.); *De Standaard* (Belgium); *Maxi* magazine (Germany); *The Observer*, *Daily Mail*, and *The Guardian* (United Kingdom). Jason has exhibited extensively and received numerous national and international awards, including amongst others the Abdul Shariff Award in 1999 and Fuji Photo Award (South Africa) 2000, Fifty Crowns International Fund for Documentary Photography (Africa) 2002, and Vodacom Journalist of the Year (Photography) (South Africa) 2003.

In his series of images, "People's Justice," Jason documents the phenomenon of vigilantism, a widespread practice throughout the "townships" of South Africa. In 2000, South Africa's largest vigilante group, Mapogo a Matamaga (which translates as "When a leopard is attacked by a tiger it turns into a tiger itself") claimed a membership of more than 50,000 people. Hundreds of people have been killed in vigilante killings since then. Research conducted by The South African Institute for Security Studies into the growth of vigilantism since 1994 shows that this is primarily due to high levels of crime, public perception that the government does

not provide adequate security services, and the fact that justice continues to be inaccessible for many South Africans.

Jason was prompted to start this project after witnessing one of these events taking place in the street where his parents live in Guguletu.

Guy Tillim was born in Johannesburg in 1962. After obtaining a bachelor of commerce degree from the University of Cape Town he joined Afrapix, a collective of South African photographers. During this time from the mid-80s until the early '90s he documented political turmoil within South Africa and abroad while working for Reuters and other South African and foreign press agencies. He was awarded the Mondi Award, South Africa, for photojournalism in 1998 and 1999; as well as the Pix SCAM Roger Pic, France in 2002; the Higashikawa Overseas Photographer Award, Japan in 2003; the Daimler Chrysler Award for Photography, South Africa in 2003; and most recently the Oskar Barnack Prize Germany for 2005.

Tillim has published and exhibited extensively, highlights for 2004 and 2005 being a Daimler Chrysler Award exhibition, Stuttgart, Germany, as well as the South African National Gallery in Cape Town; Africa Remix, which opened at the KunstPalast, Düsseldorf in 2004 and is traveling to The Hayward Gallery, London; The Pompidou, Paris, and The Mori Art Museum, Tokyo. Tillim will have a solo show at the Photographers' Gallery in London in August of this year 2006.

Guy Tillim's "Soldiers" series of black-and-white handprints were taken between December 2002 and January 2003 and convey the devastating effect on civilians of the five-year war between the Congolese government and the ever-splintering rebel groups. According to UN figures, some two million people have been displaced by the conflict in eastern Congo, an area rich in gold, diamonds, andcobalt and columbia tantalite, or coltan. More than three million people are estimated to have died as a result of the armed conflict since 1998. Following a cease-fire agreement in 2003 and the formation of a government of national unity, a joint military command was established, but the country remained fragmented under various armed forces with the resurgence of conflict particularly in the northeast of the country.

During the conflict, all armed political factions within the Democratic Republic of the Congo recruited child soldiers, many of them under the age of 15. Many of these children were forcibly removed from their families or coerced into joining. Some volunteered. A large percentage of these children either witnessed or participated in committing human rights violations against civilians as well as being deployed in the front line. In 2003 it was estimated that at least 50% of the Mai-mai militia were under the age of 18. During the height of the conflict young girls were abducted, raped, and forced to act as "wives" to commanders within the militia. At the start of the cease-fire, about 30,000 child soldiers were awaiting demobilization. By February 2004 it is estimated that around 5,500 children had been demobilized, but that recruitment continued.

Kathy Grundlingh—Cape Town, South Africa.

Kathy Grundlingh is Curator of Photography and Media at the Michael Stevenson Gallery, Cape Town, South Africa.

FANIE JASON **mapogo a matamaga: people's justice**

In the townships of the new South Africa, there is still an inherent mistrust of uniformed authority or enforcers of any kind. "People's Justice" is not merely a sporadic social evil with its roots in poverty and deprivation, and which, with targeted funds can be "policed away." There is a sinister nature to these chilling and unreported acts of "punishment by the people," carried out within a close-knit community. It is disturbing enough that the victim's word alone is sufficient evidence to incite community wrath. It is equally alarming that there is no judge, no jury, and no trial. Stones, whips, "necklaces," and naked parades through the streets are punishments that have been meted out by township communities. In some cases, a pitying onlooker calls the police, who may arrive in time to prevent murder.

In one weekend, vigilante killings claimed the lives of six people in the Western Cape. Three men suspected of robbing trains from Khayelitsha to Philippi were found "necklaced" on a bridge near Philippi, after being besieged by irate residents. (A "necklace" describes the process of placing a tire around a victim's neck, filling it with petrol, and setting it alight.) The naked body of another man, apparently stoned to death, was found in Samora Machel—a shack settlement—he same weekend. On the Friday night, in Khayelitsha, the body of a man bludgeoned to death in a similar attack was discovered. Two weeks earlier, bodies of two men shot in the head in "vigilante-style J executions were found next to the road in Nyanga, Western Cape. In all these cases perpetrators were protected by the community's "stonewall" of silence.

Once justice is carried out, no one will speak of it to outsiders. As a photographer, I too, become a silent witness.

In these photographs, I am not trying to be specific—in terms of analyzing the reasons for any one particular instance of revenge. I am most interested in documenting what happens when a community takes the law into its own hands.

Fanie Jason—Capetown, South Africa.

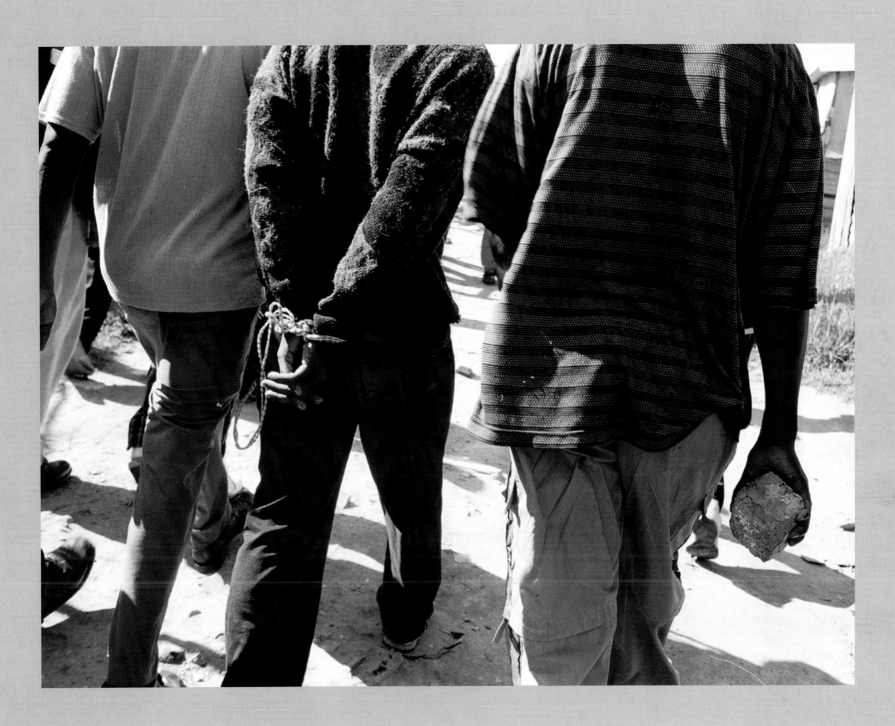

This man, caught stealing, was led through the streets of Khayelitsha, his hands tied with rope. South Africa.
© FANIE JASON.

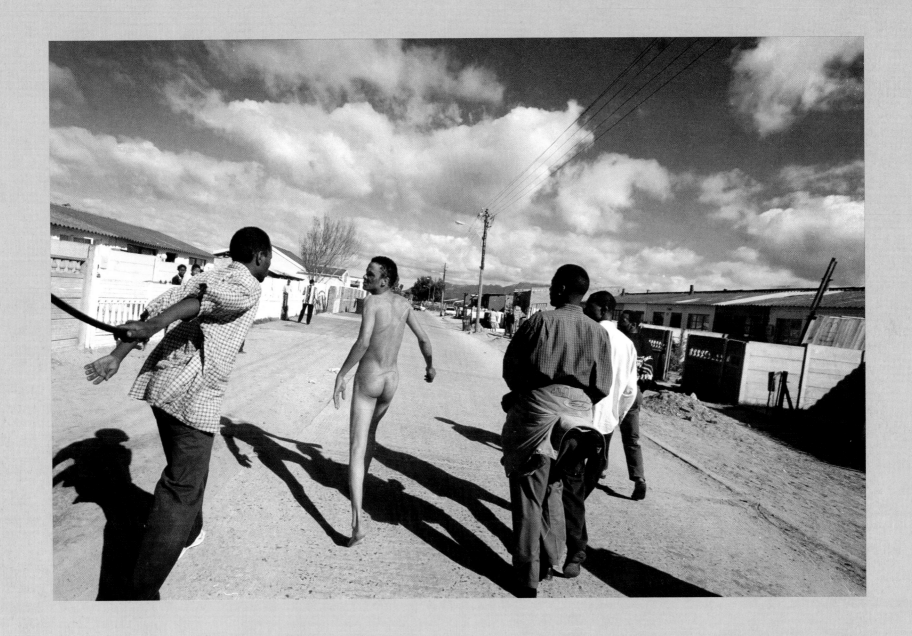

This man, who had been released on bail after being arrested for rape, returned to terrorize his victim. The community in Gugulethu took the law into their own hands. They stripped and whipped him in public. South Africa.

© FANIE JASON.

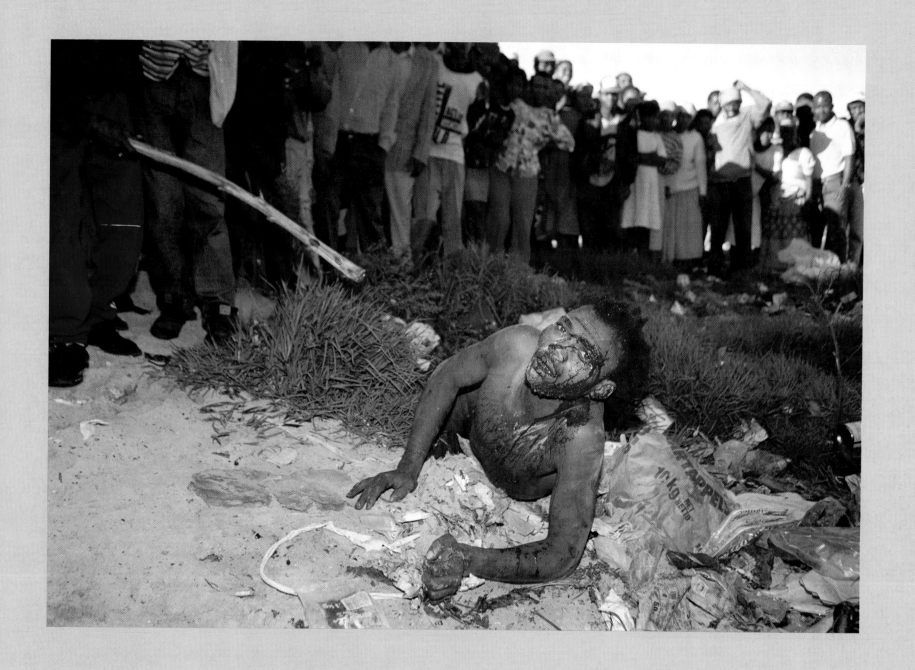

This man, found to have stolen goods in his house, after a series of burglaries in his locality, received a public stripping and beating from the Gugulethu community. Behind him, girls on their school break, laugh at his plight. South Africa.

© Fanie Jason.

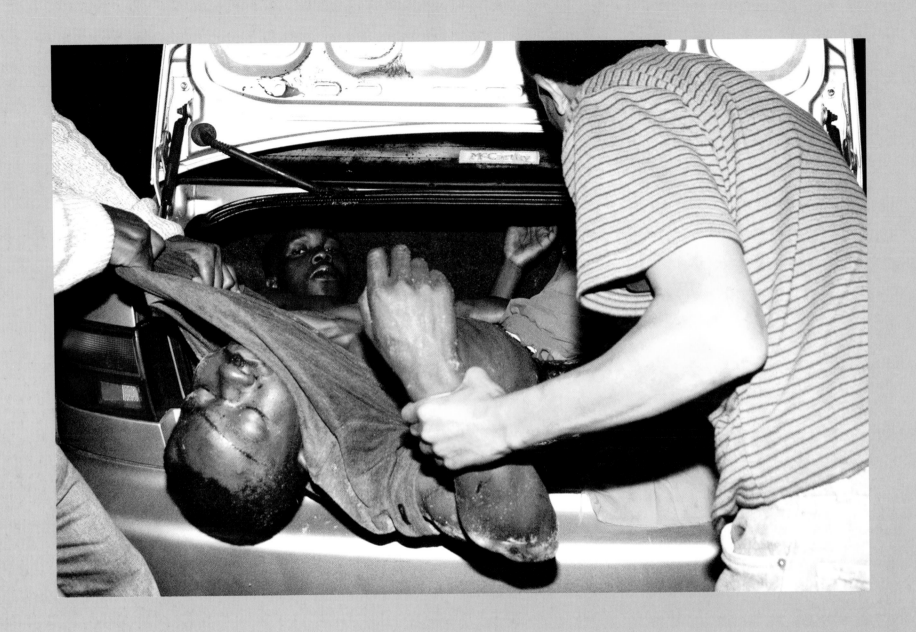

These two men were caught stealing from a church in Khayelitsha. Two accomplices managed to get away. After being apprehended by the community and beaten, the two men were bundled into a car boot and taken to the police station. One of the men later died in police custody. South Africa.

© Fanie Jason.

58.

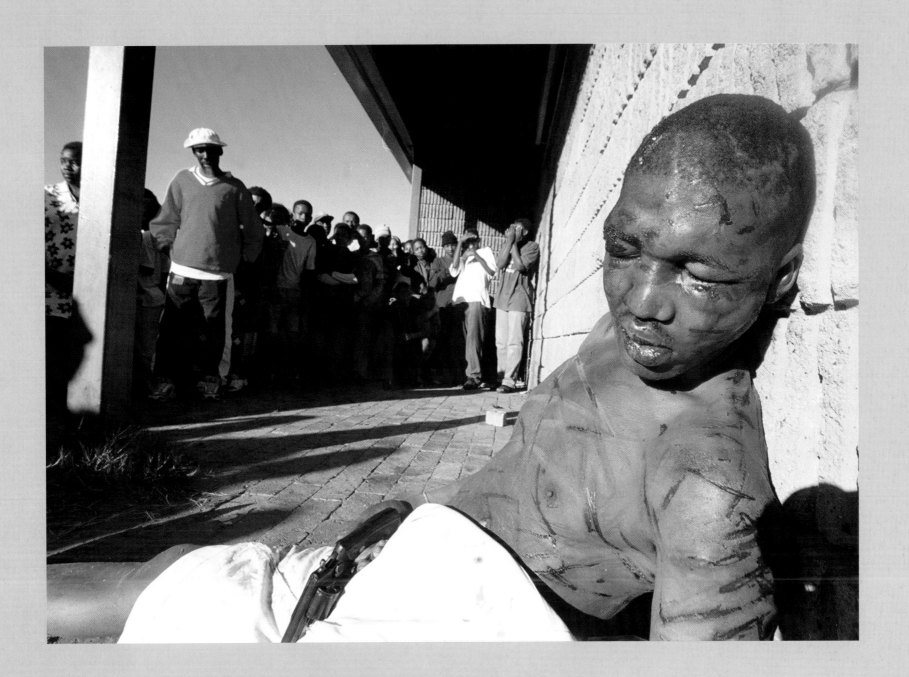

This man, out on bail for an alleged rape, had returned to terrorize his victim. After the victim alerted her community in Gugulethu, the man was set upon with sticks. Here the man lays propped up, gun in hand, so that all can gaze at his sorry state. South Africa.

© FANIE JASON.

GUY TILLIM mai-mai: little soldiers

These portraits were taken in December 2002 of Mai-mai militia training in camouflage near Beni, eastern Democratic Republic of Congo.

Mai-mai means water. The name refers to their belief in magic that turns their enemies' bullets to water. They are a traditional defense militia who are often co-opted by political groups, or are forced to choose sides in disputes between rebel factions. These troops, boys ranging between 12 and 16 years old, were sent for immediate deployment with the Armée Populaire du Congo (APC), which was the military wing of the Rally for Congolese Democracy-Kisangani-Movement of Liberation (RCD-KIS-ML).

The RCD-KIS-ML, allied to the Kinshasa government, 2,000 kilometers to the west, was arrayed against another RCD splinter group in the region, led by Jean-Pierre Bemba, and the notorious Union of Congolese Patriots (UPC), led by the 26-year-old Thomas Lubanga.

Guy Tillim—Johannesburg, South Africa.

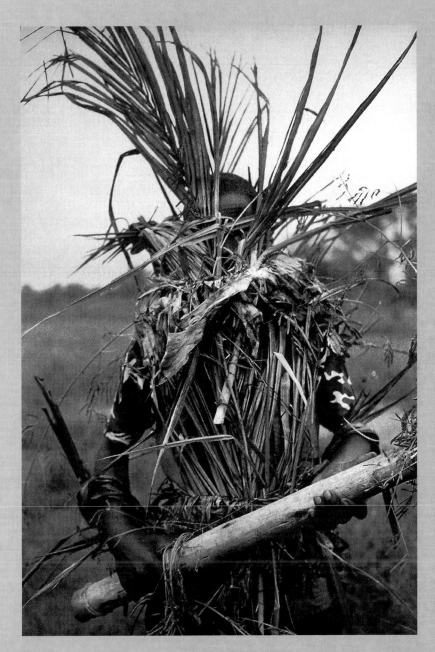
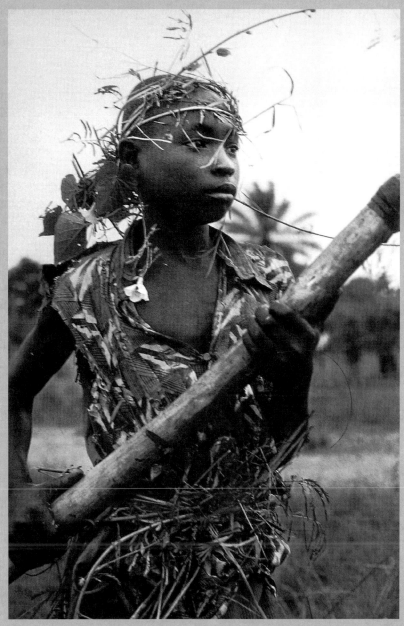

Mai-mai militia in training near Beni, eastern DRC, for immediate deployment
with the APC (Armée Populaire du Congo), the army of the RCD-KIS-ML.
DECEMBER 2002. © GUY TILLIM.

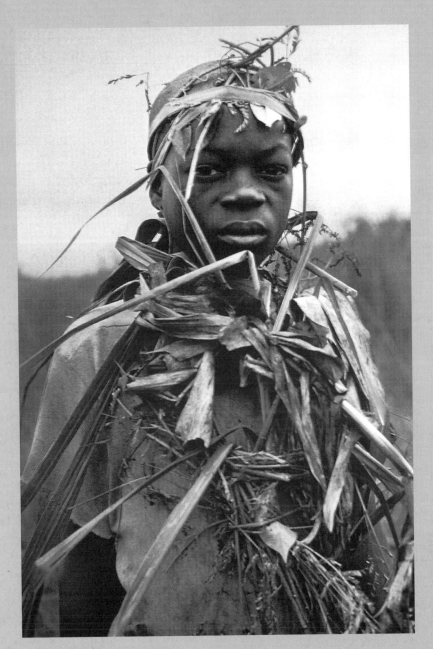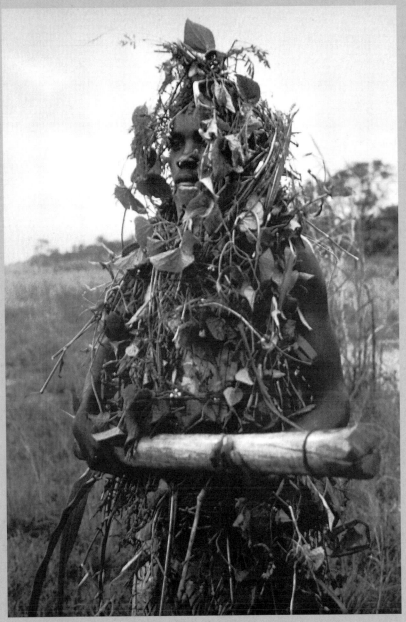

Mai-mai militia in training near Beni, eastern DRC, for immediate deployment
with the APC (Armée Populaire du Congo), the army of the RCD-KIS-ML.

DECEMBER 2002. © GUY TILLIM.

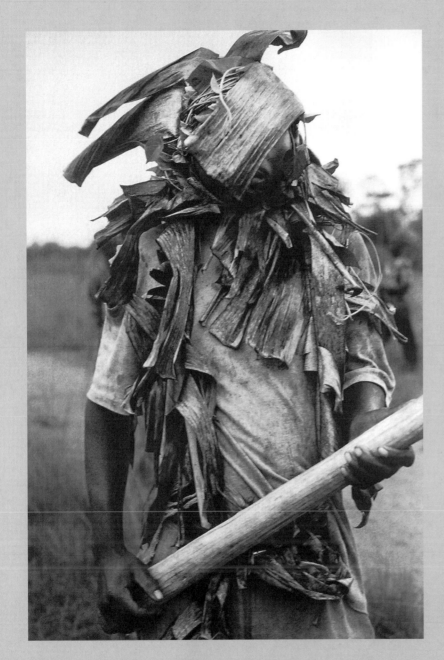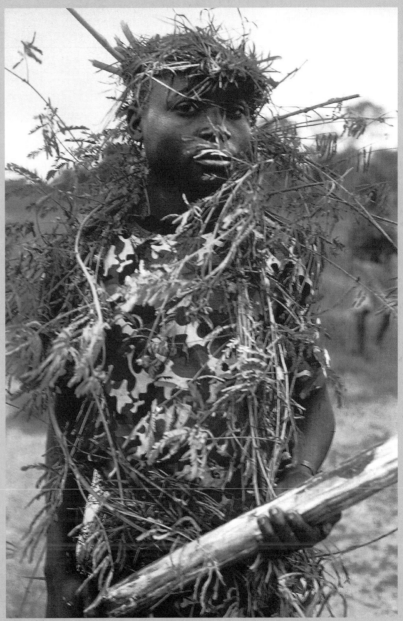

Mai-mai militia in training near Beni, eastern DRC, for immediate deployment
with the APC (Armée Populaire du Congo), the army of the RCD-KIS-ML.
DECEMBER 2002. © GUY TILLIM.

WANG YISHU tsunami holidays 2004

Wu Jiabao: Curator

WANG YISHU'S TSUNAMI WORKS

It took the Americans almost 100 years to take photography from its beginning as a medium searching for an identity as an art form to its present role as a significant digital information carrier. This same process took the Japanese 50 years, and the Taiwanese more than 30 years. But the Chinese took photography through this change in a mere 20 years.

A dynamic market energy driven by a 1.3-billion strong population, more than 5,000 years of history and culture, and the seemingly endless pool of educational resources (added to the unbalanced and rapid changes in recent years) have given the photographic culture of China—as compared to any other country in the world—a rather unique character.

Next to major Western news agencies, Chinese photojournalists were perhaps the second largest group on the field during the 2004 Tsunami disaster in southern Asia. But from among all the Chinese photojournalists I contacted in preparation for this exhibition, Mr. Wang Yishu's work was different from the "standardized style" of photo reportage that Western photojournalists have established during the last 50 years.

Mr. Wang Yishu studied Chinese literature at university and started his career as a reporter for a local newspaper in China. He turned himself into a photojournalist three years ago. Three years' experience should only be the starting point of any photojournalist, but Mr. Wang shows his talent, not only for finding the message and creating a story from the state of the matter as it appears in the street, but also for digging out conflicting elements, with semantic meaning, in the available visual figure and juxtaposing them within the frame of the image.

As a photo educator and promoter of Asian photo culture, I started my contact with mainland China in the late 1980s. More than two-thirds of the numerous photographers I have met, identify themselves as "JiSu" photographers (the Chinese term for street photography). Most of them learned photography from Chinese photo magazines, monographs by Western masters, or an experienced photographer. Much of their work is derivative of the currently popular, so-called "Magnum style" of the 1950s. The first department of photography at a Chinese university opened in 1985, but before 2000, there were no more than five schools teaching photography in the whole of mainland China. Compared to the population of the country and the needs of the publishing industry for the whole market in China, the number of photographers graduating from universities was like a grain of sand. As a result, most gifted photographers or photojournalists in China, including Mr. Wang Yishu, unlike many photographers from the West, do not have any photography education or even an art background.

I "found" Mr. Wang Yishu's images among the works hanging on the exhibition wall in the Guangzhou photo biennial in February 2005. Despite his non-photo-education background, the works he has produced during the past three years surprise me. His existence reminds me once more of what I have acknowledged ever since my early contact with China: Within the size of this population, the cultural history and the country, *anything* can happen!

Wu Jiabao—Taiwan, China

Wu Jiabao is Director/Founder of FotoSoft Institute of Photography, Taipei, Taiwan, China and a commissioner of the Pingyao International Photography Festival, Pingyao, China.

WANG YISHU **tsunami holidays** 2004

Never in my ten years of experience as a photojournalist have I experienced such tragic devastation and witnessed so much debauchery in the midst of so much death.

I have previously covered many stories and known many people from Thailand. The Tsunami of 2004 was one of those many stories. And yet the devastation on the island of Pukett was so huge that it reminded me of Shakespeare's lines from Hamlet, "To be or not to be?" Would Pukett exist or cease to exist?

Life and death are not so far removed from each other in Thailand. The swollen and rotted faces of the dead seemed familiar to me. Taking pictures of them was like taking pictures of myself. At times I felt heartbroken and at other times I felt very little emotions. However I do know that all this enormous tragedy is of little consequence within the universal scale of things.

Wang Yishu—Taipei, Taiwan.

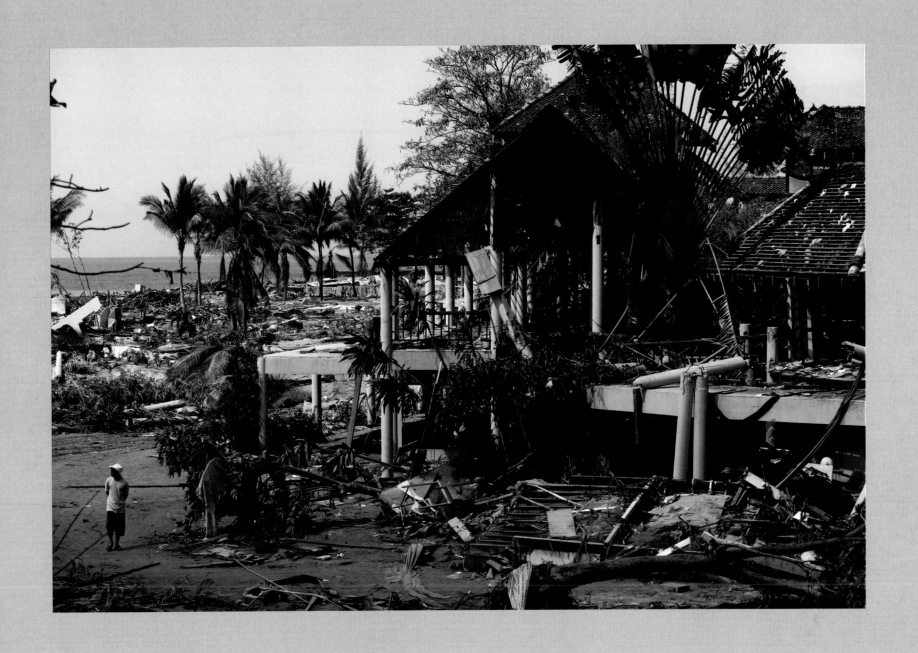

The village of Pukett in Thailand devastated by the Tsunami of December 26, 2004. ©Wang Yishu/Wu Jiabao.

Thai men in "drag" offered themselves to Westerners for "fun and games" while the local population experienced the Tsunami, one of the worse natural disasters of modern times. Foreigners book special sex tours that take advantage of these clubs where young women and boys are often forced into prostitution due to extreme poverty. Pukett, Thailand.

DECEMBER 2004. ©WANG YISHU/WU JIABAO.

Thai men in "drag" requesting donations for victims of the Tsunami. Pukett, Thailand. DECEMBER 2004. ©WANG YISHU/WU JIABAO.

Thai men in "drag" offered themselves to Westerners for "fun and games" while the local population experienced the Tsunami, one of the worse natural disasters of modern times. Foreigners book special sex tours that take advantage of these clubs where young women and boys are often forced into prostitution due to extreme poverty. Pukett, Thailand. DECEMBER 2004. ©WANG YISHU/WU JIABAO.

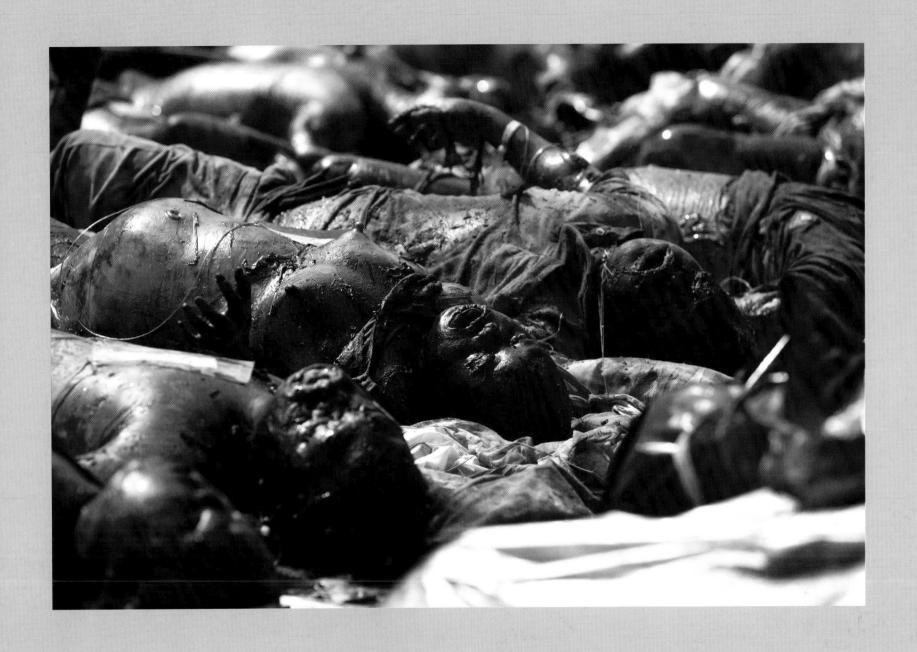

Victims of the Tsunami. Pukett, Thailand. DECEMBER 2004. ©WANG YISHU/WU JIABAO.

NOEL JABBOUR occupation and resistance
ILAN MIZRAHI falashmura in israel
SHARON PAZ minor protest

Nissan Perez: Curator

CONCERNING LIFE IN ISRAEL

Life in Israel is marked by a great number of facts and factors, some historical and some surfacing as a result of the social and geopolitical circumstance. From the indelible memory of the Holocaust to day-to-day concerns of social, political, and security issues, the reality of contemporary Israel creates a haunting, and equally challenging environment in which living (surviving?) becomes an incessant challenge, not to speak of creating art, which at times seems to be a gratuitous and futile act.

For contemporary Israeli artists issues of human rights, racism, and humanism are extremely concrete subjects, even more so than for artists in Western countries for whom these notions belong rather to the realm of "romanticism." In the harsh reality of today's Israel—in the fear of the future, and the faltering peace process, while the entire population is in constant friction with the Palestinian people, and issues of security and terrorism are an integral part of daily life—there is little room for romanticism. The mode of existence interspersed with periodic wars, where every man and woman has to serve in the army for a lengthy period of time and deal with constant threats to the existence of the nation, leaves little latitude for theory and philosophy—all this on top of social problems, since the country is still a melting pot of cultures. These burning issues constantly preoccupy and are ever present in every citizen's mind, and even more so with artists highly aware and involved in the life of the country.

Despite this intricate situation, and the inevitable traces of it in the artists' work, in many instances a first reading of their work does not reflect these concerns. Each one of these artists expresses his or her vision in a different—overt or subdued—form. While some may tackle these issues in a straightforward fashion, many others would consciously avoid them and find refuge in their imagination and inner world.

A compilation of the work of artists reflecting such deep concerns for the burning issues at stake would require a massive exhibition. Therefore, the three artists selected for this project are only the tip of the iceberg, and come to illustrate just a few of the approaches, and the manner in which they deal with various topics.

Ilan Mizrahi takes a close look at the ordeal of the Ethiopian immigrants. He documented their path of immigration, as a symptom, and as a means of generalizing the difficulties of immigration. In exile, both in their old and new countries, the Falashmura find themselves in an impossible situation, caught between cultural gaps, bureaucracy, and political and religious intricacies.

One of the most acute and intricate situations is no doubt the Israeli-Palestinian conflict, with the unbearable living conditions of the population in the territories, and the separation wall being built around it.

Noel Jabbour and Sharon Paz address these issues each in their own different way. Jabbour, an insider, through her series of "postcards," looks at Palestinian daily life swaying between an aspiration to normality and the madness surrounding it. The fact that she chose to create postcards—which by definition are images of beauty and serenity—is in itself symptomatic and accentuates the unbearable conditions.

On the other hand, Paz, in her short video, physically attacks the separation wall, desecrates it, and in the end leaves a tiny window of hope, as the character in her work is able to penetrate it and go through a (secret?) passage to the "other side."

Jabbour, Mizrahi, and Paz are among the many young artists trying to raise the level of awareness of injustices of all sorts, and through their work incite the viewer to reconsider opinions and attitudes, and eventually take action toward creating a better and more just society in our part of the world. Given the actual situation, as utopian as this might sound, a fragment of optimism is absolutely necessary to reach such a goal, and these artists are fulfilling their duty twofold by pointing out the wrongs and injustice, and yet leaving a small chance to a better future.

Nissan N. Perez—Jerusalem, Israel.

Nissan N. Perez is the Horace and Grace Goldsmith Senior Curator of Photography in charge of the Noel and Harriette Levine Department of Photography at the Israel Museum, Jerusalem.

NOEL JABBOUR **palestinian struggle for existence**

The chosen images tell the story of the Israeli-Palestinian conflict and the struggle for Palestinian existence. It is a series of photographs that contains in its margin the painful clashes; on the other hand, they carry in its heart, deep humanity. They are from the series "Postcards, 2000."

The "Postcard" series has been generated from my photo archive, which I created as a freelance photographer in Jerusalem during a period of three years. The main motive to photograph in Jerusalem and the Palestinian Territories was to find my own truth about the Israeli-Palestinian conflict. I wanted to be a close eyewitness and not a passive viewer, especially through TV media. I tried to get to a personal picture through photography by being in the places where the heart of the conflict lays.

These works were first published in the international media and then shifted to an artistic project presented as a set of postcards on a stand, as they might appear in a shop in the Old City of Jerusalem. A series of 21 photographs narrate my truth— as a story that refers to the social and political issues that dominate the place and its people, but are perceived from a different perspective—through the format of the postcard. Eventually, the images speak for themselves, regardless of their form of presentation. They show part of a very sad reality, which continues to be the daily experience of many residents.

Noel Jabbour—Israel/Germany.

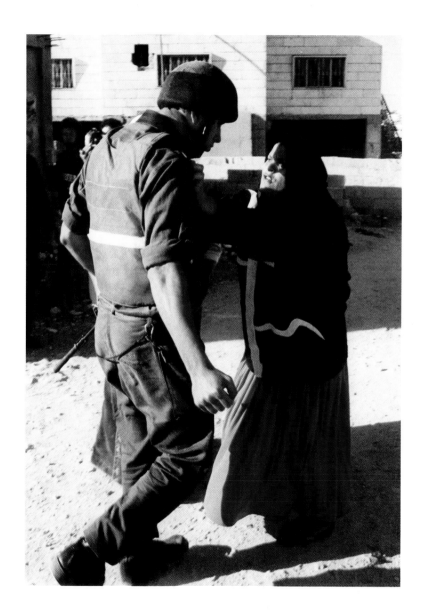

A Palestinian woman tries to stop an Israeli soldier from shooting rubber-coated bullets at stone-throwing youths. Clashes began when soldiers moved on a group of Palestinians trying to prevent a bulldozer from paving a bypass road for exclusive use for Jewish settlers. Forty acres of farming land were confiscated in order to build the road in the Al-Khader, Bethlehem area, the West Bank.

NOVEMBER 15, 1998. © NOEL JABBOUR.

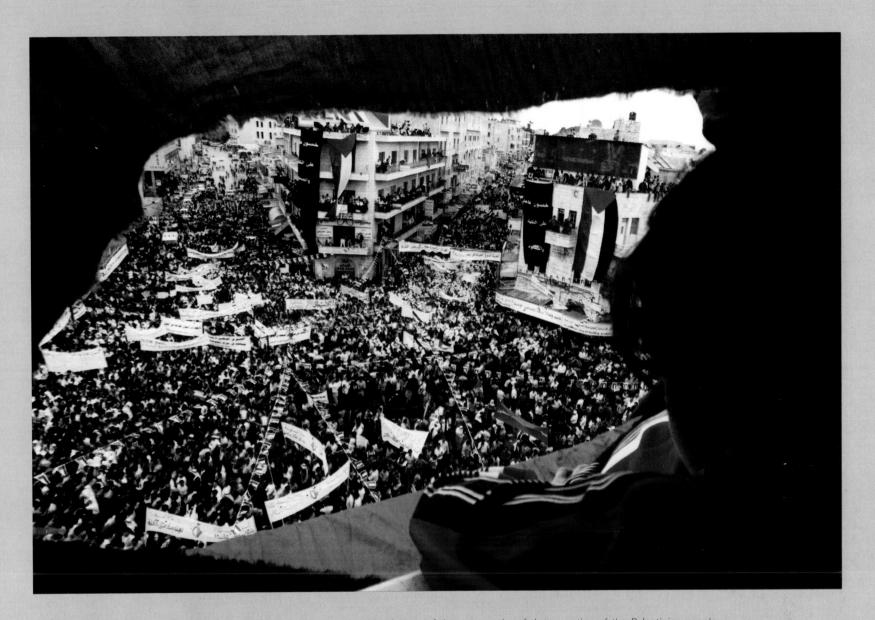

This image shows the demonstration in remembrance of the catastrophe of the uprooting of the Palestinian people after Israel's creation in 1948. My mother, with her family, was expelled during the war in 1948 from the Christian village Kufr Barem in the upper Galilee of Palestine. The village was among the approximately 418 Palestinian cities and villages erased after the establishment of the state Israel in 1948. After a brief exile in Lebanon, my family was able to return to a neighboring village, which was depopulated but not razed like Kufr Barem. It had already been replaced by a Moshav for Jewish settlers only. My mother later married and my family started over in Nazareth after losing all property and rights in Kufr Barem. They were considered "internal refugees." Nakba, Palestinian Remembrance Day, Ramallah, the West Bank.

MAY 14, 1998. © NOEL JABBOUR.

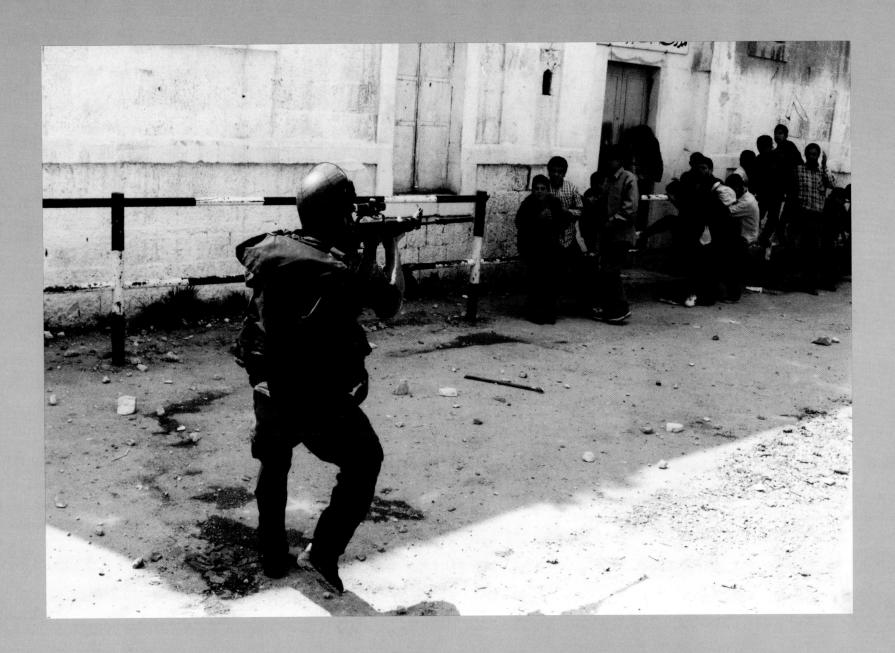

After the killing of three Palestinian workers by Israeli soldiers at an Israeli roadblock, clashes were continuing all over the West Bank for the third straight day. The clashes reached an extreme peak of violence. Israeli soldiers used live ammunition, raising the number of casualties, and were in exchange pelted with a rain of stones. In this frame, which I took during that day, I will never forget, how the soldier was sheltering himself behind a wall and all of a sudden he went to the open street aiming and shooting randomly at the people, whoever was there, stone throwers, adults, or children. Hebron, the West Bank.

MARCH 13, 1998. © NOEL JABBOUR.

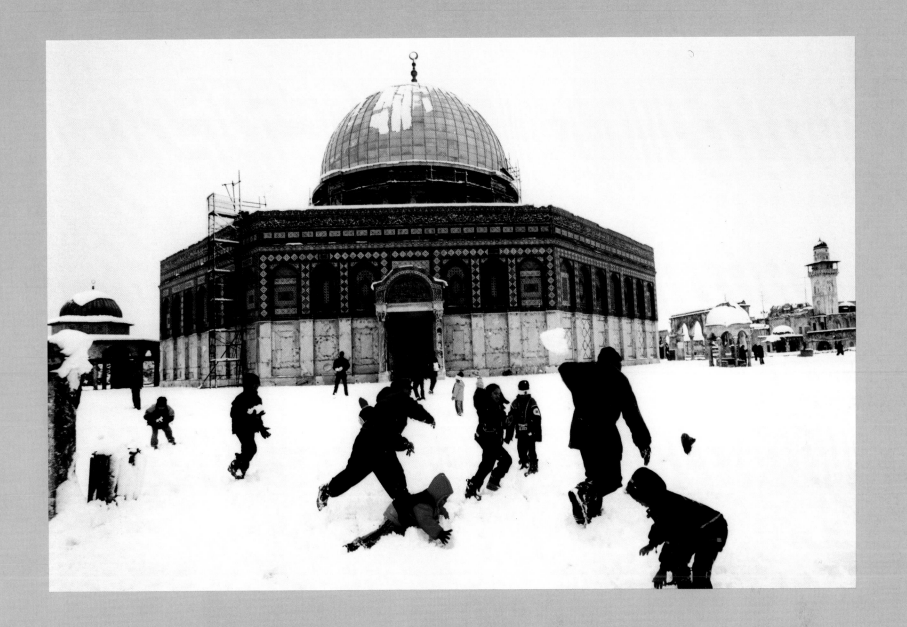

Palestinian kids frolic in the snow in front of the Dome of the Rock. A rare holiday mood prevails throughout the city. An event, which brings people together in a spirit of joy and happiness. A state of emergency that paralyzes a country always prepared for a war, but not really for snowy weather, is a very welcome change. Schools, shops, and public transportation are shut down. Dome of the Rock, Jerusalem.

JANUARY 28, 2000. © NOEL JABBOUR.

ILAN MIZRAHI falashmura in israel

The Falashmura maintain ancient Jewish customs, lead devout religious lives, and have family relationships with Ethiopian Jews who have immigrated to Israel.

Today, in makeshift camps in Addis Ababa, Ethiopia, over 10,000 non-Jewish Falashmura people live in constant longing for the land of Israel. They are not recognized as being Jewish by the Official Israeli Rabbinate until they are circumcised and they pass the Judaic test.

Up until 100 years ago, the definition of "Falashmura" did not exist. In the hard days of "Kapo Ken" (the end of the 19th century and the beginning of the 20th) of the Ethiopian Caesars Yohanes and Theodor, the Ethiopian Jews were obliged to convert to Christianity. Also, the Darwish Muslim warriors who came from Sudan tried to convert Ethiopians to Islam. That's why Ethiopian Caesars converted the Jews so that they would stay loyal to the Christian side of Ethiopia. Those who converted to Christianity, but practiced Judaism behind closed doors, became known at the Falashmura.

After 1991 when Israel brought the rest of the Jewish community from Ethiopia in a second operation called "Mivtza Shlomo" (Operation Solomon), the Falashmura people found themselves out of power in their Ethiopian villages and they asked to be reunited with their relatives in Israel.

Ilan Mizrahi—Jerusalem, Israel.

After leaving their houses and belongings behind in small villages in Ethiopia, they found themselves stranded in the capital of Addis Ababa (sometimes for as long as five years or more) with their fate in the hands of Israel's Ministry of Internal Affairs, which was responsible for checking the claims of the Falashmura who wanted to come to Israel. The problem is that Israel sent one or two workers to process 10,000 to 20,000 Falashmura.

Once they arrive in Israel, the Falashmura are exposed to the difficult reality of political conflicts, the poverty of new immigrants starting a new life in Israel, and that of the different cultures to be found there. The conflict with the Palestinians is that the Falashmura are part of Israel's lower class. These new immigrants are settled in dangerous and poor areas like Gadera, Yeruham, or in the mixed Jewish Arab cities like Lod and Ramallah.

The worst tragedy is the racism that they suffer from their fellow white Jews who are not used to African Jews. Documenting the subject since 1997, I have presented these beautiful black Jews living in their surreal multiracial world. Having been personally subjected to racial prejudice, I found myself sympathizing with their suffering and I hope my images will serve as a bridge between the Falashmura and the solution to this issue both in Israel and in Ethiopia.

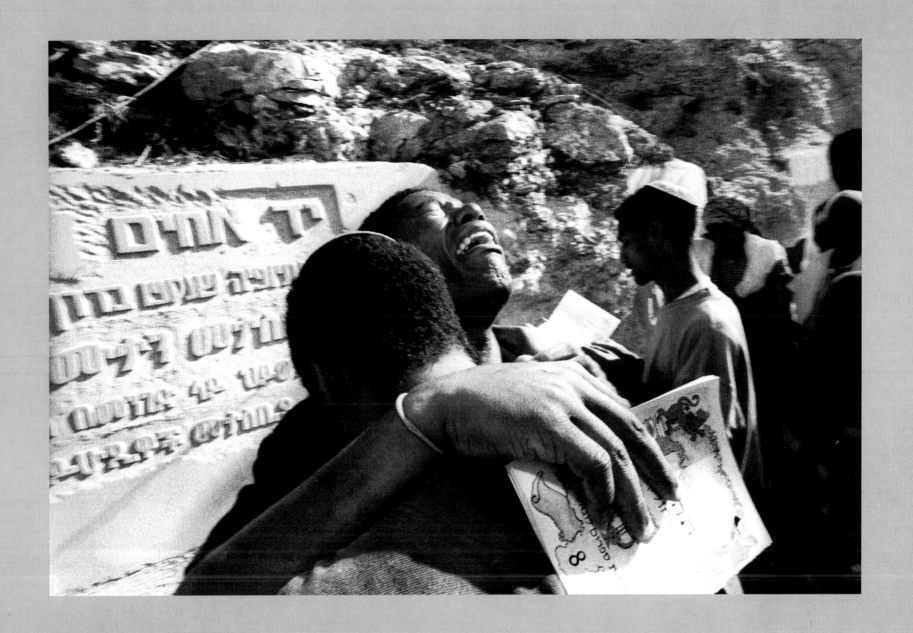

Ethiopian man crying at the Givat Amatos memorial place for the Jews who died in the long walk from Ethiopia to Sudan, on the way to Israel. Jerusalem, Israel.

2000. © ILAN MIZRAHI.

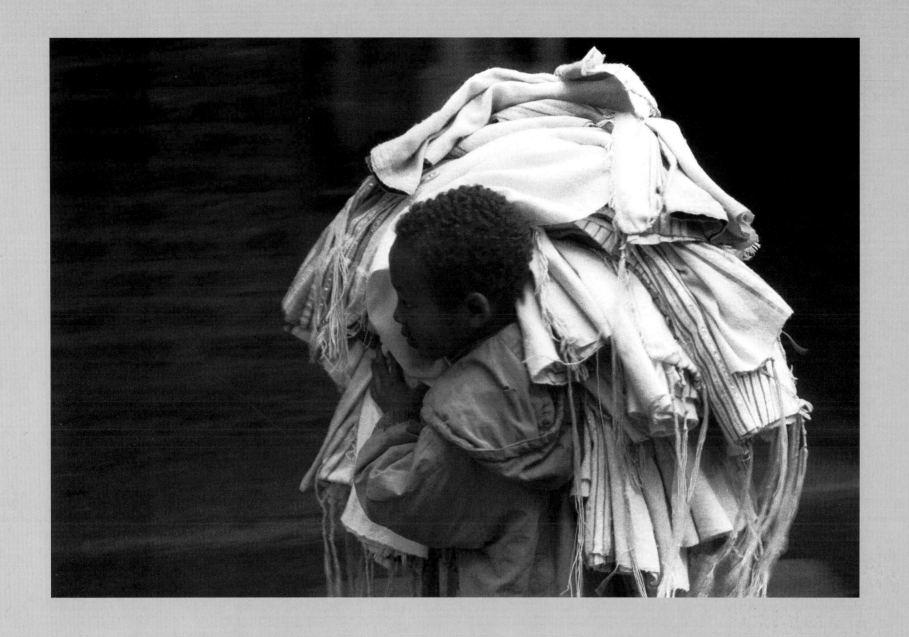

A Jewish boy carries a pile of Talitot (Jewish praying cloth) after a morning prayer in the Falashmura compound. Adis Ababa, Ethiopia.

1999. ©ILAN MIZRAHI.

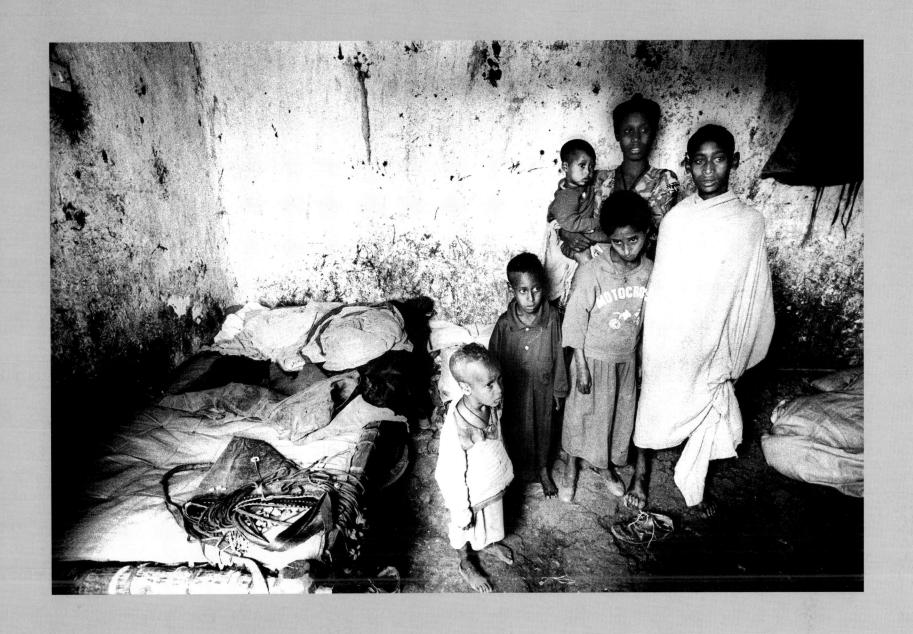

A Jewish Falashmura family at their poor rented house near the Israeli embassy and compound in Adis Ababa, Ethiopia. 2000. © ILAN MIZRAHI.

SHARON PAZ **minor protest**

Through the years I have found myself observing the space between people and their various ideas, searching for the basic feelings and thoughts that we all share. I was born and raised in Israel, a country that carries many conflicts, a cultural mix of diverse origins and beliefs. In my work I investigate ideas about human psychological perception of home, land, nation, and culture.

Borders define ownership and territory, a reduced space one can move in. We are all born into predefined borders that place us on one side or another; they change with time and create new reality. There are different kinds of borders with diverse natures of dynamism and visibility. The types I am interested in examining and deconstructing are walls, which block communication both visually and physically.

Walls are built in situations of conflicts and fear; they generate an illusion of total separation and safety. As when one closes his or her eyes when feeling endangered, with the hope that the problem will disappear. On both sides a control system develops to maintain this division, transforming towers, bridges, and tunnels from ways of connection to points of separation and power.

Minor Protest investigates the various situations created by walls. Clothes, rooms, homes, yards, cities, states, are all means of separation, layers that divide in from out. Walls construct borders, physical and invisible, psychological cultural ones. This work explores the duality of walls both as shields and confinement spaces.

Sharon Paz—Jerusalem, Israel.

The images on display are stills from the video, *Minor Protest*, 2004 (1:15 min., single channel DVD, edition of five plus two AP).

Minor Protest, 2004, 1:15 min. Single Channel DVD, Edition of 5+2 AP. Stills from this video. ©Sharon Paz.

Minor Protest, 2004, 1:15 min. Single Channel DVD, Edition of 5+2 AP. Stills from this video. ©SHARON PAZ.

Minor Protest, 2004, 1:15 min. Single Channel DVD, Edition of 5+2 AP. Stills from this video. ©SHARON PAZ.

DAVID BINDER will the circle be unbroken?

ALEXANDRA BOULAT afghan refugees

HEIDI BRADNER chechnya: a decade of war

CUBAN COLLABORATIVE life in rural cuba

PETER ESSICK killing us softly: u.s. nuclear waste

PHILIP JONES GRIFFITHS vietnam today

CAROL GUZY in memoriam

GEERT VAN KESTEREN why mister? why?

GARY KNIGHT a tragic divide

FERNANDO MOLERES children at work

LUCIAN PERKINS far from home

JOHN STANMEYER out of sight out of mind

VIDA YOVANOVICH in the shadow of time

Geno Rodriguez: Curator

CAUSE AND EFFECT

As I interpret the unfolding events of our times I wonder how the citizens of our global village interpret the efforts of my government to create a world of "Freedom and Democracy." Might they think that we Americans unfairly hold back on desperately needed food, medicine, or foreign aid because they will not support our political agenda at the United Nations or the World Bank? Are we seen as waging perpetual war for freedom and democracy at the expense of their political aspirations, national stability, or religious beliefs?

I wonder if we Americans consider the ramifications of our international social and political actions? To be sure, other nations do not always perceive our "National Interest" to be compatible with their interest.

Thy Brothers' Keeper is an effort to bring to light many of the pressing issues of our times. In the future, today's youth will make the decisions that will inform and define their lives and to a great extent, tomorrow's world. My hope is that young viewers will develop a more humanitarian way of looking at and reaching out to our global communities because of projects like this one. And, that they will become "kinder and gentler" stewards of a safer and just world.

As the curator for this particular section of the show, I made my specific selection of images based on what I believe to be important issues and what I believe to be images of extraordinary artistic quality. Many of the images in this exhibition have never been published because they do not "fit" the commercial or political "story line" editors might wish to present to their public.

The photographers I have chosen are all seasoned and respected professionals. Their images surpass the usual journalistic documenting of a news story. These men and women live dangerously in very dangerous places and under dangerous circumstances, bringing us the images that we do *not* usually see on television's

nightly news hour. Instead, their best work is often seen in book form or at exhibitions such as *Thy Brothers' Keeper*.

Alexandra Boulat's image of a woman and child fleeing the bombing of Afghanistan reminds me of a "Madonna and Child" Renaissance painting. Her work brings to our attention the everyday difficulties of living in today's Afghanistan. Tragic images of Israel's "Wall of Separation" by Gary Knight emphasize the illegal occupation of Palestinian lands while visually exposing the cruelty self-imposed segregation creates.

Photographs can at times be contradictory. In this case, John Stanmeyer's photographs of inmates at Asian mental institutions can be said to be horribly heart wrenching while at the same time painfully beautiful images. The inhumane conditions that these wretched people are subjected to should be repellent to us and a call for change. Philip Jones Griffiths' images focus on the egregious commercialization of today's Vietnam. After winning a long fought war, Vietnam now finds itself once again, opposing Western economic ambitions as well as social influences that are foreign to their culture.

Why are children today exploited like 11th-century slaves? Does society really profit from the exploitation of children's labor? What would happen if children went to school instead of the mine pits? These and other questions are asked by Fernando Moleres's images of child labor exploitation.

Carol Guzy's portrayal of New York City's emotionally distressed firemen at the 9/11 memorials for their fallen brothers is a painful reminder that we are never far from or immune to the pain and grief of death.

David Binder's black-and-white images are a stark reminder that AIDS has not been entirely dealt with at home; that families in America suffer this deadly epidemic as deeply as families in far away continents.

A sensitive and compelling video by Lucian Perkins, *Far from Home*, provides an insight into the things that go wrong every day in so many ways to so many of the world's victims of war and poverty. Peter Essick's photographs capture fantastical and surreal images of extraordinary beauty. In them we see America's hidden fortresses—dumps for nuclear waste that scar and pollute our nation. They are a wake-up call!

An ugly incursion into Iraq is presented in the powerful, gut-grabbing images of Geert van Kesteren. These images question the presence of our "liberating" troops and the cold and often deadly reception they face every day from the many Iraqis that oppose the American intervention. Tears, fear, and panic are evident in Heidi Bradner's images. Her photographs speak to the complex issues of ethnic and nationalist ambitions in Chechnya. They speak to the issues of injustice and the ugliness of war.

Vida Yovanovich and the Cuban Collaborative photographers all present images of life "south of the border." Yovanovich's images give an insight into some of Mexico's homes for the aged. A place she refers to as the prison of dreams, a place for the forgotten. Humberto Mayol and Raul Canibano on the other hand give an insight into a Cuba we seldom see or hear about. Their Cuba is one of pride and one that exalts the *guajiros*, Cuba's mountain peasants. The *guajiro* survives "to smile another day," in spite of the oppressive economic and political sanctions he faces every day.

Presenting this project is my personal way of chipping away at what I perceive to be the almost indestructible block of ignorance and indifference to the plight of our global community. I hope that in some small way it contributes to "our" creating a world with justice and mutual respect for all.

Geno Rodriguez—Dinan, France.

DAVID BINDER **will the circle be unbroken**?

Gail Farrow was the mother of four, a devoted wife and friend, whose life was interrupted and finally cut short because of AIDS. In letters she left for her children, Gail expresses her total and complete love for them saying, "Since you were born, I've been the best mother I could be. I tried to teach you to be good boys. I am asking you now to be the best you can be. I know you will be great people because you were loved from the moment you were born."

David Binder—Boston, Massachusetts, USA.

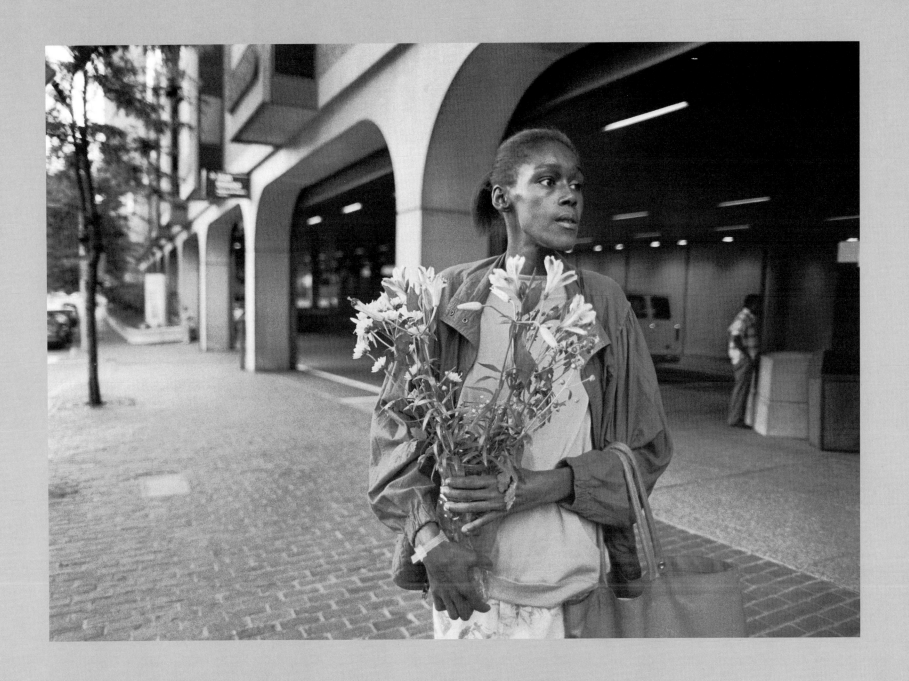

Gail waits for a taxi ride home after a week-long hospitalization for AIDS-related pneumonia. Roxbury, Massachusetts, USA. 1988. © David Binder.

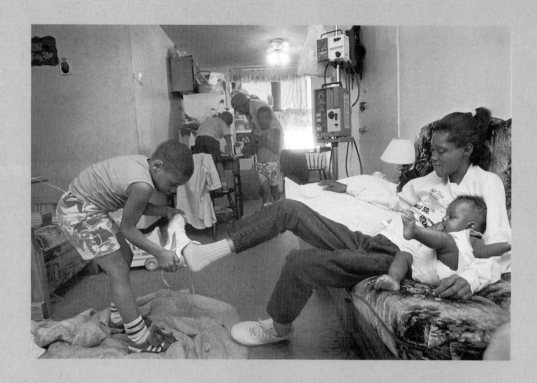

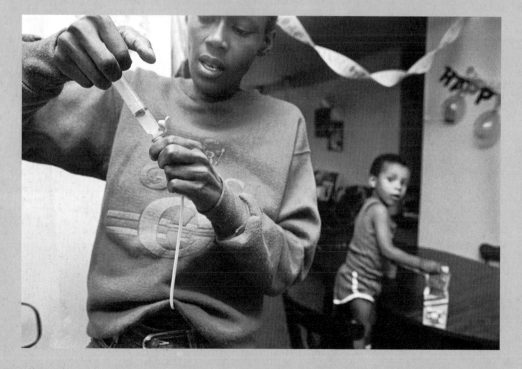

ABOVE LEFT: Frank helps remove his mother's shoes while Ronald makes sandwiches for the kids.

LEFT: Gail adjusts her medication to better maintain energy prior to giving her twins, Kenny and Benny, a birthday party. She insisted on managing her own medical treatment in order to be home with her children.

Roxbury, Massachusetts, USA.

1988. © DAVID BINDER.

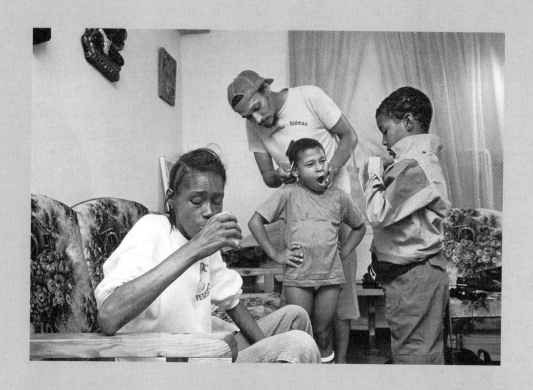

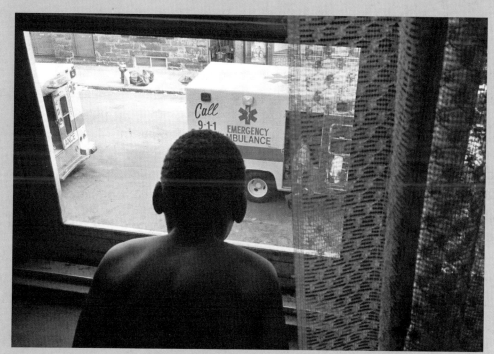

ABOVE RIGHT: Ronald dresses Ronald, Jr., and Frank for their first day of school. Gail tries to help but is too tired and in too much pain.

RIGHT: Seven-year-old Frank waits on the ambulances he has called for his mother.

Roxbury, Massachusetts, USA.

1989. © DAVID BINDER.

91.

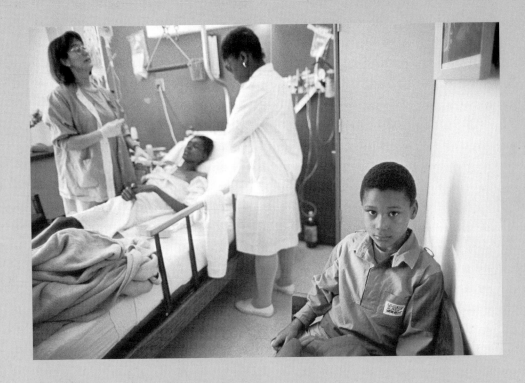

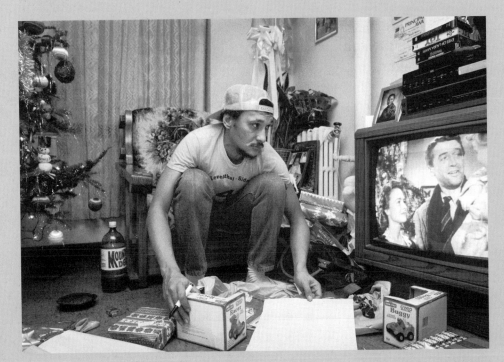

ABOVE LEFT: Frank comes to the hospital after school because that's where his mother is.

LEFT: Ronald wraps Christmas presents on Christmas Eve, five weeks after Gail's death.

Roxbury, Massachusetts, USA.

1989. © DAVID BINDER.

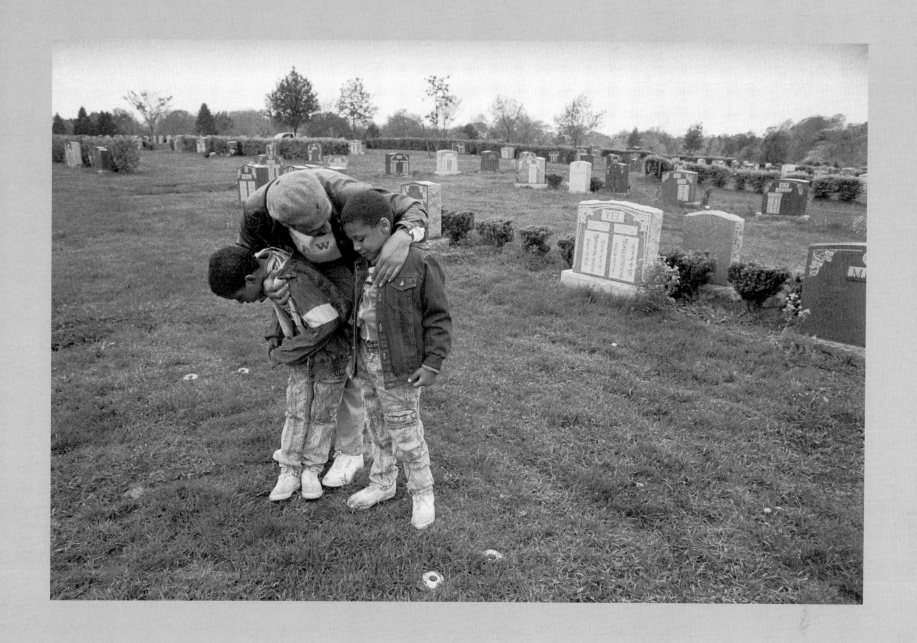

On Mother's Day Ronald takes his two oldest boys, Ronald, Jr., and Frank to visit Gail's grave for the first time since her funeral. Not able to afford a proper gravestone, the only marker is the cemetery's chromeplated plot number. Roxbury, Massachusetts, USA.

1990. © DAVID BINDER.

ALEXANDRA BOULAT afghan refugees

I had 24 short hours in Afghanistan to complete this assignment. A day of grace for me, another day of misery for the Afghans. They were dying of cold and poor conditions in a suburban camp outside Herat. At that time, Afghanistan was ruled by the Taliban; it was difficult to get a visa to enter the country, and even more difficult for a photographer to work in Afghanistan. The Taliban simply banned photography. In order to complete the assignment I had to be quick, focused, and precise. I spent the night in a cold room at a nongovernmental organization's guesthouse. Just before dawn, I asked my driver to take me directly to the camp cemetery. On our way there, we came across destitute families. They arrived at the camp, loaded with a few personal belongings like bed covers and water cans. They were looking for refuge, food, and help.

By the side of the road, facing a line of gray tents was an improvised cemetery. I saw a young man digging a grave, so I asked my driver to ask him to take us to the tent where the deceased was lying. There, only a few meters away, below the yellow mountains made of sand and dust, a group of men were preparing the burial of a young boy. I followed the procession back to the cemetery, and watched the men praying, hands raised to the sky and eyes cast down to earth. Around us were dozens of children's graves; the earth was freshly turned over, suggesting that many children were dying daily. By noon, I had left Afghanistan. In those few sad hours I attempted to describe, to share with the world, the horrible conditions of the life of the refugees in Herat.

Alexandra Boulat—Paris, France

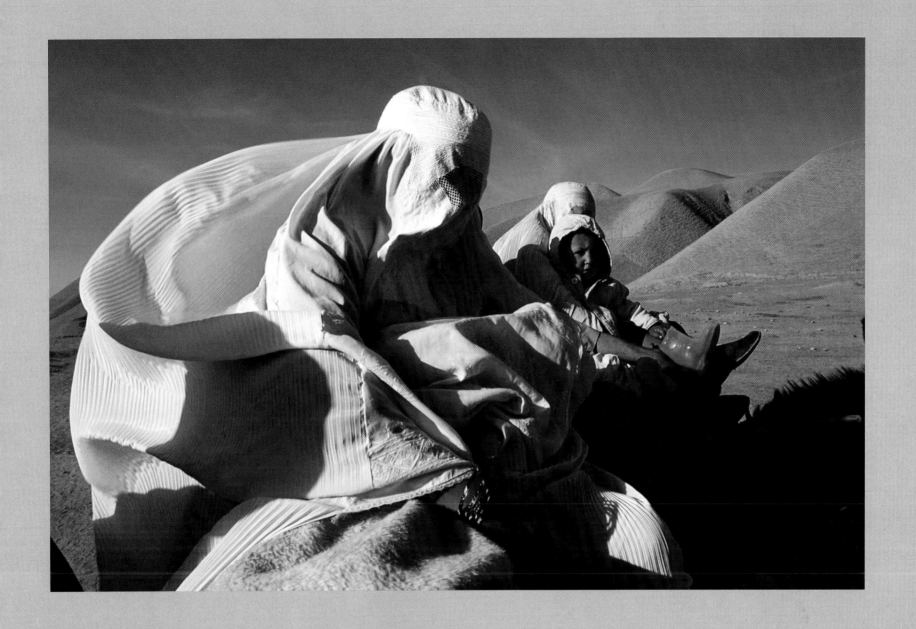

Afghan women and children cross the front line as they flee Kunduz, still under Taliban control, to seek refuge with the Northern Alliance. Afghanistan.

NOVEMBER 23, 2001. ©ALEXANDRA BOULAT/VII.

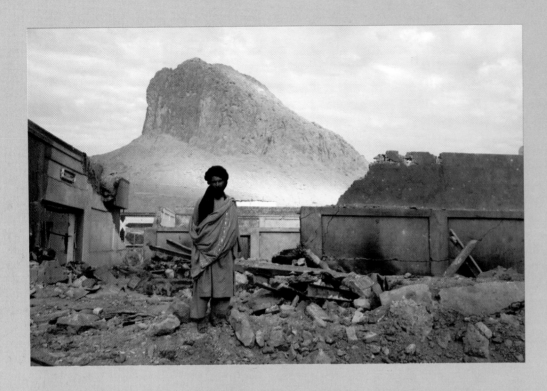

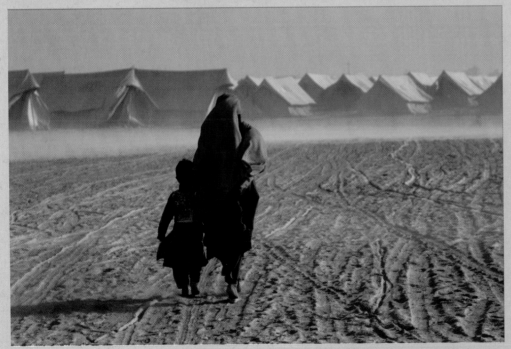

ABOVE LEFT: An Afghan at Mullah Omar's former residence, which was destroyed by U.S. bombing. Kandahar, Afghanistan. DECEMBER 12, 2001. © ALEXANDRA BOULAT/VII

LEFT: Wind blows sand on an Afghan refugee camp at the Chaman border crossing in between Afghanistan and Pakistan. NOVEMBER 23, 2001. © ALEXANDRA BOULAT/VII.

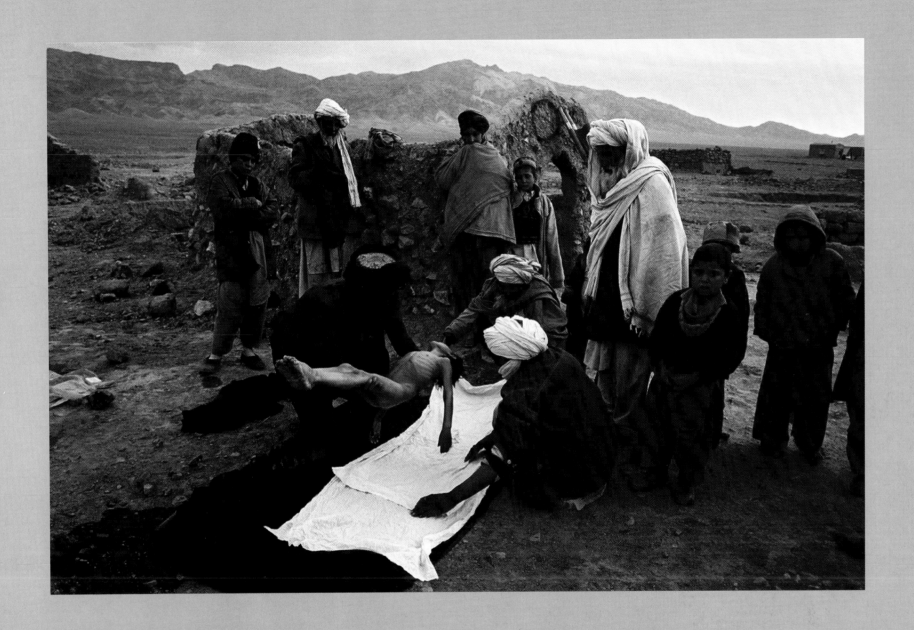

Preparations for the funeral of an eight-year-old child who died of cold in the Herat Marsak refugee camp. His two uncles are preparing the body before bringing him to the camp cemetery under the eyes of a few of his family members.

Thirty thousand IDP (displaced people) are living in miserable conditions in a camp a few kilometers away from Herat city, western Afghanistan. Because of the drought, and the war raging on several fronts in Afghanistan, one million people are facing a humanitarian disaster all over the country.

FEBRUARY 15, 2001. © ALEXANDRA BOULAT/VII.

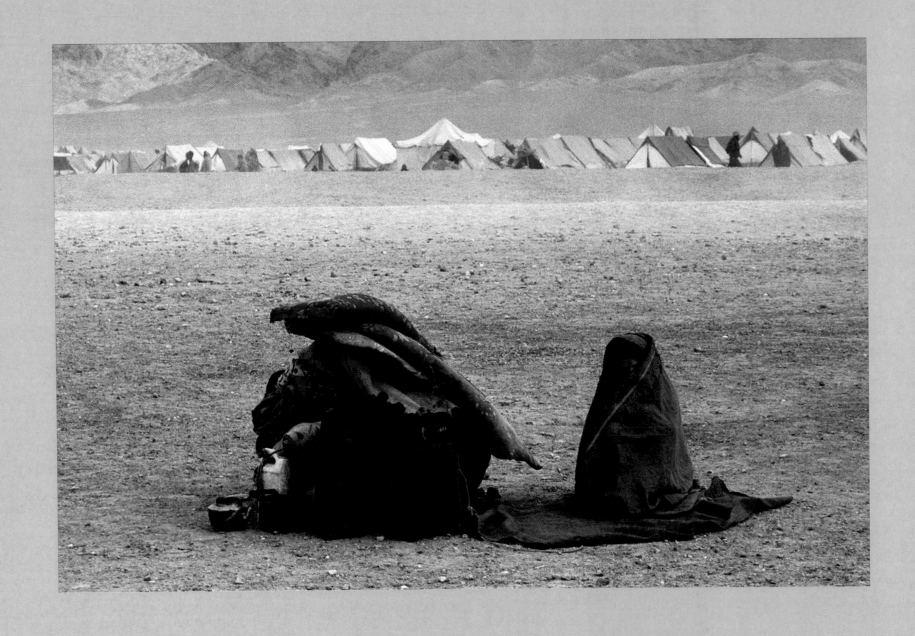

A young girl who has abandoned her village with her family because of the drought has just arrived in the Herat Marsak camp after a long journey through the desert. She is seeking humanitarian aid. Afghanistan.

FEBRUARY 15, 2001. © ALEXANDRA BOULAT/VII.

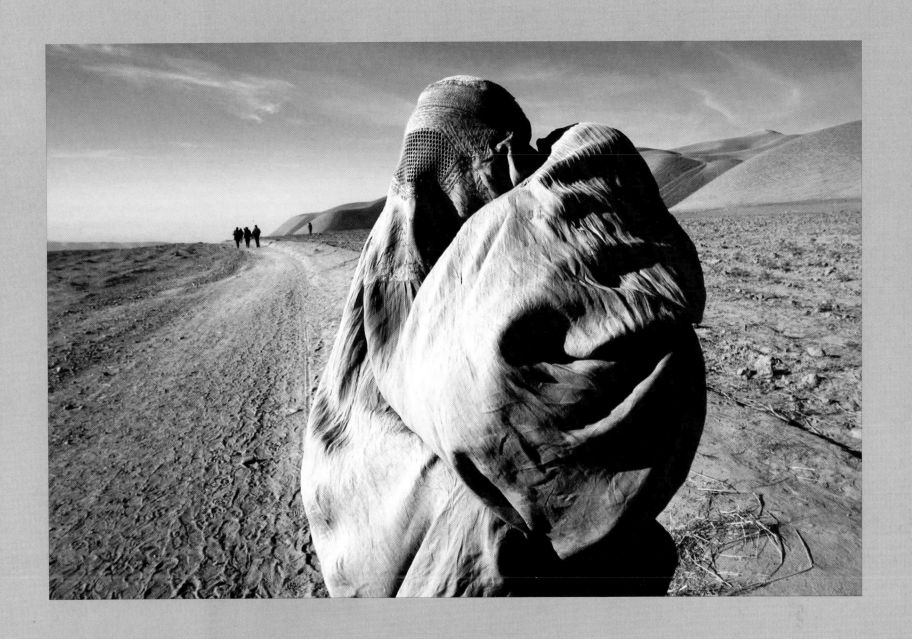

An Afghan woman holding a child under her burka crosses the front line as they flee Kunduz, still under Taliban control, to seek refuge from the Northern Alliance. Afghanistan.

NOVEMBER 23, 2001. © ALEXANDRA BOULAT/VII.

HEIDI BRADNER chechnya: a decade of war

Over the course of the two-year war, the rugged landscape of the Caucuses was transformed into a physical and spiritual battleground. The area became a crucible for a volatile mixture of Muslim versus Western ideals, ancient mountain customs versus modern beliefs, a warrior people's pride versus a conqueror's abandon. Also, it became a high-stakes game for control over future oil pipeline royalties, which will gush forth from the Caspian Sea basin in a few years.

I photographed all of this as a part of a multiyear project because I found that the story of the Chechen people, who number just over 1 million (less than one percent of Russia's population), mirrored the predicament of many small cultures around the world, who face the same treatment by their own governments or by modern pressures. Their dilemma is how to preserve autonomy and identity in the face of the increasing globalization of weaponry, communications, technology, assimilation, capitalism, and crime.

The traditional Chechen greeting and farewell are simply "come in freedom" and "go in freedom." It is the deeply instilled love of freedom, which makes these clannish, mountainous, spirited people as ruthless to their enemies as they are overwhelmingly kind to their friends and guests. The Chechens, above all the people inhabiting the Caucuses, have always fought long and hard against domination, living by a code of fighting, vendettas, and honor that still prompts outsiders and especially enemies, to conveniently label them bandits, wild men, and criminals.

In my project, I would like to probe the character, culture, and spirit of the Chechens that make them such an unyielding opponent to domination. Both sides walk a tightrope on which they must find prosperity and trust with their former enemy. Despite the virtual destruction of their country and the death of so many loved ones, the Chechens are experiencing a revival. Yet they are also experiencing anarchy, and civilians are fearful of destabilization and economic hardships.

Beyond the physical destruction of war there is also the psychological effects that haunt or shape perceptions throughout a lifetime and history of a nation or a people. As part of my project, I also spent time photographing what for countless centuries has been Russia's secret weapon—what the Czars called their "general manpower"—the endless numbers of expendable soldiers from across the vast expanses of Russia who by their sheer numbers outlasted their enemies. I photographed the faces and moods of these youngsters drafted into the unpopular Chechen War. I hoped to reveal the difference between the war fought by governments and by men on the ground.

Heidi Bradner—Alaska, USA.

An elderly Russian woman, a resident of Grozny lies dead on Grozny's snow-covered streets after she was hit by an artillery attack. Many Russians residents had no relatives in Chechnya where they could refuge and leave the city during the bombing. Chechnya, Russia. 2000. © HEIDI BRADNER.

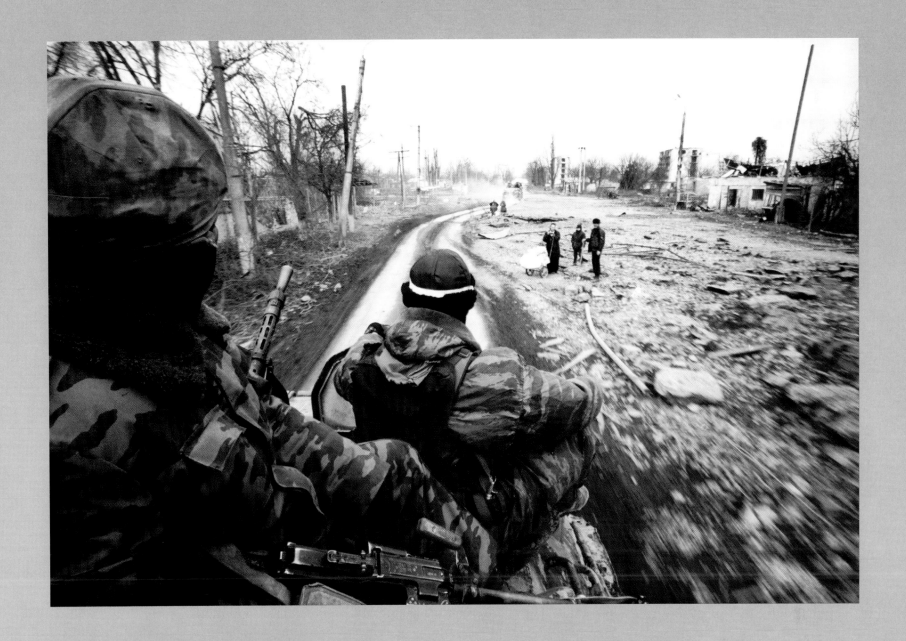

A Russian Special Forces unit on an armored personnel carrier drives through the flattened remains of war-torn and bombed central Grozny. Civilians on the roadside stay well clear of the tanks and APCs that overpower the city terrain and often run over cars or any object in their way. Women mainly move on foot or on buses carrying their water, food, and clothing from villages back to Grozny, as the city is considered unsafe for men, who are subject to random arrest. Grozny, Chechnya.

2000. © HEIDI BRADNER.

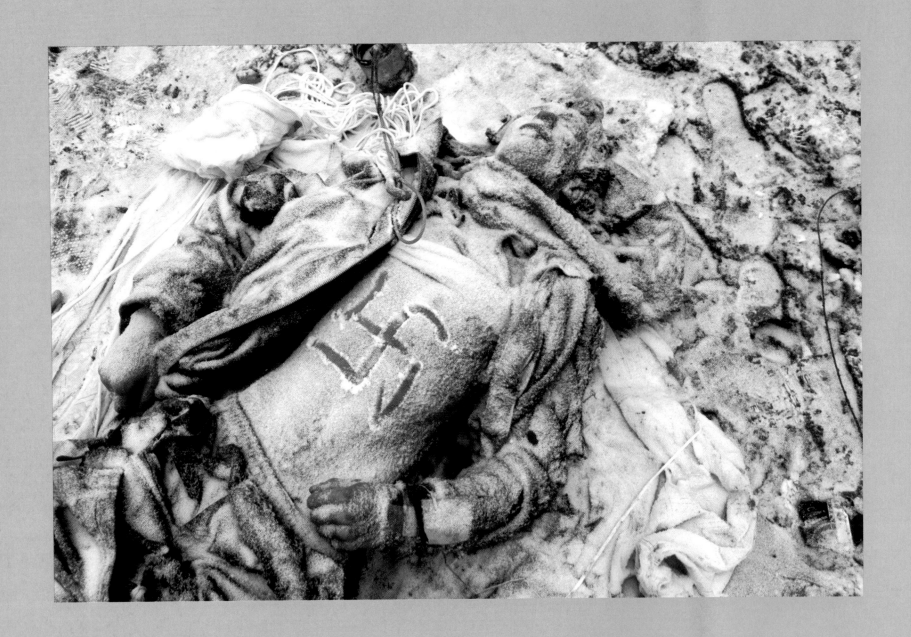

An unidentified man lies in the street of Pervomaiskoe after Chechen rebels broke out of the village during the hostage crisis of January 1996. Villagers put the swastika sign on his chest to protest the violence and aggression of the Russian force's hostage-taking and bombardment of their village. Grozny, Chechnya.

JANUARY 1996. © HEIDI BRADNER/PANOS PICTURES.

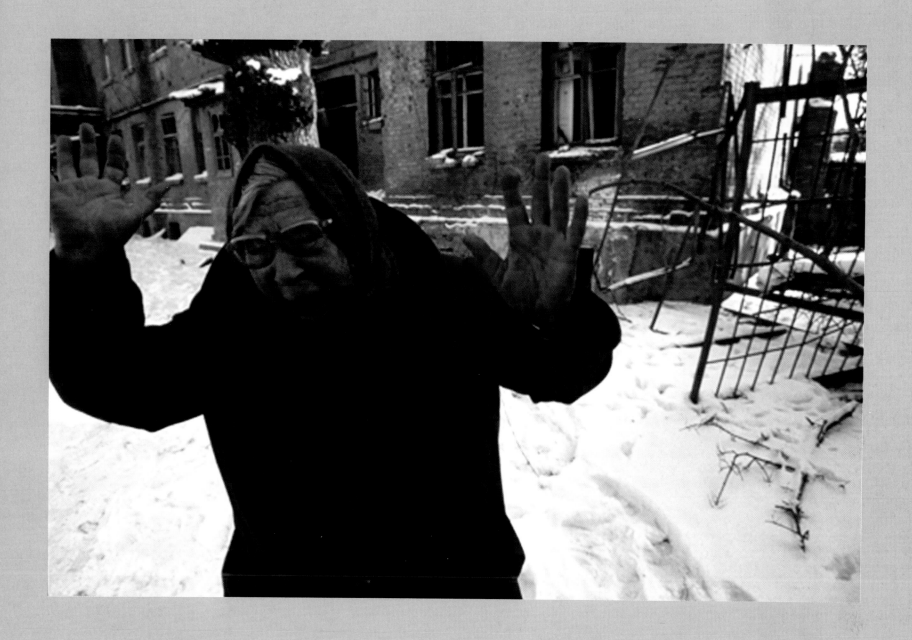

An elderly Russian woman grieves when she discovers a relative has been killed, buried in the rubble of a collapsed building that was bombed. Chechnya.

1996. © HEIDI BRADNER.

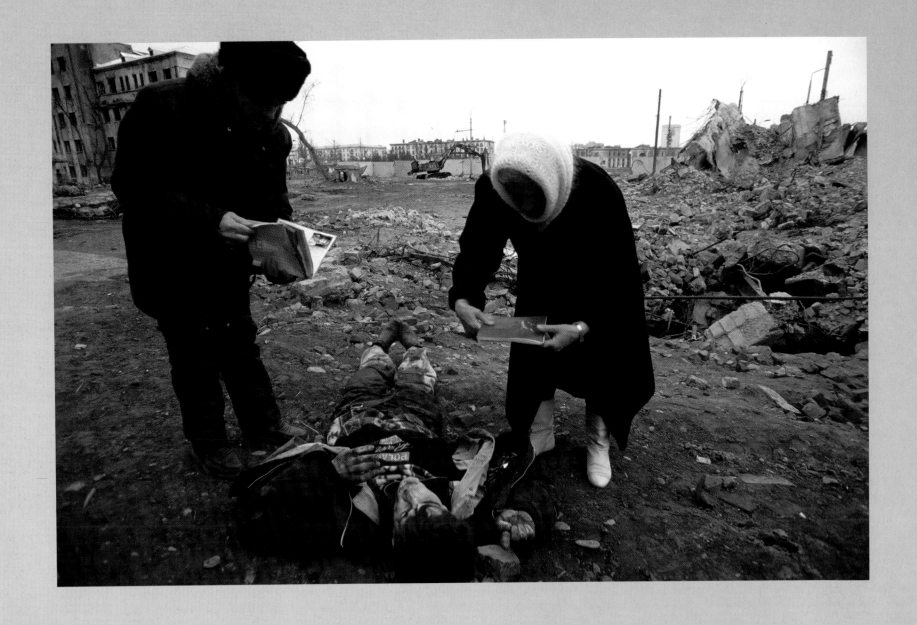

Chechen passersby find a dead teenager killed by gunshots lying cold and frozen in a district of Grozny in the spring of 1996. A student—they look through his notebooks to try to find his identify to notify his parents. Grozny. 1996. © Heidi Bradner.

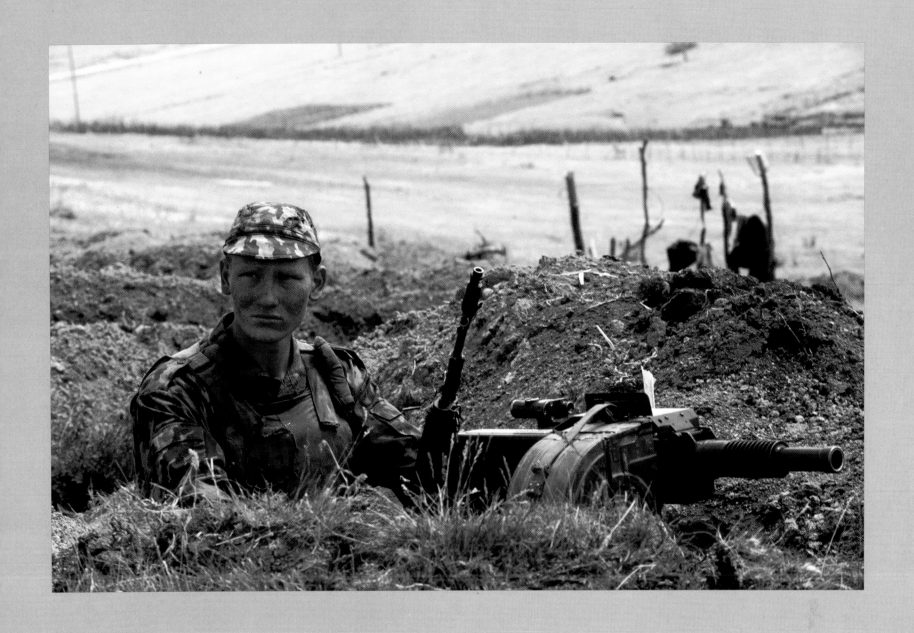

A Russian conscript in his trench. Grozny, Chechnya. 1996. © Heidi Bradner/Panos Pictures.

CUBAN COLLABORATIVE life in rural cuba

RAUL CANIBANO

"Tierra Guajira" is the result of three years of work in rural regions of my country, Cuba. My main goal is to document the way of life and traditions that might be lost because of economic development. At the same time I want to honor Cuban *guajiros*, the people who work the land, who, as in other developing nations, are the most vulnerable as well as the most human and noble of people.

Raul Canibano—Havana, Cuba.

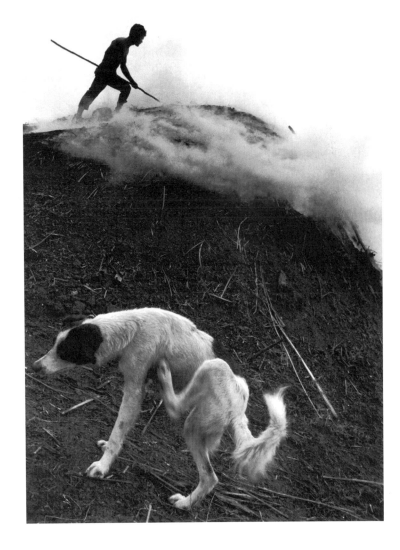

Vinculo, Cienaga de Zapata, charcoal worker.

© RAUL CANIBANO.

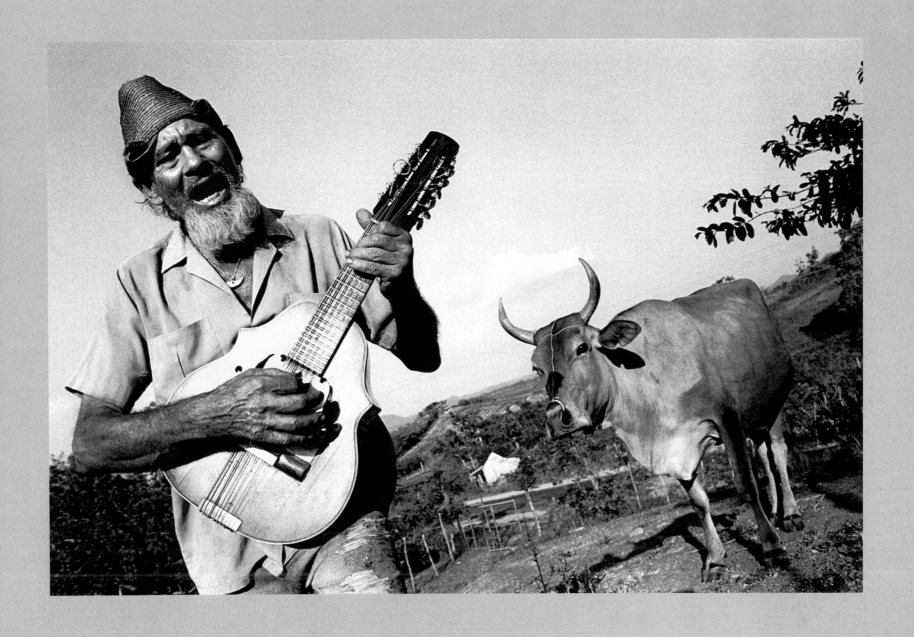

Pedro, although a hard working *guajiro* (farmer) finds time to masterfully play the "laud" (a type of Lute). Cumanayagua,
in the municipality of Cienfuegos, Cuba.
© RAUL CANIBANO.

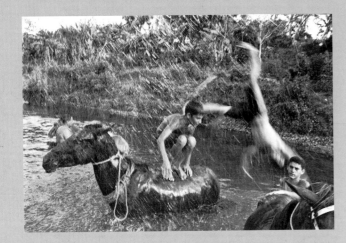

ABOVE: Cumanayagua in the municipality of Cienfuegos is a river where children bathe their horses while playing.

RIGHT: Cienaga de Zapata, province of Matanzas, a forest and ecological reserve. Local people dedicate themselves to making vegetable charcoal for cooking.

This production is a means of earning an income and a tradition that goes back many centuries to the days when Spanish colonialism brought the practice to Cuba.

©RAUL CANIBANO.

HUMBERTO MAYOL

PHOTOGRAPHY: THE GREAT ADVENTURE OF MY LIFE

As a boy I discovered the magic of photography by the odors of the chemicals that I inhaled in the "darkrooms" at the old, large house near the Prado, in Havana, where I used to escape from my infantile games. My father had converted that house into a photographic laboratory, which became the meeting place for many of our colleagues who were going to develop and print their works. That was my first contact with the magical world of photography.

When I became a teenager my father handed me my first camera and under his strict supervision I entered into a world of light and dark, of the negative, and into the secrets of the darkroom. Since then I have dedicated most of my life to photography. It has been the great adventure of my life as it has taken me through wondrous paths and dramatic encounters, all of which I have confronted camera in hand.

"The Romantic Angels of My Native Land" are visual reminders that bring together more than 20 years of my life in the world of photography. In this series I investigate the meaning of being Cuban in this small Caribbean island. I have been blessed with the good fortune of being able to visually chronicle my people throughout all these many years. Life's daily surprises, confrontations, illusions, happiness, and sadness that have accompanied us for all these many years without losing our sense of belonging and identity.

These images are of the Cuban countryside and the people of that landscape. They are images that make up a large part of this project, which showcases the grand sociocultural and ethnic mosaic that is Cuba. These simple hardworking people, *guajiros*, who always welcome visitors with a flowering smile and a mug of *café*, are the guardians of our land.

Humberto Mayol—Havana, Cuba.

A farmer sorts coconuts in a wooden housewhere they are kept until they remove the coconut flesh that is used to make coconut oil. Cienfuegos, Central Cuba. 1990. © HUMBERTO MAYOL.

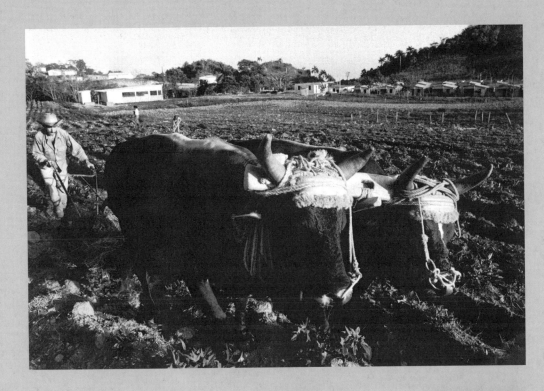

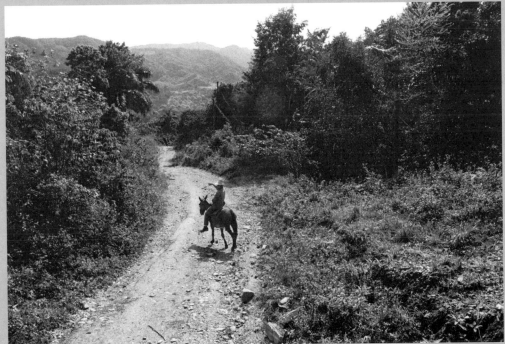

ABOVE LEFT: A farm peasant with his yoked oxen prepares to till the land for seeding in the eastern mountains of Guantanamo, Cuba.

1993. ©Humberto Mayol.

LEFT: A farmer rides his mule up a steep road to his farm. Mules are an important and traditional form of transportation in the mountains. Yateras, Cuba.

1993. ©Humberto Mayol.

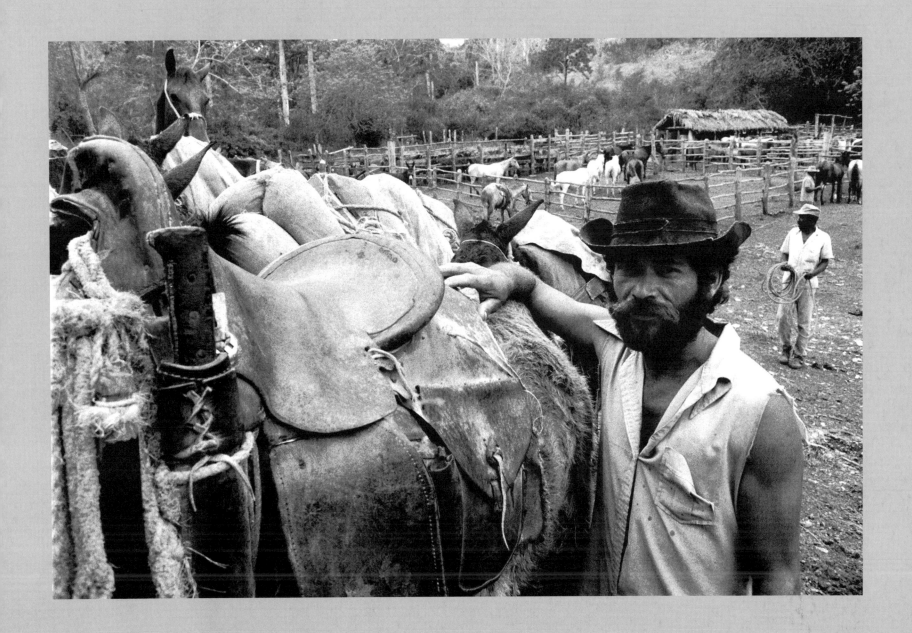

Man poses at a mule-breeding farm. These mules are very important in the mountainous regions of Baracoa, Cuba. 1995. ©Humberto Mayol.

PETER ESSICK **killing us softly: u.s. nuclear waste**

With the end of the Cold War, many of the U.S. government laboratories that had been making nuclear weapons for 50 years were looking for a new job to do. It turned out that production of nuclear materials for the bombs created large quantities of waste. Much of it was highly radioactive for thousands to millions of years. There were also over 100 commercial nuclear reactors in the U.S., each of which produced radioactive byproducts.

No one had seriously considered what to do with the waste during the height of the Cold War. Now a major effort was underway to try to clean up, manage, and permanently dispose of the waste. However, to date, there has not been an easy solution to the problem and almost all of the waste is still sitting in temporary and potentially hazardous sites throughout the country.

Peter Essick—Atlanta, Georgia, USA.

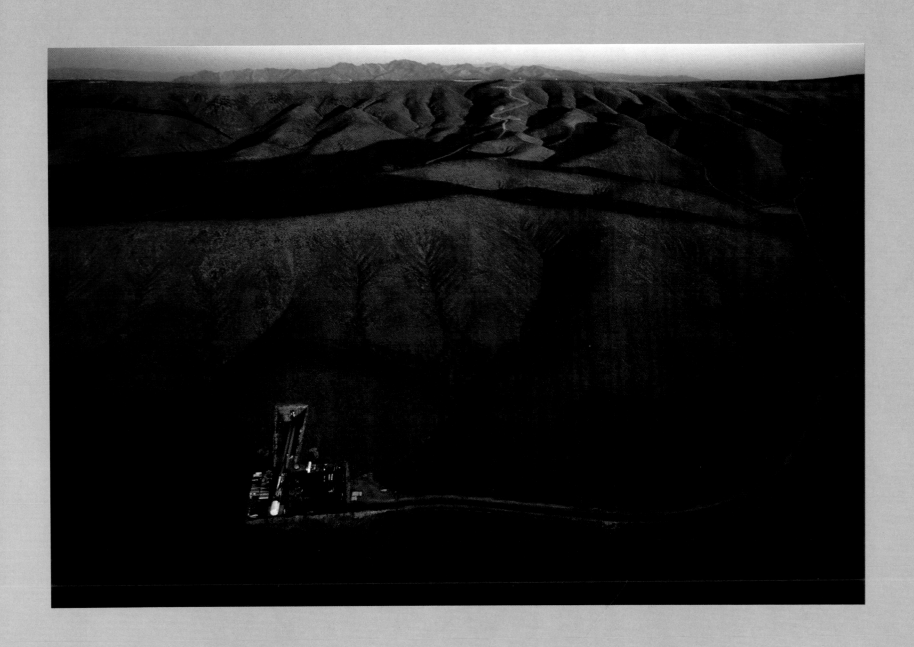

Aerial view of Yucca Mountain—most of the South Portal. Nevada. USA. December 4, 2000. ©Peter Essick/Aurora Photo.

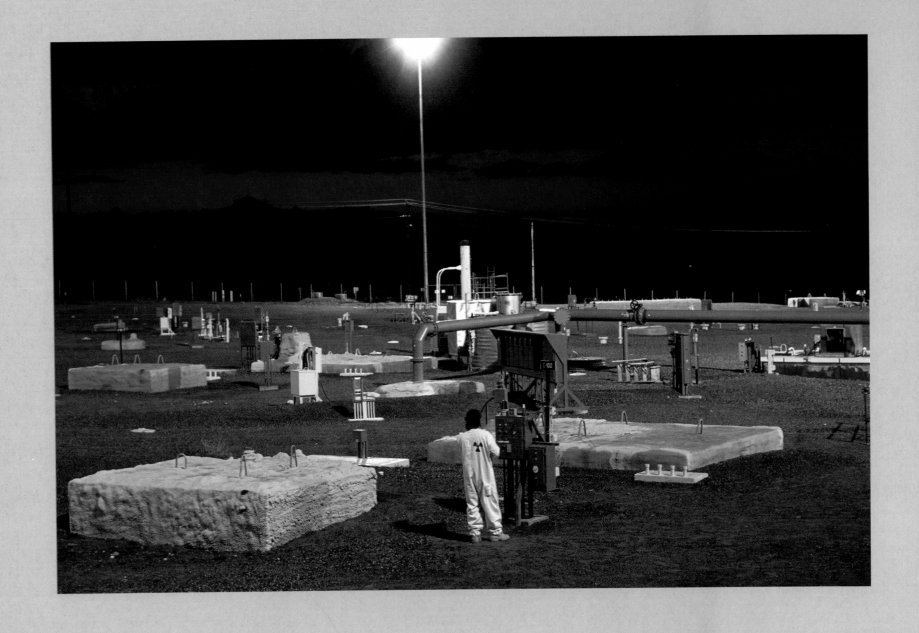

The C Tank farm at sunset, Hanford Nuclear Site, Washington. There are 12 single shelled tanks, which were constructed in the '40s. Washington, USA.

DECEMBER 4, 2000. ©PETER ESSICK/AURORA PHOTO.

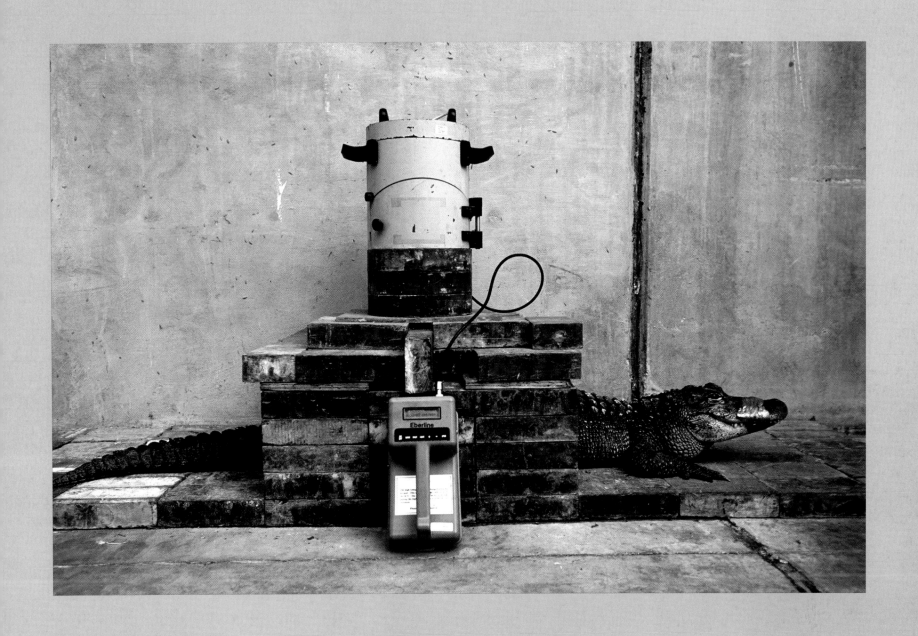

An alligator at the Savannah River Ecology Lab gets tested for levels of Cesium-137, which are detectable in the muscles. USA. MARCH 31, 2001. ©PETER ESSICK/AURORA PHOTO.

115.

ABOVE LEFT: Spent fuel storage. Dry storage for spent fuel at Idaho National Engineering and Environmental Laborator near Idaho Falls, Idaho, USA.

MARCH 31, 2001. ©PETER ESSICK/AURORA PHOTO.

LEFT: The Waste Encapsulation and Storage Facility (WESF) at Hanford Nuclear Site, Washington. Nuclear Chemical Operator Glenn Garman with 1,325 cesium, 137 capsules, and 601 strontium capsules in the pool. The cesium and strontium were chemically separated from the tank farm waste in 1975. Their half-life is 30 years. The blue light is given off by the cesium and is called Cherenkov radiation. A blue light is emitted when a charged particle moves in a transparent medium with a speed greater than that of light in the same medium.

There is more radiation in this pool than anywhere else in the world. Washington, USA.

DECEMBER 31, 2000. ©PETER ESSICK/AURORA PHOTO.

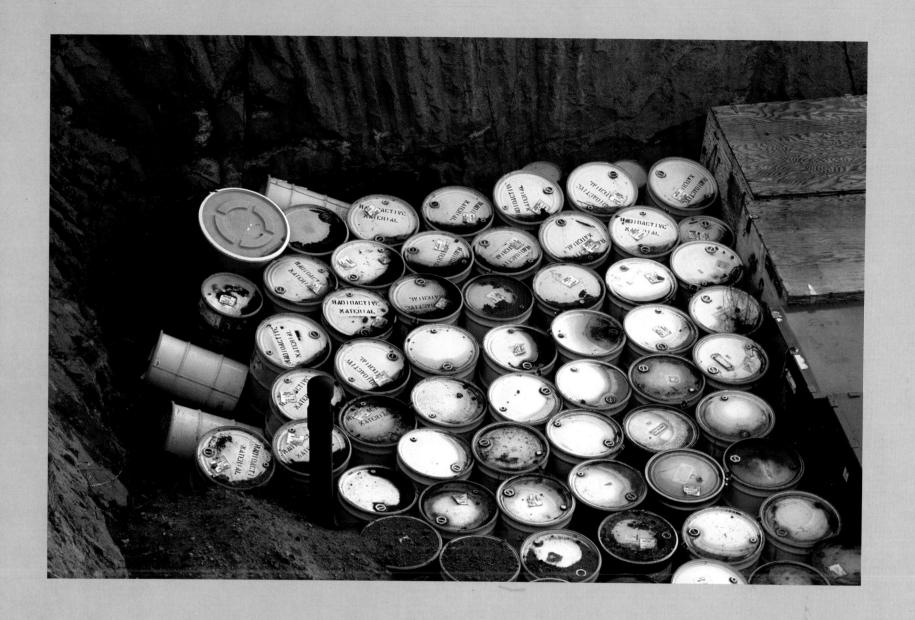

Los Alamos waste. Area G at Los Alamos National Laboratory, New Mexico, the barrels are transuranic waste and are being stored before shipment to WIPP for burial. There are also low-level wastes, which are being buried in Area G. USA.

MARCH 31, 2001. ©PETER ESSICK/AURORA PHOTO.

PHILIP JONES GRIFFITHS **vietnam today**

Thirty years ago I proposed that an understanding of the Vietnam War had to see beyond the physical carnage, and appreciate that America was endeavoring to impose its values on the Vietnamese. The agrarian Confucian culture that had defined the Vietnamese people for over 3,000 years was under a severe attack by U.S. consumer capitalism.

The policy was clearly revealed by Professor Samuel Huntington of Harvard University who stated that "forced-draft urbanization" (the forcing of villagers into the towns and cities as their homes and land were destroyed) could prevent a rural revolutionary movement from coming to power by instigating an "American-sponsored urban revolution." This revolution would supplant the traditional claims of status in Vietnamese society such as wisdom and poetry, with the trinkets and baubles of consumerism.

What I observed and photographed in the three years I spent covering the war was a confused and disenfranchised people living in vastly overcrowded towns and cities. With most of their familiar traditional values stripped away, they seized at the substitute status symbols offered by the Americans. Vietnamese soon learned that the brand was more important than the product!

As the war ended, the supply of consumer goods quickly dried up, as the U.S.-led economic boycott took effect and the remaining samples were rarely flaunted for fear of reprisals by the new regime. With the collapse of the Soviet Union—the main giver of aid to the new Vietnam—the leaders had no choice but to open the country to foreign corporations. The country, especially the South, soon became redolent with the visible signs of foreign commercial penetration.

However, the purveyors of Western goods overestimated the willingness of the Vietnamese to participate. A perceptible change has taken place in the last five years. Many of the wild excesses of the marketplace have been toned down. The public has become more discerning and is increasingly skeptical of products whose benefits were previously heralded. Many American and other foreign "joint ventures" have collapsed, resulting in a steady flow of Western entrepreneurs to departing airplanes.

All of this indicates resilience by the Vietnamese to any kind of foreign domination. Certainly the signs of commercial globalization are everywhere to be seen, but there are increasing restrictions on the more egregious examples.

Vietnam has still a long way to go before achieving true independence, but there are signs that it is rapidly learning to reject the worst and embrace the best that the West has to offer.

I have visited Vietnam 25 times since the end of the war. I was the first Westerner to travel by road from Hanoi to Ho Chi Minh City after the war, and later the Ho Chi Minh Trail. I've had a privileged opportunity to record with my camera the postwar transformation of the country. My new book, *Viet Nam at Peace*, chronicles not only the country's shattered terrain, but also the destruction by consumerist excesses, its citizens' culture, minds, hearts, and hopes.

Philip Jones Griffiths—London, U.K.

On the "more is more" principle, the Anglo-Dutch giant Unilever has blanketed Vietnam with washing powder advertisements. Vietnam.
©PHILIP JONES GRIFFITHS/MAGNUM PHOTOS.

ABOVE LEFT: Families live in shacks beneath hoardings for products they can rarely afford. Vietnam.

LEFT: A shop selling televisions being refurbished in downtown Ho Chi Minh City. Vietnam.

©PHILIP JONES GRIFFITHS/MAGNUM PHOTOS.

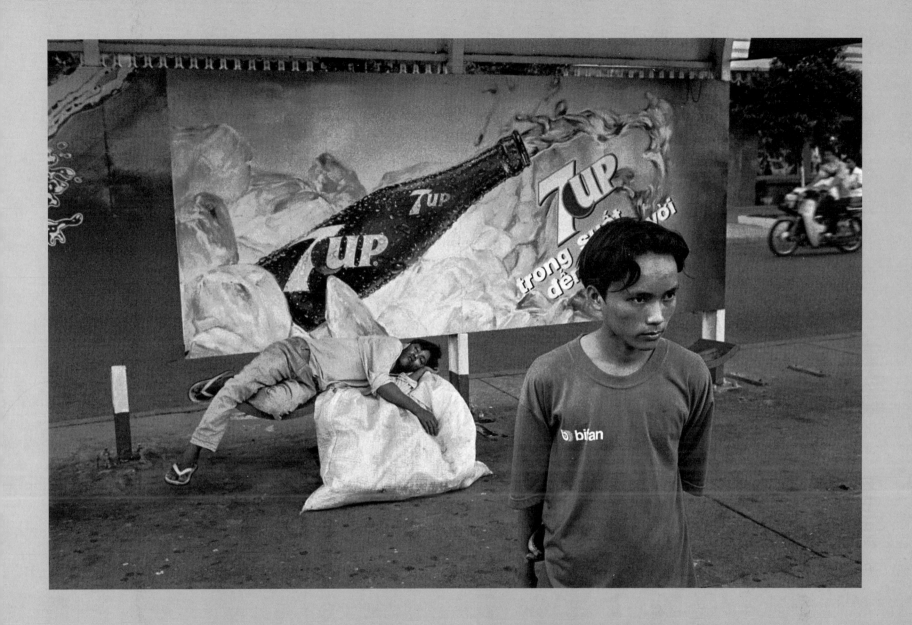

Foreign penetration can now be observed everywhere in Vietnam. A poster on a bus stop in Ho Chi Minh City provides shelter from the sun and rain and a place for the weary to rest. The product, which some claim causes bone weakening, tooth decay, and obesity, is unpopular as it makes the drinker thirsty. Vietnam.

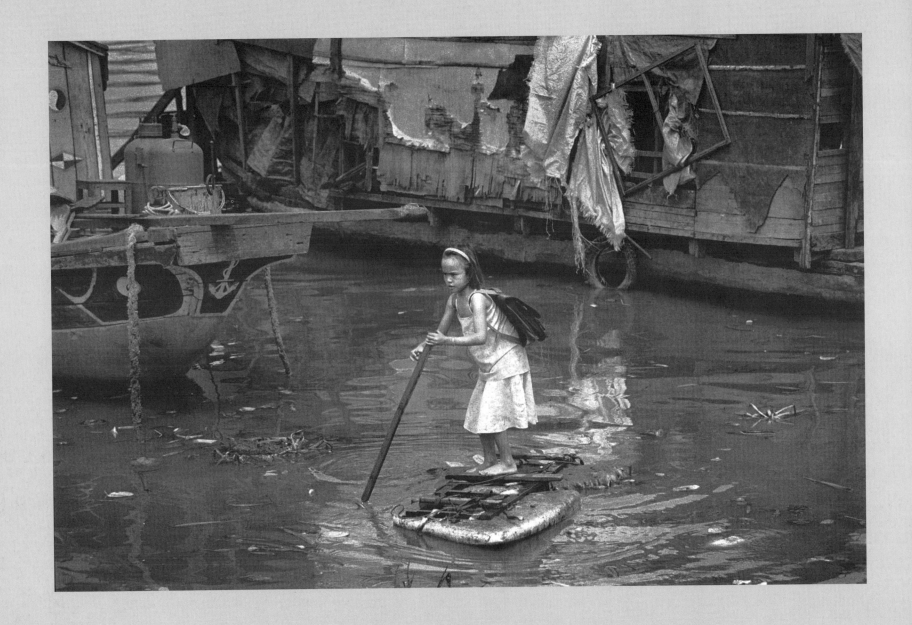

This girl lives with her family on their boat moored on the Sai Gon River. To get to school, she punts herself to the bank standing on a piece of Styrofoam packing material. Vietnam.

©Philip Jones Griffiths/Magnum Photos.

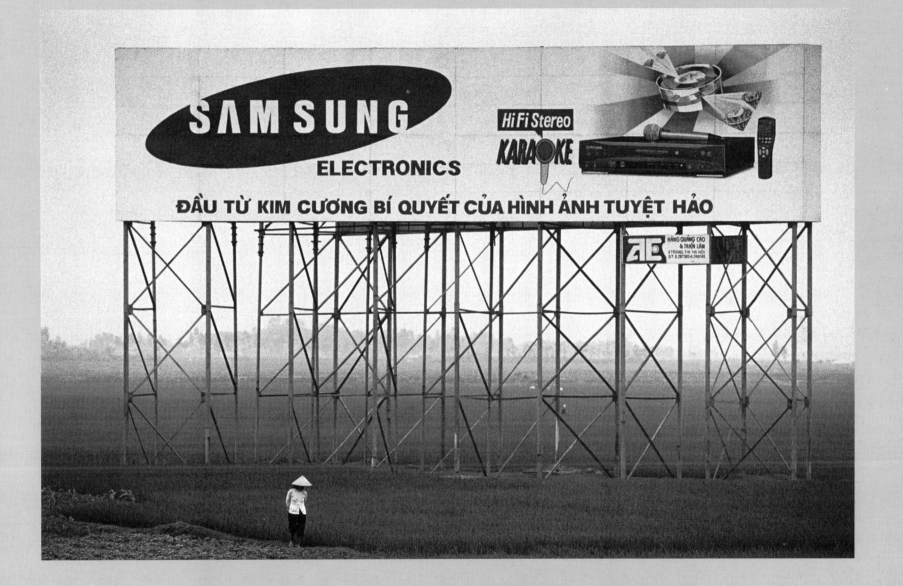

Near Ha Noi, billboards nowadays cast a shadow over the rice fields. Vietnam. ©PHILIP JONES GRIFFITHS/MAGNUM PHOTOS.

CAROL GUZY **in memoriam: fdny**

The story idea originated after covering the first of hundreds of funerals and memorial services for the fallen firefighters of 9/11. It was humbling to witness the grace with which they embraced such profound sorrow. It seemed important to document the stages of grief and also the endless services to honor their fallen brothers in this unprecedented tragedy. I had hoped to do the project for my newspaper, but the editors decided not to pursue it. A leave of absence was granted to work on another story I had been doing in New York as well.

It was heartbreaking to cover the services; I still weep when I hear bagpipes. The media was usually asked to stay outside the church, but many times there were loudspeakers to fill the streets with the sound of the eulogies. The hardest to hear were letters written by the children to their fathers who passed away. It brought back my own feelings of losing my dad at age six. During one of the early funerals, I watched the children leave the church and all the repressed emotion from photographing the devastation at Ground Zero and the intense grief of victims' families caused me to break down in front of the church. It was quite embarrassing and unprofessional, but I couldn't stop crying. One of the firefighters from the ceremonial unit stepped out of formation to comfort me. It was one of the warmest hugs I've ever experienced. I'll never forget him for that moment of humanity.

So often journalists are perceived in negative ways, especially when covering sensitive events like funerals. The firefighters treated us with a great deal of respect. Once, when I was struggling to climb down from a ladder with all my gear, a white-gloved hand reached up gallantly to help me down. It was one of those photographs you don't take that are forever etched in your heart.

Carol Guzy—Washington, D.C., USA.

"FALLEN HEROES." Three hundred and forty-three firefighters perished in the World Trade Center terrorist attacks on 9/11 in New York last year. Even a year later, the fire department was still holding funerals and memorial services for those who never found the remains of their loved ones. It was the greatest tragedy in the history of any U.S. rescue department, yet New York's bravest handled their tremendous loss with grace. New York, USA.

AUGUST 3, 2002. © CAROL GUZY/WASHINGTON POST.

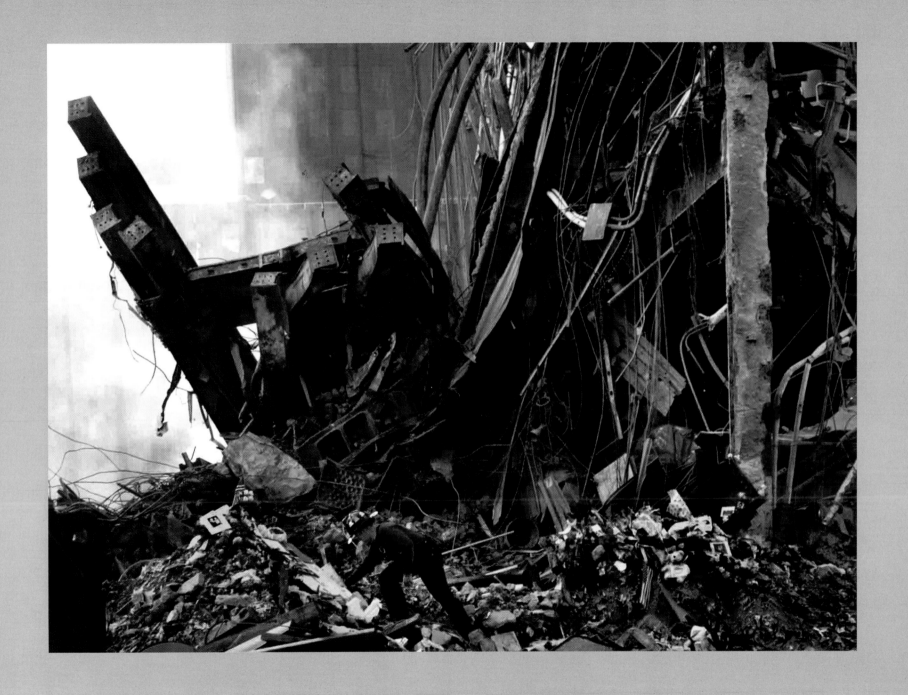

"DANTE'S INFERNO." Smoke billows from the wreckage of the World Trade Center after the towers' collapse following the terrorist attacks on September 11. New York, USA.

©Carol Guzy/Washington Post.

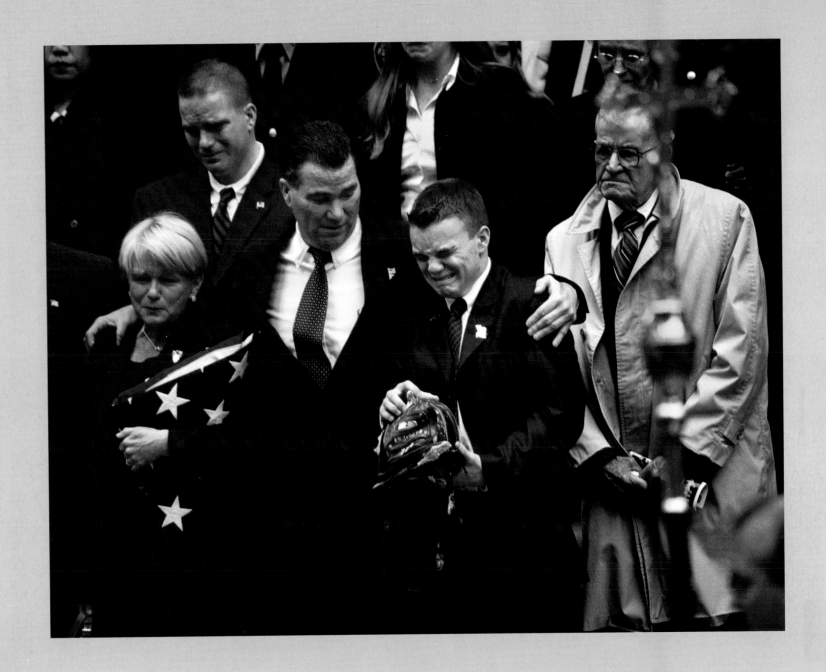

"PROFOUND SORROW." Tommy Riches sobs while holding the crumpled helmet of his brother, New York firefighter James Riches (ladder 114 assigned, Engine 4 rotation), as his coffin is carried from the church during the funeral service at St. Patrick's Cathedral in Manhattan. The fallen firefighter was killed in the World Trade Center terrorist attacks on 9/11. Finding the remains in the rubble of Ground Zero gave some families closure. New York, USA.

APRIL 12, 2002. ©CAROL GUZY/WASHINGTON POST.

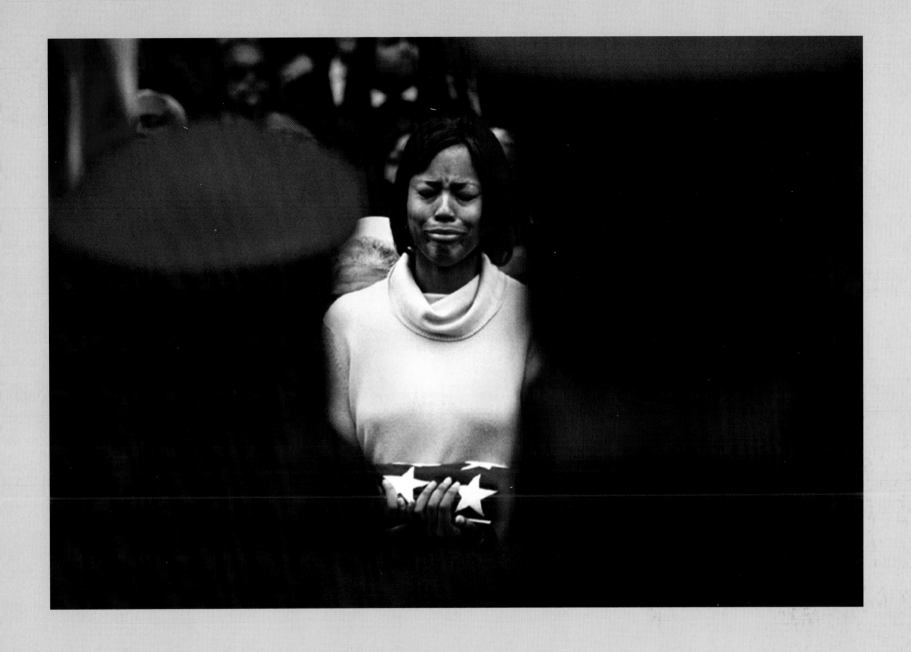

"SORROW." Family members weep during a memorial service in Brooklyn for a fallen firefighter killed in the World Trade Center terrorist attacks. New York, USA.

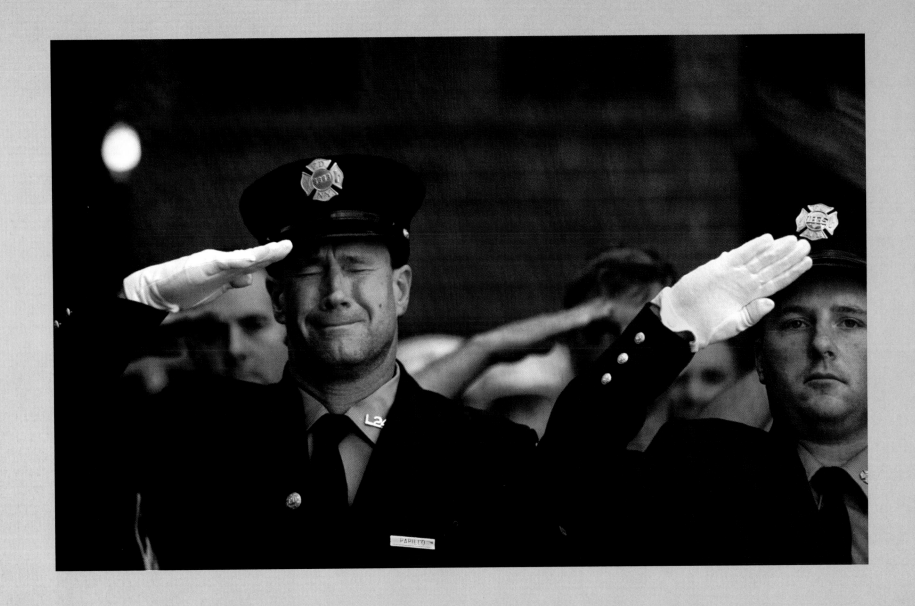

"A NATION GRIEVES." Firefighter Joe Papillo struggles to hold back his tears at the funeral of Rev. Mychal Judge, a beloved chaplain who died giving last rites to a fireman in the rubble of the World Trade Center terrorist attacks on September 11 at Ground Zero. He was listed as the first victim of the tragedy. New York, USA.

©Carol Guzy/Washington Post.

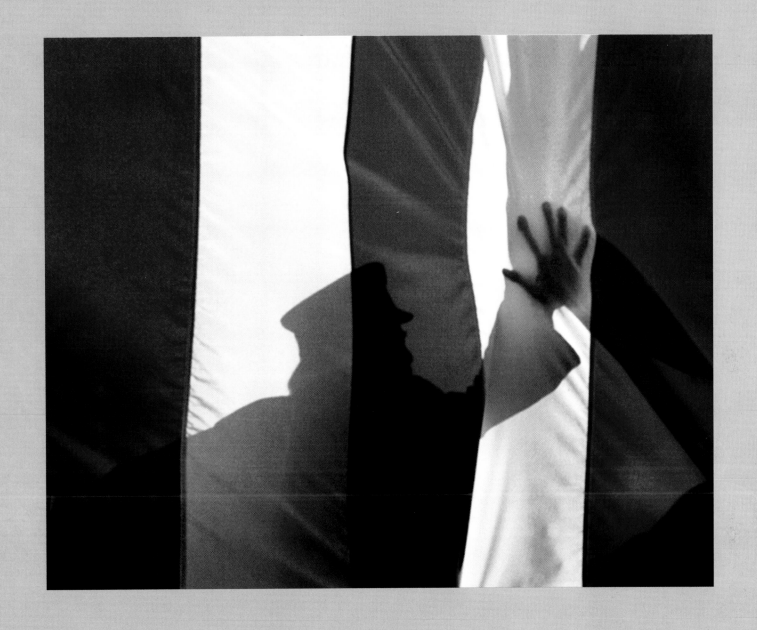

"NEW YORK'S BRAVEST." A New York firefighter takes down an American flag after a memorial service for one of his fallen brothers killed in the World Trade Center terrorist attacks. New York, USA.
© CAROL GUZY/ WASHINGTON POST.

GEERT VAN KESTEREN *why mister? why?*

Just a week after the war ended in April 2003, I traveled to Baghdad. Assigned by UNICEF, *Newsweek*, and *Stern*, I reported from Iraq for almost seven months. I worked as an embedded journalist for seven weeks, a position about which I initially had had strong doubts. But I had no choice. Having visited Iraq and the Arab world extensively in prior years, I had my own contacts and insights into this complex society that was once again being shaken by violence. I experienced the absurdity of the war and the underlying clash of cultures, and converted this into images and text.

"Why Mister, why?" Iraqis cried out these words in outrage at the acts of U.S. troops, which they could not understand. American soldiers in turn used them as a taunt to ridicule the despair of the people they captured. I saw it written as such, on the door of a toilet at an American base. My images illustrate the widening gap between the Iraqis and their occupiers. It underlines the culture clash between a world power and an ancient Arab world.

While on assignment in Iraq I met many Iraqis. They all had something to say about the occupation. One of them was a humble man named Abbas. This man had nothing, but he insisted on sharing the last of his tea with me. He knew little and has never been to school, but he possessed a wisdom that, in the eyes of most Iraqis, is still somewhat lacking in their politicians. Abbas says, "You must always be honest, I was tortured the Saddam regime and everything was taken away from me. My sincerity is the only thing that keeps me standing, and gives

Geert van Kesteren—Amsterdam, the Netherlands.

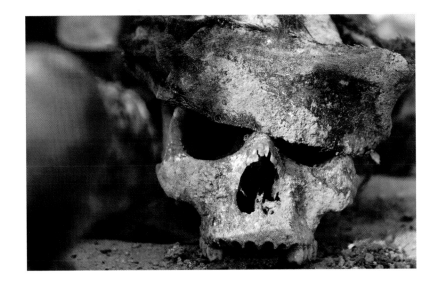

my family dignity." That statement rings true to me. Anyone pretending to bring democracy to a country must themselves act sincerely: uphold the Universal Declaration of Human Rights, the Geneva Conventions; act with common decency; and respect the culture of that country.

There were countless people in Iraq who said the same thing about the occupation: "If this is democracy, then they can keep it." Nations should lead by example. Unfortunately, politics and sincerity rarely coincide.

ABOVE: A blindfolded skull found in the al-Mahawil mass grave, where more than 2,000 people were killed by the regime of Saddam Hussein in 1991. Hilla, Iraq.
MAY 2003. © GEERT VAN KESTEREN/MAGNUM PHOTOS.

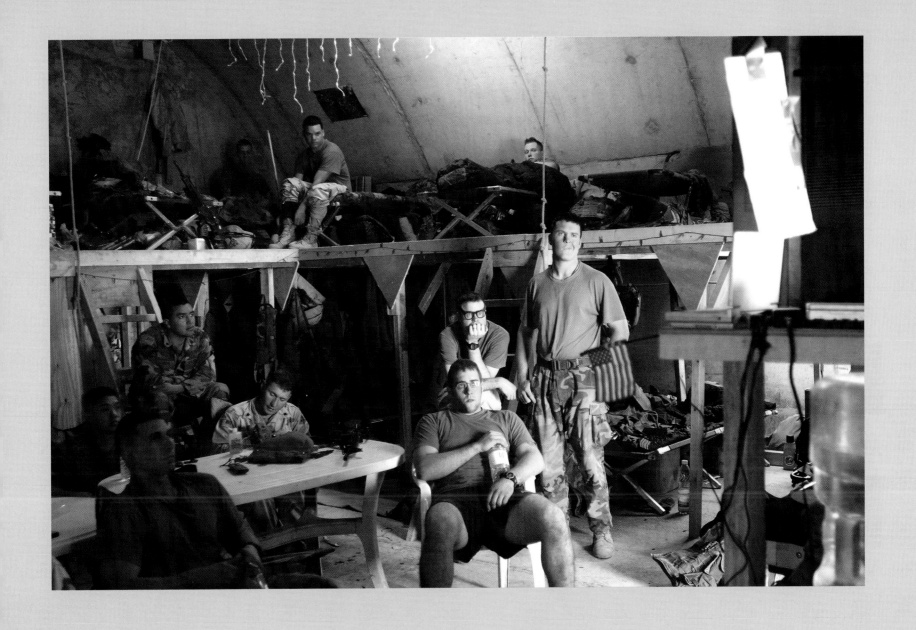

Bravo Company 1/8, 4th Infantry Division, watch a DVD at their base, a former bunker to store ammunition. Balad, Iraq.
FEBRUARY 19, 2004. © GEERT VAN KESTEREN/MAGNUM PHOTOS.

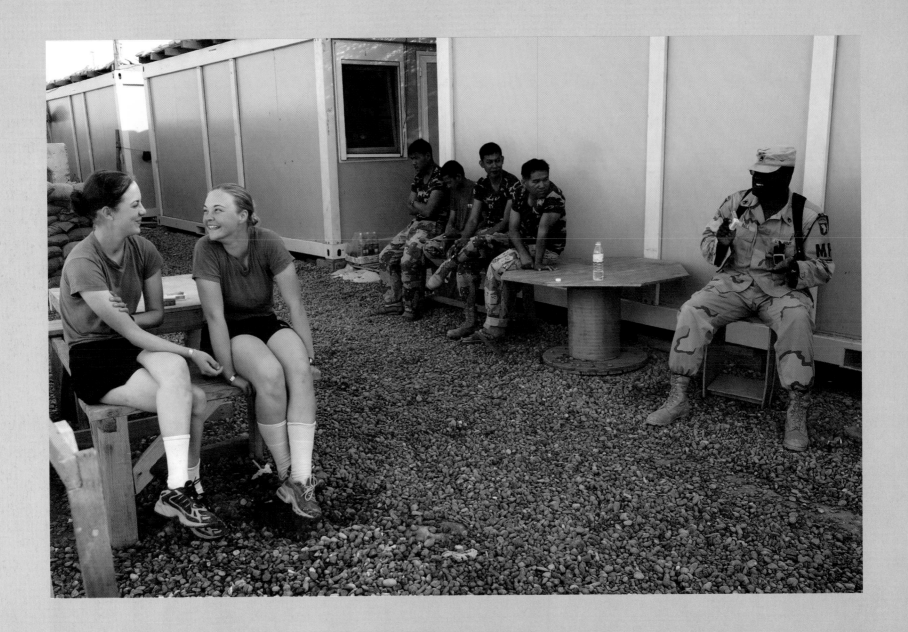

194th Military Police Company, 716th Battalion. Spec. Melany Fink (20, middle) and Spec. Corrie Jones (27) from 194th Military Police Company, 716th Battalion, mingle with other soldiers at the Karbala base where soldiers from the U.S., Hungary, Thailand, and Poland are based. "I used to be a cheerleader and my favorite color is pink," says Melany, "but now I love guns, the bigger the better." Karbala, Iraq.

MARCH 2004. © GEERT VAN KESTEREN/MAGNUM PHOTOS.

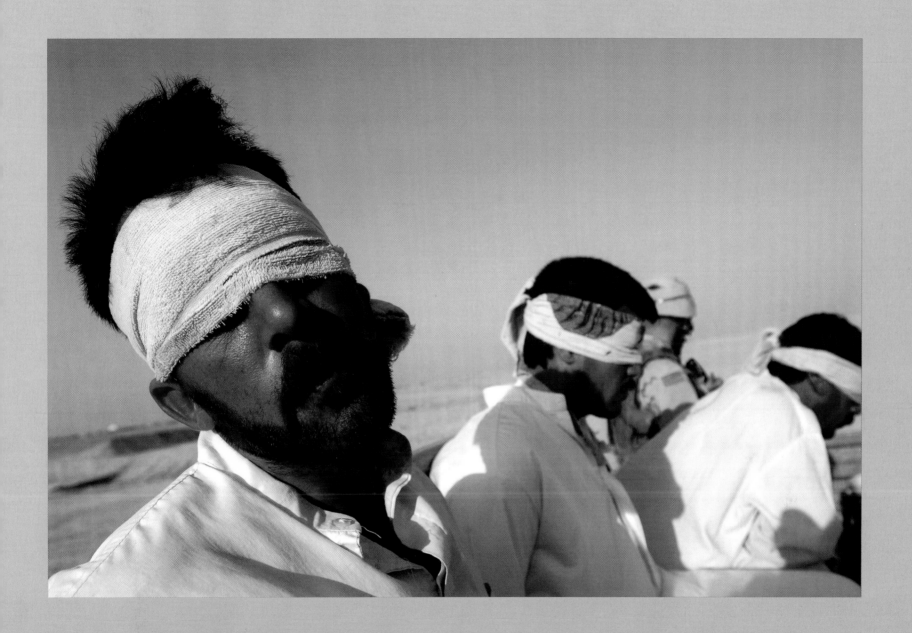

Six arrested Iraqi men are brought by lorry to an improvised prison at a military base. Engineers of the 4th Infantry Division raided their farm near Tikrit, where they found several weapons and a field phone. Though it is 60 degrees celsius, the prisoners were provided with hardly any water. Tikrit, Iraq.

AUGUST 2003. © GEERT VAN KESTEREN/MAGNUM PHOTOS.

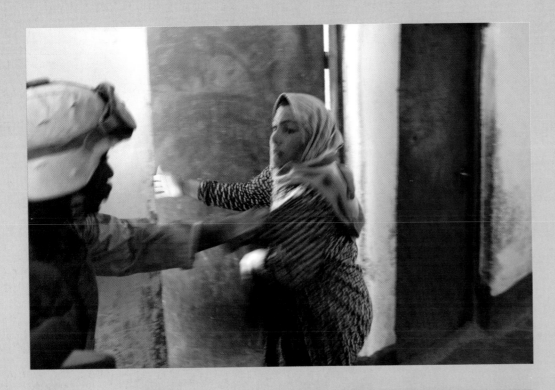

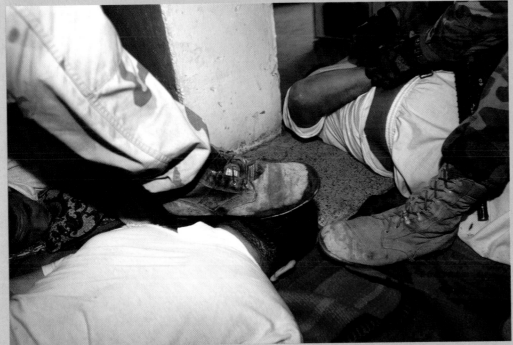

ABOVE LEFT: Engineers of the 4th Infantry Division raid a farm near Tikrit. A woman tries to get a key for the soldiers who kick in the doors of her house. As there was no translator present, she was not understood and pushed aside. Tikrit, Iraq.

August 2003. © Geert van Kesteren/Magnum Photos.

LEFT: Soldiers of Bravo Company 1/8th, 4th Infantry Division arrest several men on a raid. As they handcuff the Iraqis, the soldiers use their Army boots to stand on their backs and heads, to hold the men down.

Hitting a man with a shoe in the face is the biggest insult possible in Iraq. These men were arrested after soldiers found weapons in a nearby hotel. This is not the hotel, but the hotel owner's house, where all males were arrested; "You never know, they can be insurgents," said 2nd Lt. Tomlinson. Samarra, Iraq.

January 2004. © Geert van Kesteren/Magnum Photos.

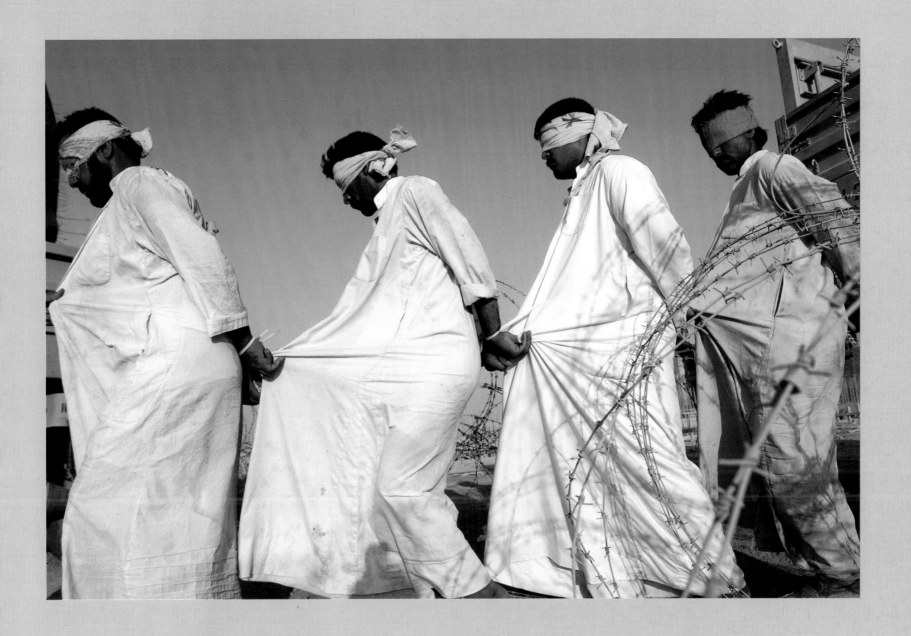

"The Elephant Walk" is what U.S. soldiers call this, as arrested men walk to an improvised prison at their base. The U.S. Army is on the hunt for terrorist Baath supporters, weapons, and Saddam Hussein.

Engineers of the 4th Infantry Division raid a farm near Tikrit where they find several weapons and a field phone. Six men were arrested and brought to an improvised prison on the base. Tikrit, Iraq.

AUGUST 4, 2003. © GEERT VAN KESTEREN/MAGNUM PHOTOS.

GARY KNIGHT **a tragic divide**

I do not have strong feelings about any of my photographs. For me they are tools, much like any other tools. They enable me to look and comment on things that I would not ordinarily be able to do. I have never considered them to be art, my only consideration is to use them as communication, and the entire creative process is subservient to that.

I think the wall is a paradox. There is beauty in its ugliness, it is probably the most significant architectural contribution to the city since the Al-Aqsa Mosque was built, and yet it functions to divide two communities, or more correctly isolate one community at a time when the Israelis and Palestinian need any thing but division.

Gary Knight—South of France.

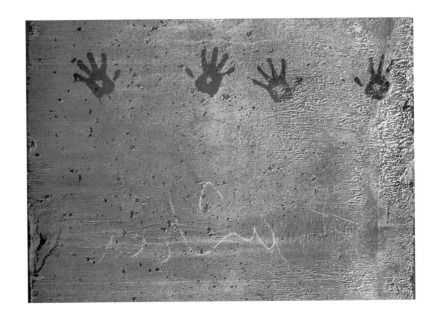

Begun in June 2002, based on the decision of the current Israeli government, the wall that is now erected between Israel and the Palestinian territories is meant to prevent suicide attacks and delinquency at large. Its aspects range from concrete walls 8 meters high, to 3-meter-high electric fences, with large buffer zones with surveillance devices. When completed, it should extend approximately 800 kms. Jerusalem.

APRIL 11, 2004. © GARY KNIGHT/VII.

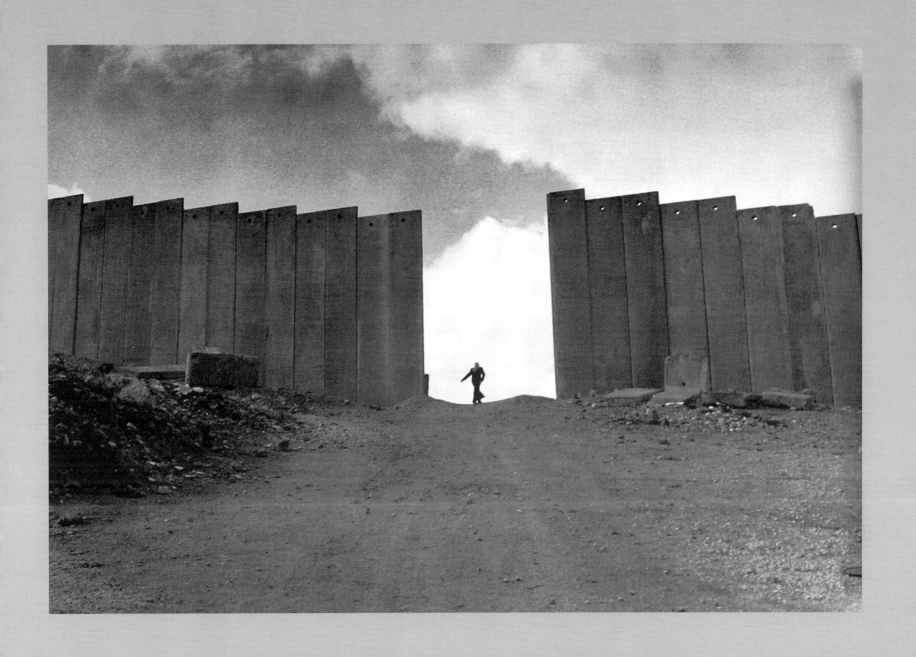

Jerusalem. APRIL 11, 2004. © GARY KNIGHT/VII.

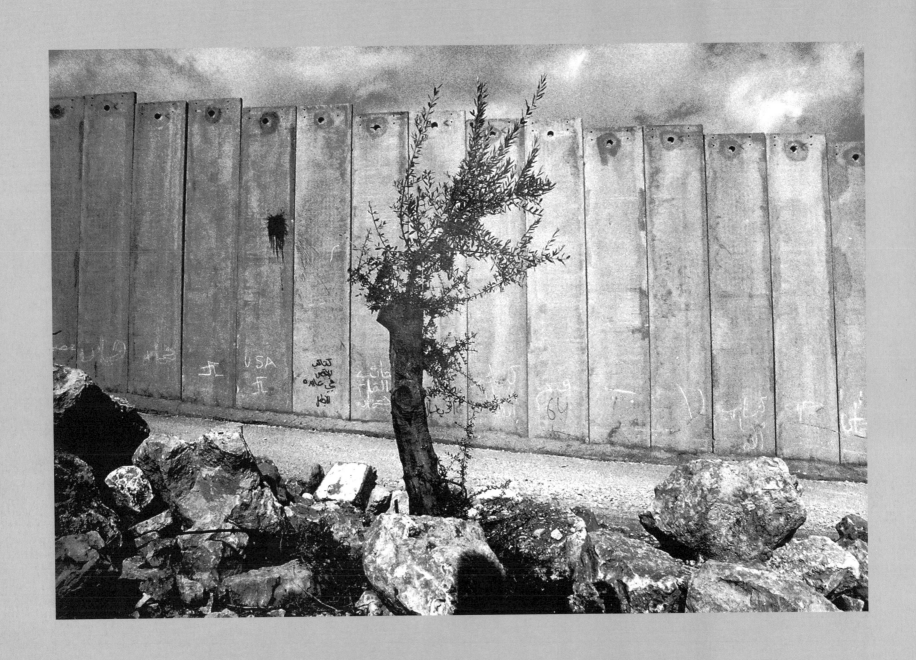

Jerusalem. APRIL 11, 2004. © GARY KNIGHT/VII.

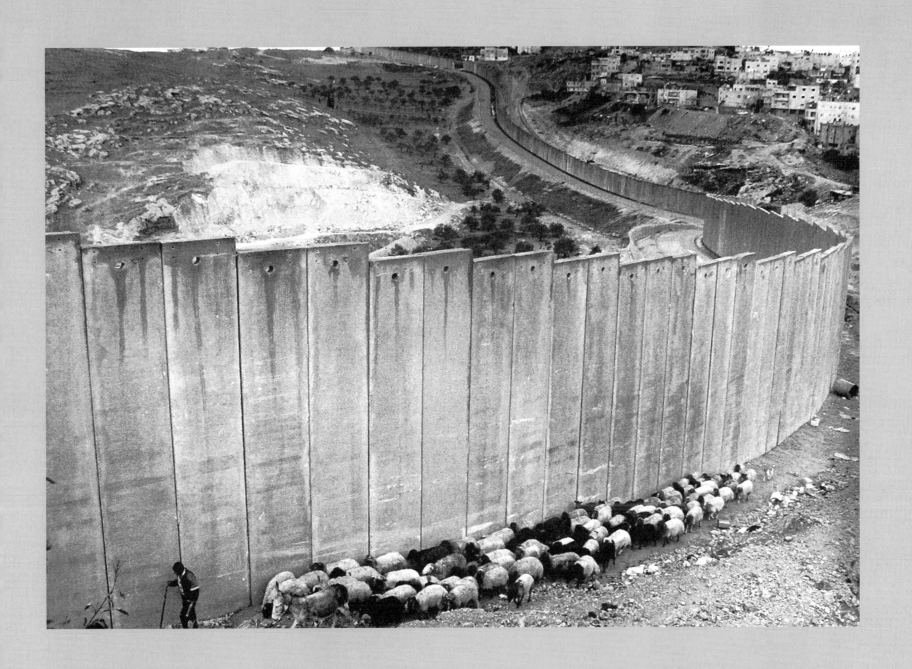

Jerusalem. APRIL 11, 2004. © GARY KNIGHT/VII.

FERNANDO MOLERES children at work

In an Age of Modernity, of Western well-being, millions of children are methodically and systematically exploited for their labor. Their childhood is stolen from them without them ever having had an opportunity to develop their full potential. For these children there are no educational or health benefits, things that we take for granted. They are not even entitled to dream of a better future.

Paradoxically, many of these children want to work, to move forward into the broader world, and to be useful in a society that would give them something in return for their efforts. Unfortunately, for the majority of these children the consequences are contrary to their hopes for future development and they demand a painful lifetime investment.

It's only with childhood strength and innocence that these children are able to move ahead, survive, and smile. But for many children this unjust situation has gone too far and they will be dysfunctional for life.

Reportage can focus on the worst conditions of child labor. It is one of the first steps that can be taken to eradicate these conditions, which are the results of poverty and unfair commerce and social abandonment.

I want to document and highlight the issues of our times in the hope of contributing toward dialogue and action.

Fernando Moleres—Barcelona, Spain

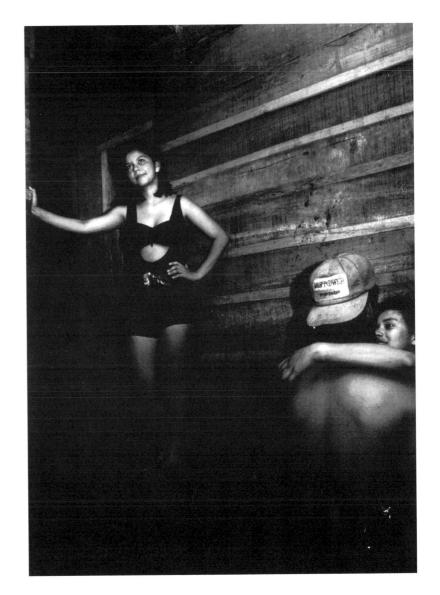

Young prostitutes all over Colombia went to the biggest emerald mine zone for prostitution. "Cortina Roja" brothel of Muzo village, Colombia.
1992. © Fernando Moleres.

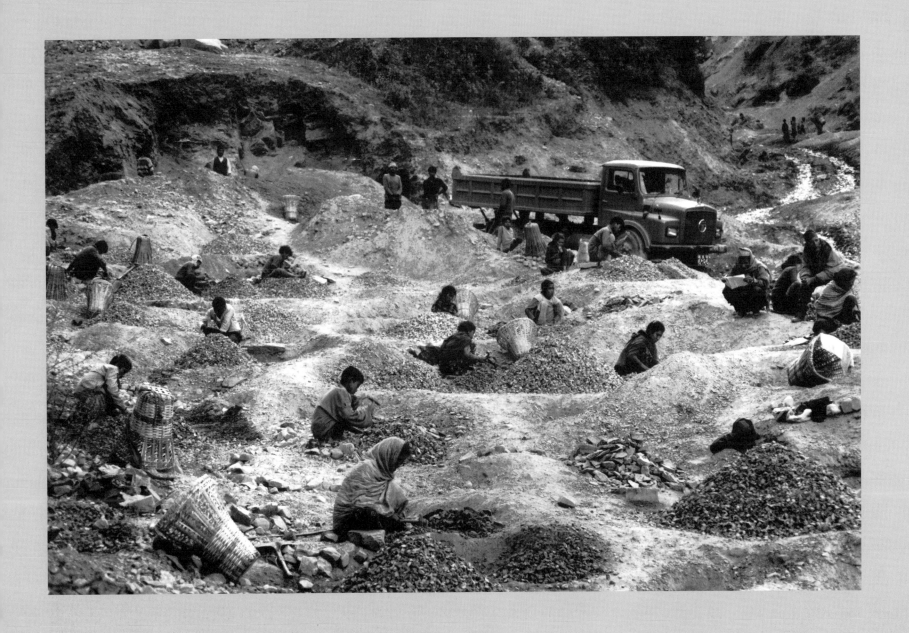

Stonecutters in the watercourse of Nepal rivers. Children are used for breaking stones into smaller ones. It's hard work because of the position and because they work more than 10 hours per day. Road to Pokhara, Nepal.

1994. © FERNANDO MOLERES/AURORA PHOTO.

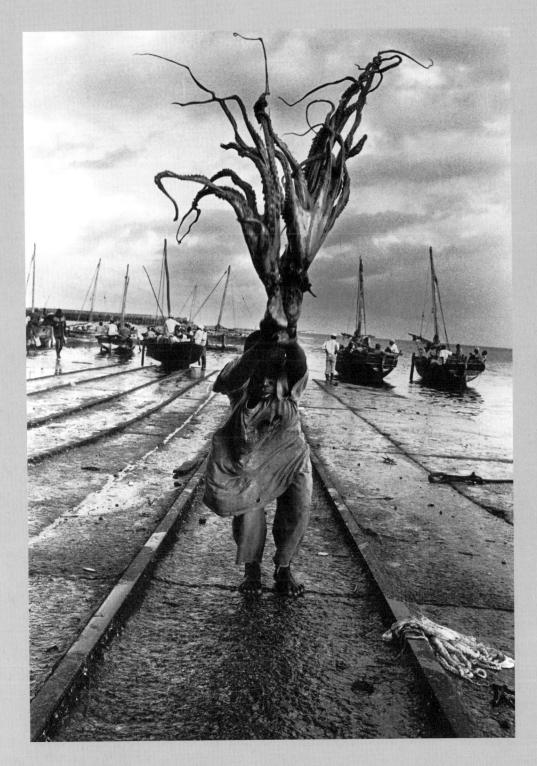

This young boy works on a fishing ship. When the ship arrives early mornings in Stone Town port one of his tasks is to kill and get the octopus softer. This is hard work because he beats each octopus an average of five minutes continually. Zanzibar.

1997. © Fernando Moleres/Aurora Photo.

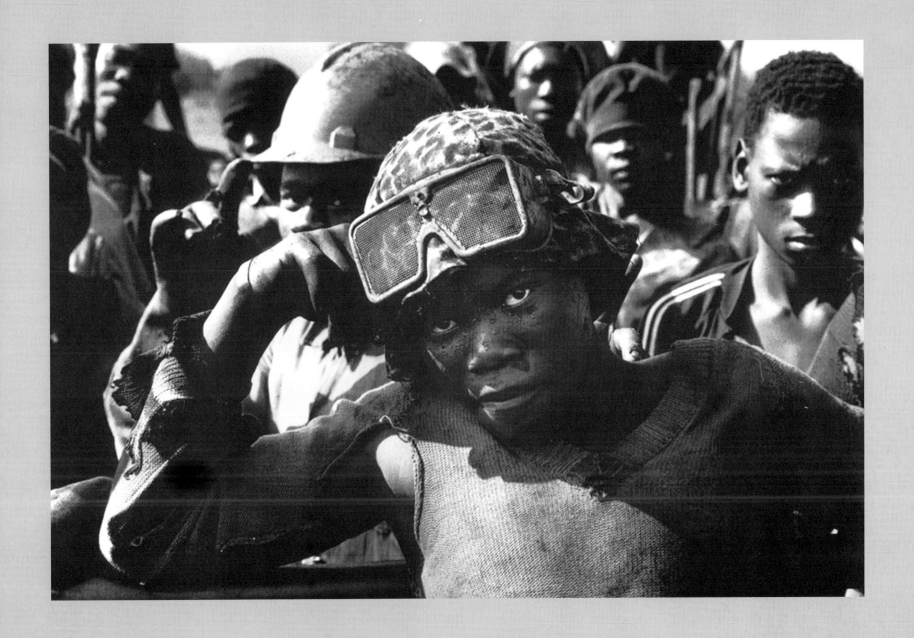

Sugar cane plantations in South Africa. During the sugar cane harvest, other workers who earn a minimum salary, subcontract children to help them cut their daily quota of sugar cane. Umzinto, Natal, South Africa.

© Fernando Moleres / Aurora Photo.

Children working in a carpet workshop in India. In Cashmere Valley there are 80,000 children working in carpet workshops. Muzzafarpur, India.

1994. © Fernando Moleres/Aurora Photo.

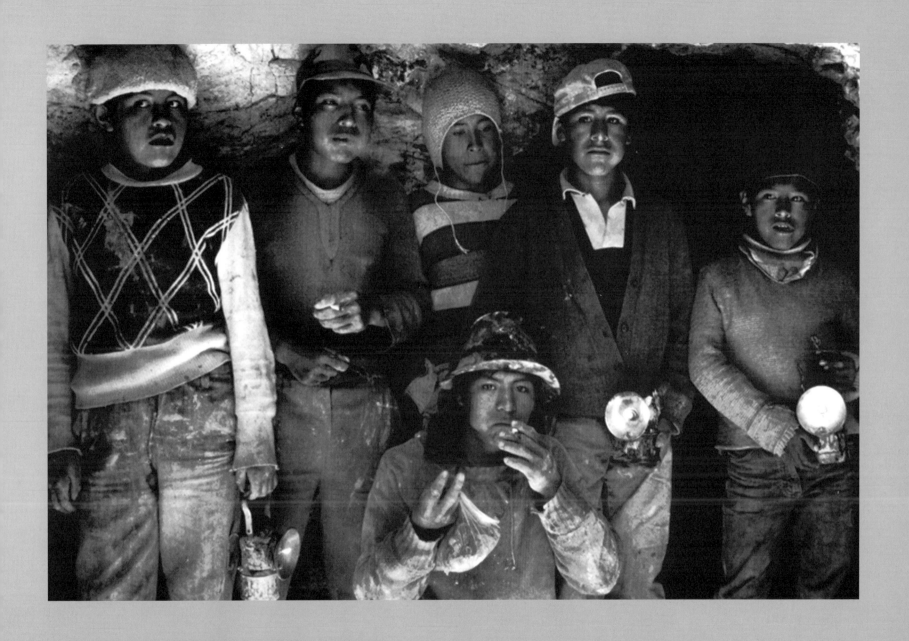

Silver mine of Cerro Potosi in Bolivia. The children work at altitudes of 4,200 meters; the conditions are so extreme that they eat coca leaves like the young boy in the center foreground. Bolivia.

1993. © Fernando Moleres.

LUCIAN PERKINS **far from home**

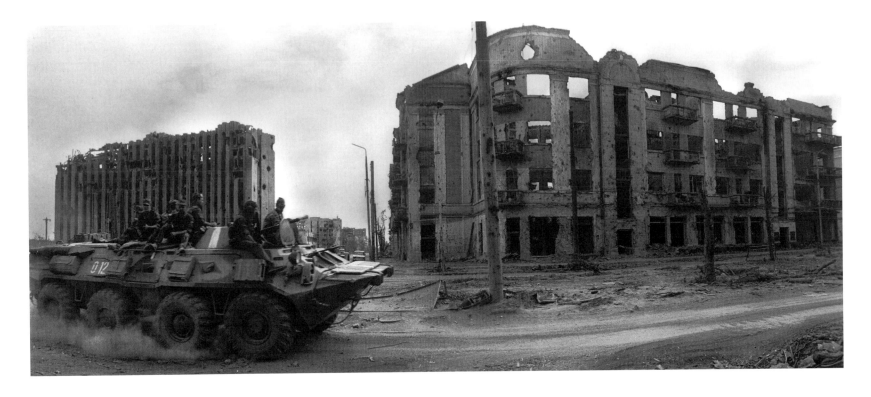

"We photographers deal in things which are continually vanishing, and when they have vanished, there is no contrivance on earth that can make them come back again." —Henri Cartier-Bresson

Have instantaneous news, the Internet, and over 500 TV channels and radio stations provided us with a better understanding of our world? How much of that news is reported directly from an "eyewitness" of the actual events? Whose voices do we hear most and believe while we flip from channel to channel to channel: those affected by the events or talking heads and pundits sitting in a studio at great distances from what they discuss?

Far from Home is a multimedia journey that explores the gap between fact and fiction. As the video weaves from the reality of being a witness in Afghanistan and Iraq to that of searching TV stations for accounts of my experiences, the question raised is, "Is the news we consume giving justice to the events that are shaping our destiny?"

The rest of the world watches America; America watches 'American Idol.' —Charles A. Kupchan, *The Washington Post*, April 2005

Lucian Perkins—Washington D.C., USA.

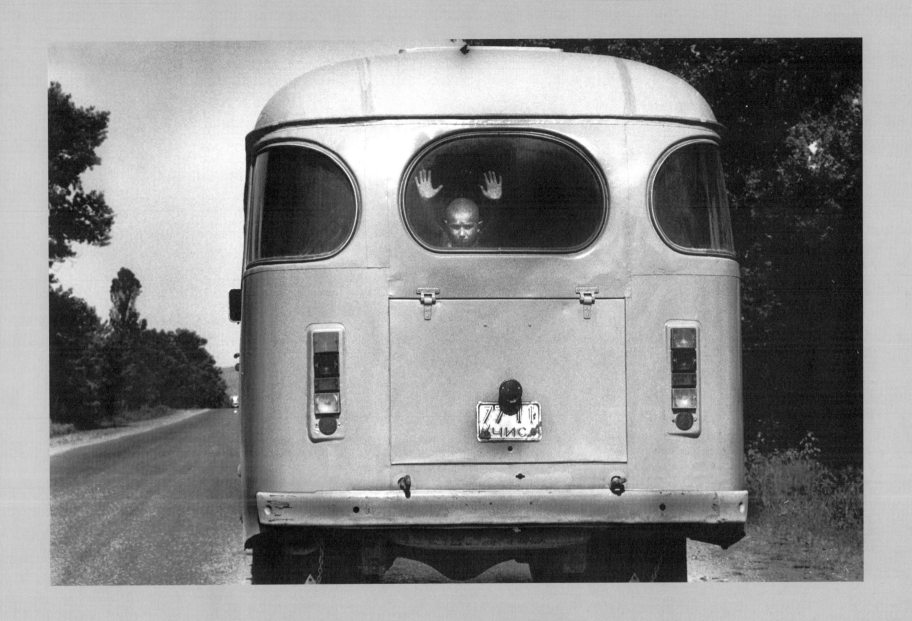

Images from: *Far from Home*, 2004, (10:00 min., single channel DVD).

ABOVE: A young boy peers out the back of a bus after he and other refugees flee the fighting between Russian troops and Chechen independence fighters. Southern Chechnya.

OPPOSITE: Russian troops patrol downtown Grozny, which was virtually destroyed during fighting between Russian troops and Chechen independence fighters. In the background on the left is what is left of the Parliament building. Grozny, Chechnya.

MAY 1995. ©LUCIAN PERKINS / WASHINGTON POST.

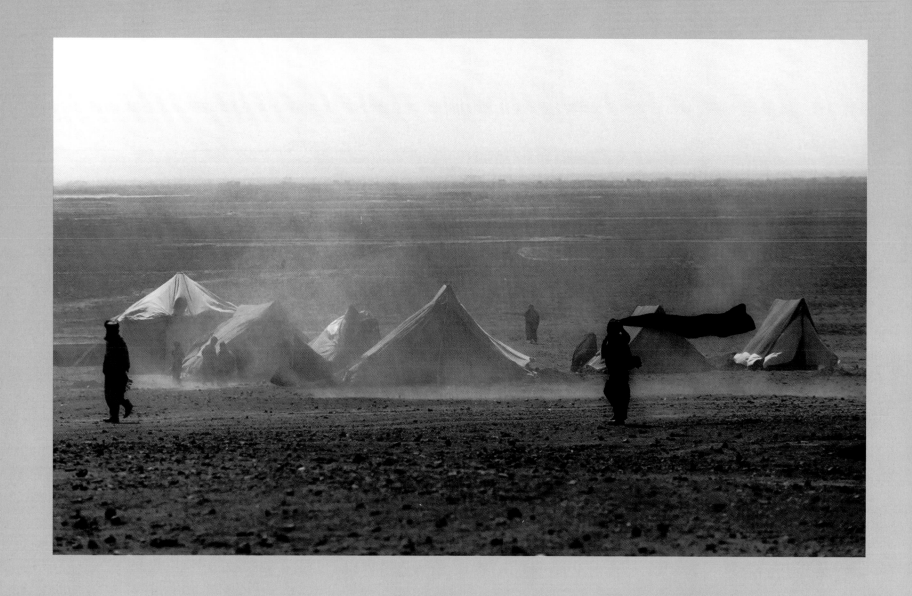

Images from: *Far from Home*, 2004, (10:00 min., single channel DVD).

Refugees brave a sandstorm at the Maslakh refugee camp, located just outside of Herat, Afghanistan, which had swelled to over 70,000 Afghans displaced by the worst drought in Afghan memory and the continued Civil War. Afghanistan.

FEBRUARY 2001. ©LUCIAN PERKINS/WASHINGTON POST.

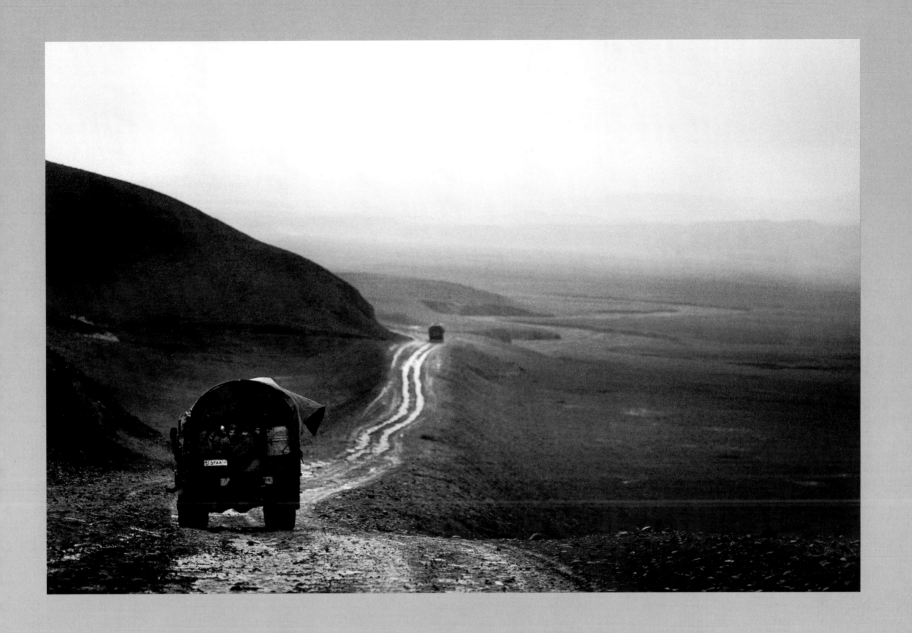

Images from: *Far from Home*, 2004, (10:00 min., single channel DVD).

Dead fields. Dead crops. Dead animals. A dead village. Afghan farmers leave their homes and their land after losing their crops and livestock to the drought and head to the border of Iran in hopes of finding work. Afghanistan.

FEBRUARY 2001. ©LUCIAN PERKINS/WASHINGTON POST.

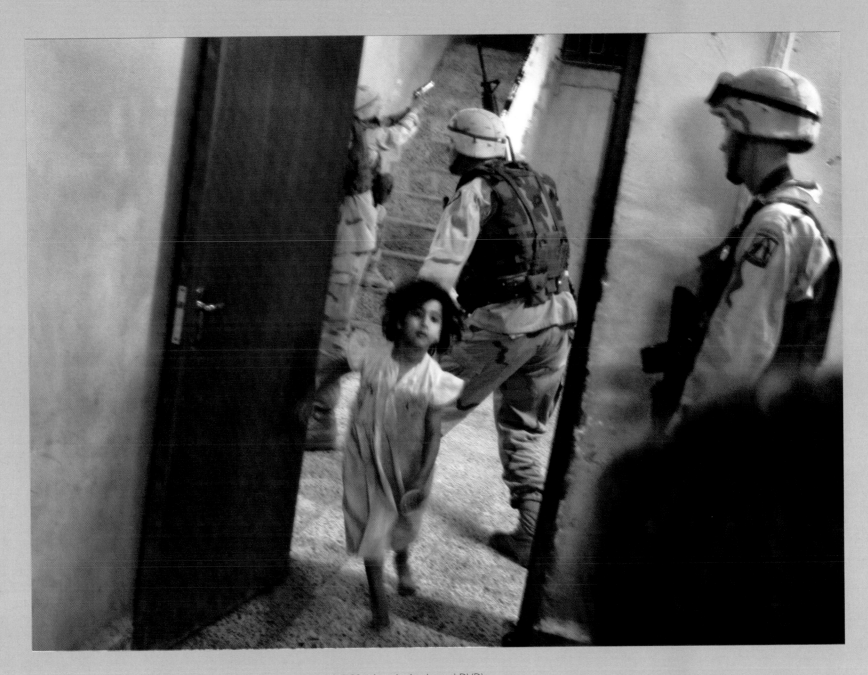

Images from: *Far from Home*, 2004, (10:00 min., single channel DVD).

A young girl dashes out in fright as U.S. troops conduct one of their raids in Tikrit while looking for Baathist supporters. U.S. troops started using this tactic as attacks against them increased. Many Iraqis believe the raids will just increase the distrust between the Iraqis and U.S. forces while U.S. forces believe the raids are slowing down the insurgency. Tikrit, Iraq.

July 1, 2003. ©Lucian Perkins/Washington Post.

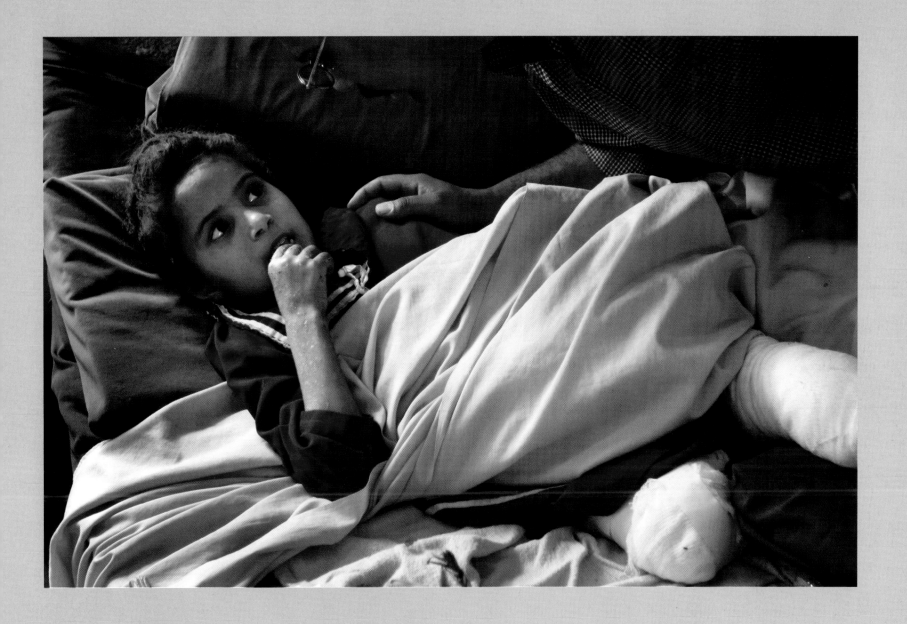

Images from: *Far from Home*, 2004, (10:00 min., single channel DVD).

Zainab Hamed, nine years old, lost her leg and 17 family members when coalition forces bombed her family's house on the third day of the war. The number of Iraqi civilians killed and wounded during and after the war has been a source of controversy, with many believing that it was greatly underreported by the media. Basra, Iraq.

APRIL 2003. ©LUCIAN PERKINS/WASHINGTON POST.

JOHN STANMEYER out of sight out of mind

Stigmatized, forgotten, and often locked away, Asia's mentally ill are left to wallow in a living hell. Asia's economic miracle is slowly on the rebound and wars may have subsided, but for thousands of people, their lives are in constant torment, many treated and kept no different than animals in a zoo. I spent much of 2003 documenting the alarming mental health crisis in Asia. Mentally, it was often difficult even for me to process what I was witnessing—especially when the conditions of fellow humans appeared to have not improved since the Middle Ages. From China to Cambodia, Afghanistan, Indonesia, and Pakistan, this important piece of social commentary illustrates the dire need for greater funding from governments and international NGOs to pay attention and act toward the needs of its people who are locked up, over-drugged, malnourished, and neglected.

John Stanmeyer—Bali, Indonesia.

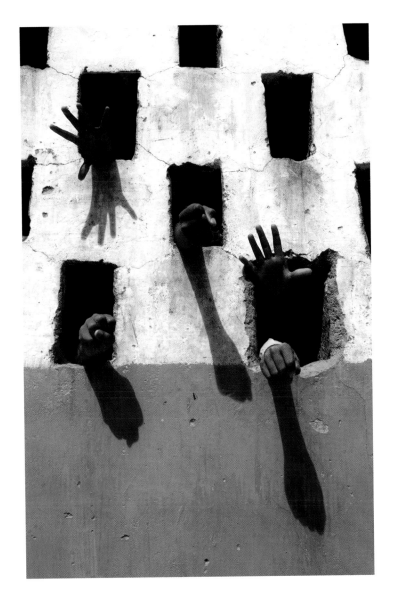

Locked behind bars, children as young as seven, languish at the Edhi Village for the mentally ill located outside Karachi, Pakistan. In Pakistan, the government has all but given up on caring for the mentally ill, having to ask private donors to handle the care.

More than 1,000 mentally ill patients live jammed together in the privately funded Karachi commune called Edhi Village, run by the prominent social worker Abdus Sattar Edhi. Iron gates lock the inmates in, some of whom, stark naked, slam their heads against the walls of their dark cells.

"Our center is becoming a dumping ground for people who consider mentally ill people as the dirt of society," says Ghazanfar Karim, the complex's overburdened supervisor.

KARACHI, PAKISTAN. APRIL 20, 2003. ©JOHN STANMEYER/VII.

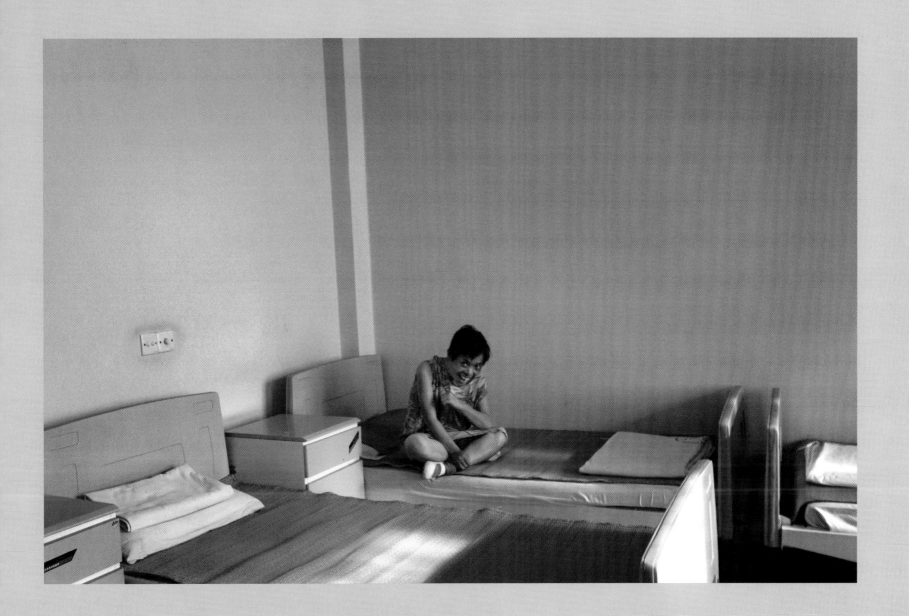

Daily life for patients in the female ward at the Mental Health Center of Xuhui District in western Shanghai. The positive signs of China's rapid development are also beginning to show the negative aspects and many are left behind in a mental health care system that lacks funding. Compounded with the stigma of mental illness in Chinese society, and the road ahead for mental health in China becomes an alarming concern. Shanghai, China.

July 24, 2003. ©John Stanmeyer/VII.

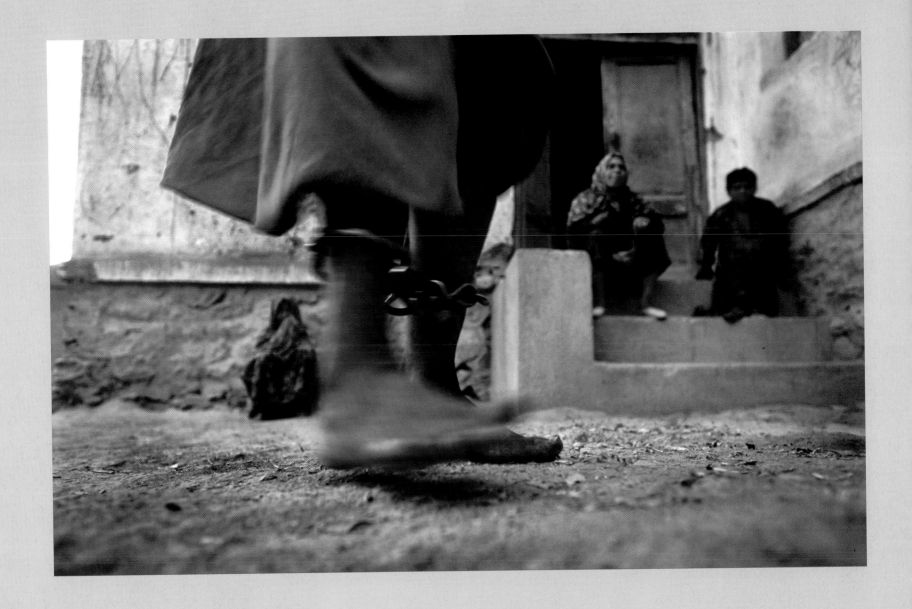

Nasrin, 22, came to the Marastoon Mental Hospital in the Afshar area of Kabul, Afghanistan, in 1995. At the time, Nasrin returned to her home and found most of her family killed by the Taliban. Since that day Nasrin has been committed to the mental hospital. Nasrin is kept in ankle chains because of her tendency to become violent. In the last five months she has killed two other female inmates.

Other than some financial assistance from the ICRC, little other funding is available for the 20 women in the only mental hospital in Kabul. Nearly all the women are suffering from the effects of war, especially from the time of the Mujahadeen war in 1992. Kabul, Afghanistan.

MAY 1, 2002. ©JOHN STANMEYER/VII.

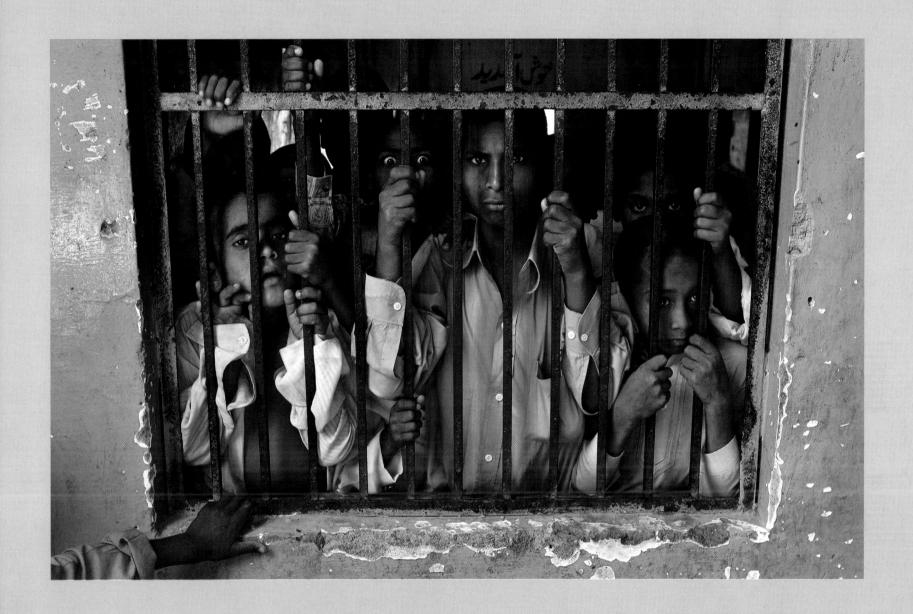

Reaching out, behind bars and with no beds to sleep on, children as young as seven languish at the Edhi Village for the mentally ill located outside Karachi, Pakistan. In Pakistan, the government has all but given up on caring for the mentally ill, having to ask private donors to handle their care.

More than 1,000 mentally ill patients live jammed together in the privately funded Karachi commune called Edhi Village, run by the prominent social worker Abdus Sattar Edhi. Iron gates lock the inmates in, some of whom, stark naked, slam their heads against the walls of their dark cells. "Our center is becoming a dumping ground for people who consider mentally ill people as the dirt of society," says Ghazanfar Karim, the complex's overburdened supervisor. Karachi, Pakistan.

APRIL 20, 2003. ©JOHN STANMEYER/VII.

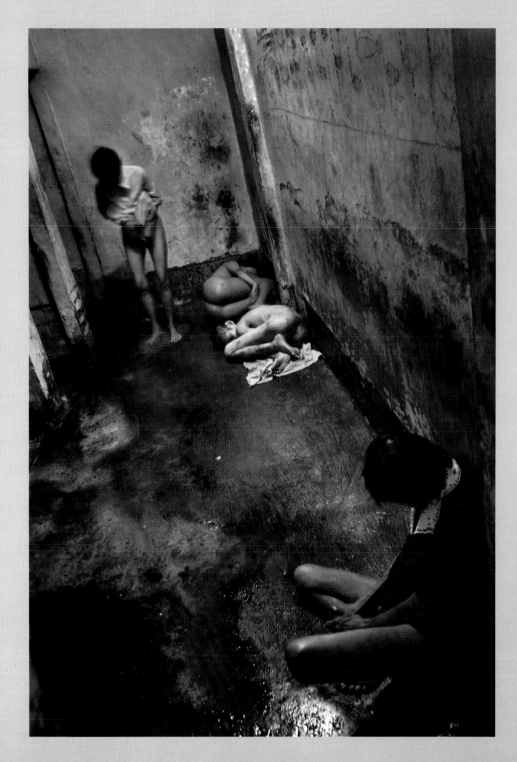

Daily life for over 300 women and men who live like animals—many of them chained to walls—at Panti Bina Laras Cipayung, a government-run center for the mentally ill and homeless located in east Jakarta. Mostly naked and given little medication, these men and women live their lives in dungeon-like conditions due to lack of government funding.

Since the 1997 Asian economic crisis hit Indonesia, funding for issues like mental health have deteriorated and due to inflation, funds available in 2003/2004 are less than what was available in 1997. The government-funded Cipayung center only has a budget of less than $1 per day to provide each patient with food and medicine.

The facility was only designed to hold 150 people, but due to the continuing economic problems facing Indonesia, many people on the streets can no longer cope and find themselves not only suffering from poverty, but also suffering mentally, part of the growing problem of mental health in Asia.

East Jakarta, Indonesia.

NOVEMBER 28, 2003. ©JOHN STANMEYER/VII.

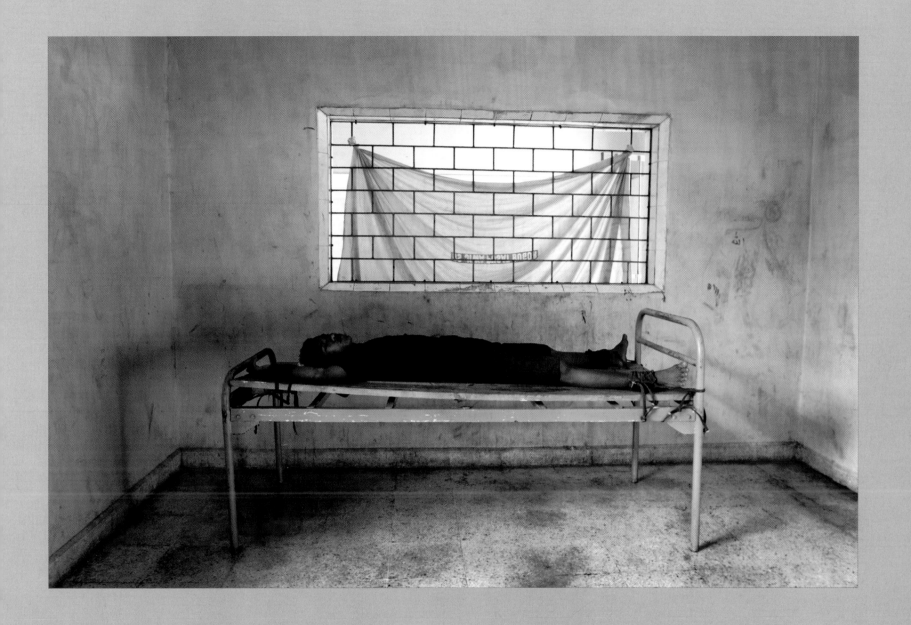

A man is tied to a bed to keep him from hurting himself and other inmates at the Dr. Marzoeki Mahdi Mental Hospital, built in 1882 during the Dutch Colonial era in Bogor, about 50 kilometers outside Jakarta, Indonesia. Over 457 patients reside at the hospital. Like all institutions in Indonesia, this mental hospital is terribly under funded, but does manage to provide care through NGO grants. Jakarta, Indonesia.

OCTOBER 28, 2003. ©JOHN STANMEYER/VII.

VIDA YOVANOVICH **in the shadow of time**

I was about to turn 40, photographing old women was something I had to do. Through the years it became a therapy, a kind of exorcism. It helped me face up to my fears, and put them into a more manageable perspective.

When I began photographing at the old age home, I felt like an intruder. I was an intruder, so I would take my time. I wanted them to become used to me, but only because I needed to become much more used to them. I am not afraid of death. I am afraid of the aging process toward death. At the beginning, each time I left the home, I would wash my hands with a terrible sense of contagion; I could not photograph, I could only feel. I think something happens to us by means of certain photographs; I try to understand life, my own life.

"This is a prison, why have they left us here?" one of my old women demanded to know, and I did not know what to answer. I then focused my attention on women in prison. Abandonment, solitude, the passing of time are recurrent subjects in my work.

My aim has been to photograph women. Women, who being imprisoned justly or not, in addition to serving their sentence, must also pay the price of their family's abandonment. I immerse myself into the surroundings, trying not to cause alarm. I listen to their testimonies and I become involved; I cannot help it.

Vida Yovanovich—Mexico City, Mexico.

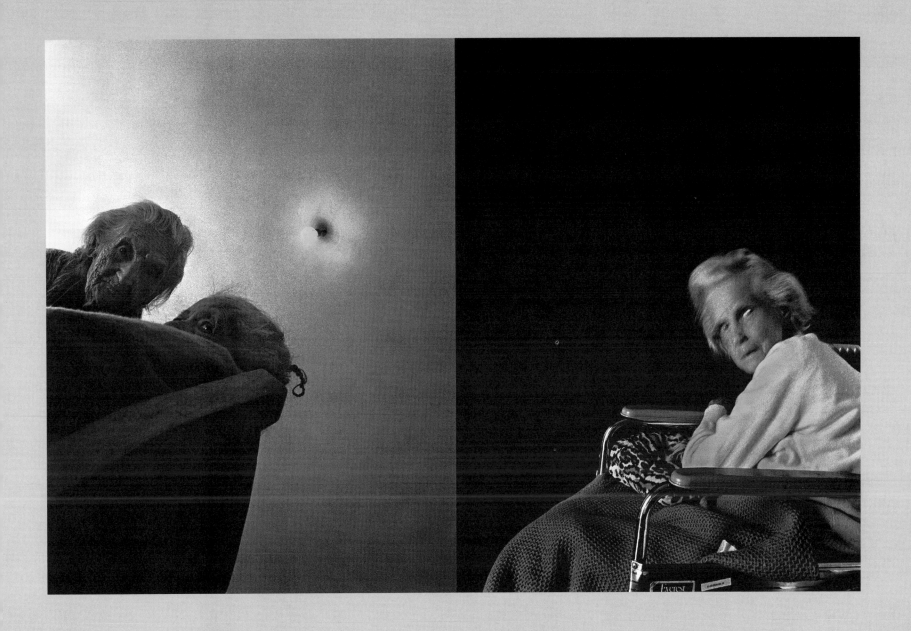

I became one of them, part of the place itself. It was hard at night. The women who during the day had been my friends, at night became my enemies, and in the dark, would scream at me to go away. Mexico City, Mexico.
© VIDA YOVANOVICH.

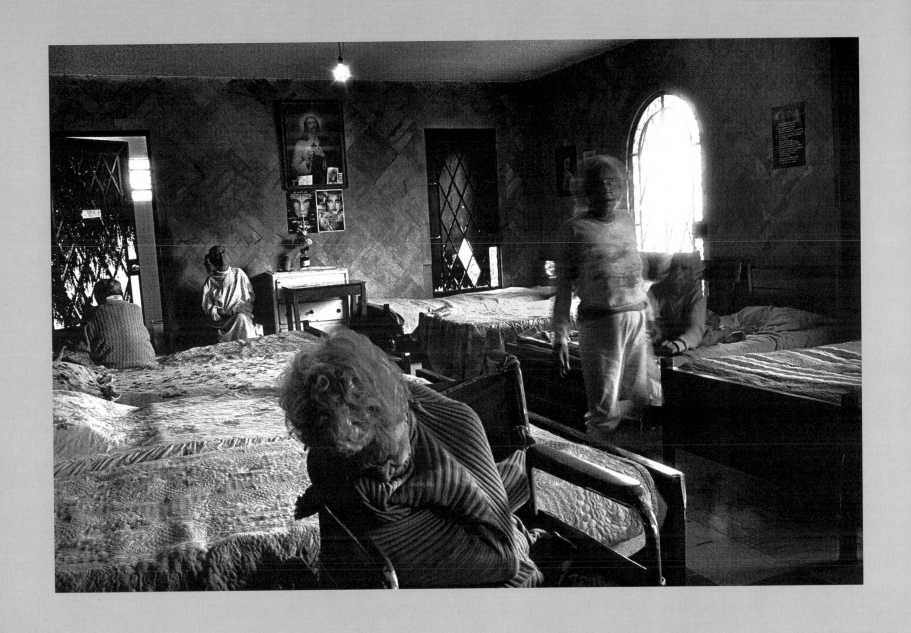

At first, whenever I left the home, I'd wash my hands with a terrible sense of contagion. I could not photograph, I could only feel. Mexico City, Mexico.

© Vida Yovanovich.

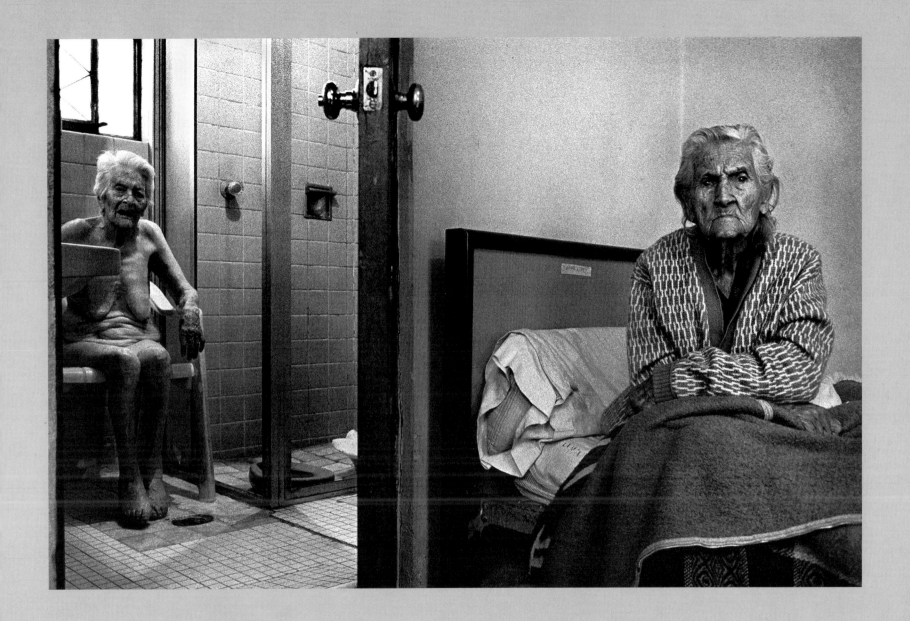

It was three years before I photographed a naked body; it was liberating for me, because as a woman, the sight of another woman's body wracked by time was awe-inspiring. It was a true examination of conscience. I became used to the decrepitude and lost my fear of it. Mexico City, Mexico.

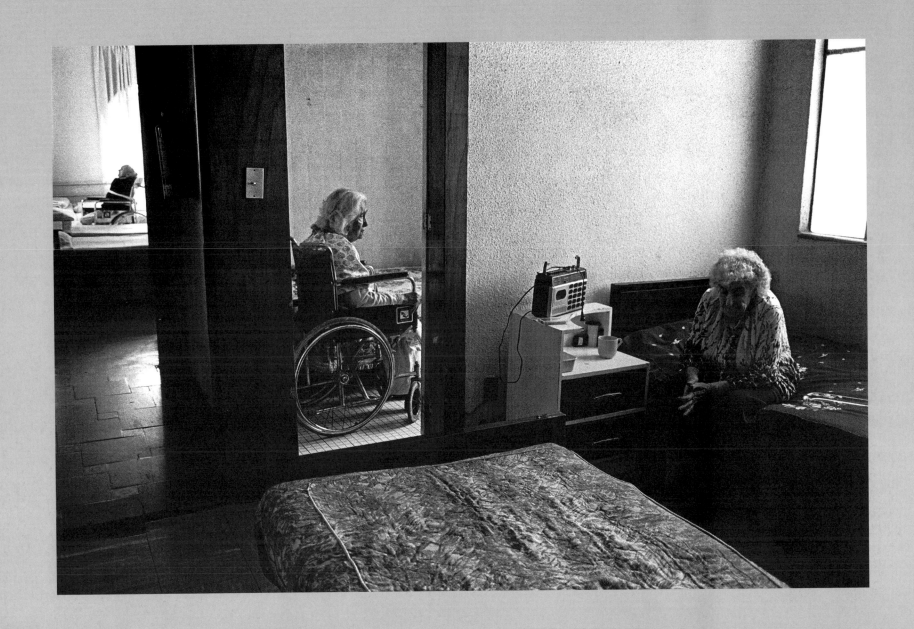

Most were women; there were only a handful of men because men die younger. Women are alone in the end, easily abandoned. Mexico City, Mexico.

© VIDA YOVANOVICH.

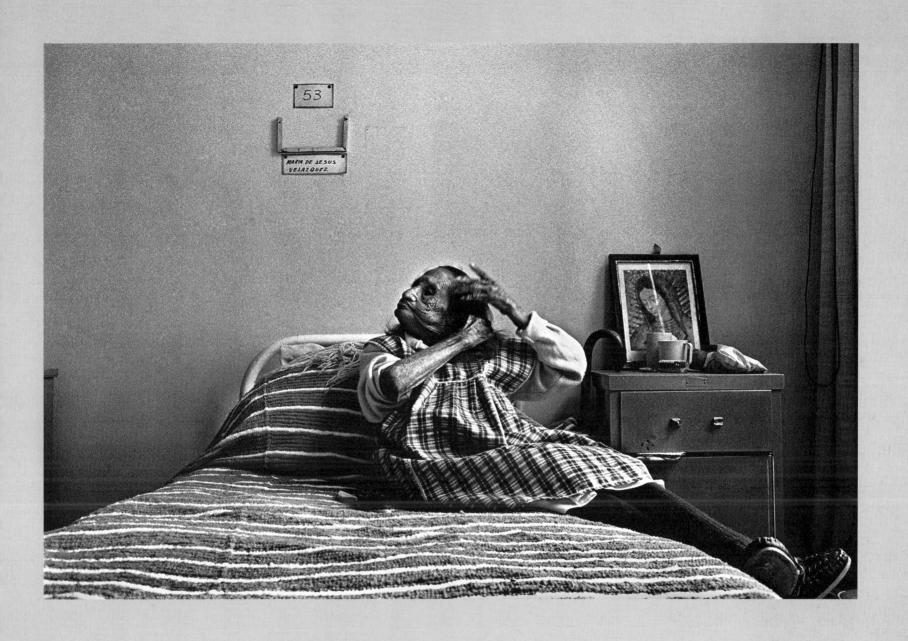

I think it is difficult to put what one feels into photographs, the things one goes through as one takes them, and at the same time it is impossible to forget, or become detached from the experience. Mexico City, Mexico.

© Vida Yovanovich.

ANDRES CARRASCO uninvited guests
ENCARNA MOZAS dream home

Katherine Slusher: Curator

I have always been interested in why people move from one place to another. I am an immigrant and have lived half of my life in another culture, speaking other languages and adapting to the differences. I have chosen to live outside my country of birth, one that was founded, grew, and flourished through successive waves of immigration. The 19th and early-20th-century immigrants in the United States consisted largely of people fleeing famine, poverty, and persecution. They came by the shiploads to Ellis Island. Most were hoping for a new start and a new life in another nation that offered more financial, political, social, or religious freedom than their native land. Many of them were unskilled workers but they knew they had a chance in the United States, and if they worked hard enough they could become prosperous.

It was their American Dream.

But I am a privileged immigrant. It was my choice to leave, to live my life elsewhere, and I didn't have to risk my life to come to another country. I packed two suitcases of the things that meant the most and carried them with me. I didn't disappear into the world and leave my family wondering what had become of me. I had job skills that were saleable and I was able to find work to support myself even though I didn't have working papers. I have never been stopped on the street to prove my identity or my right to be here because of the way I look. I easily assimilated into my new country.

For many others that is not the case. There has been a devastating displacement of people and lives in recent years. And even though it is sometimes by choice and

other times by chance, most often it is out of dire necessity. The causes are many: civil wars, collapsing governments, environmental/ecological disasters, extreme poverty, and ethnic persecution. There are masses of people flowing out of their own countries and into any other that will take them or that they can get to physically. It is not the "traditional" idea of immigrating; it is a desperate scramble to survive. There is no Ellis Island. Many are jailed or put into internment camps or live clandestinely in poverty, unrecognized and unwanted by their new country. These are the lucky ones.

The unlucky ones are those who have to cross bodies of water. They have to beg, borrow, and steal to put together enough money to pay the passage. Then they take to the seas and hope for good weather. Others literally put their lives into the hands of unscrupulous mercenaries and are often dumped out of the boats before they reach the coast, whether they can swim or not. Others make the journey in precarious rafts without sufficient food or water and if the currents take them to shore, they live. If they crash against rocks or continue to drift, they die. Most of the women are in the final months of pregnancy, with the misguided belief being that, if their child is born in the new country, they will legally be able to stay there. That is, if they are still alive.

In Spain, particularly once the weather warms up, every day or two there is a newspaper article, sometimes with a photo, of illegal immigrants from Africa and Morocco who made it to Spanish soil, either in the Canary Islands or along the southern coast. The number of people on any given day can range from 15 to well over a hundred. Sometimes the image shows them huddling in blankets, but just as frequently it shows them lined up on the beaches where they have been washed up, or their bodies have been laid out by the Coast Guard.

It is a sign of the times, of increased desperation, that rafts are now coming across in the middle of winter, so that not even the elements are on the side of the immigrants. In the first four months of 2005 close to 3,000 people were caught in rafts heading for Spain. At times there have been over 1,200 immigrants in the Detention Center in Fuerteventura, the Canary Island that geographically lies closest to the Moroccan coastline.

The desperation to get across the border is reaching catastrophic proportions. According to the European Union, as of October 2005 there were 30,000 Sub-Saharan African immigrants camped out on the borders of Algeria and Morocco trying to cross over onto Spanish soil. A number of them died attempting to cross the razor-edged fences in Melilla or from being abandoned by Moroccan authorities in the desert without sufficient water or food. In many cases, Spain is not the country of choice but merely a port of entry to Europe and so for the survivors, their odyssey has only just begun.

Katherine Slusher—Barcelona, Spain.

Katherine Slusher is an international curator of photography, Barcelona, Spain.

ANDRES CARRASCO uninvited guests

WHO PUT DOORS ON THE WORLD?

After more than a decade of shooting photographs of the drama of immigration, I don't see any difference between the first shot I took and the last one I made a few days ago. Everything's the same; it's as if no time has gone by. People continue to die, without any distinction between children, adults, the wounded, families, and orphans. . . .

The Strait of Gilbraltar, by contrast, divides two continents instead of uniting them. To photograph is to capture a piece of history. It is to look through a privileged eye and see the pain and the feelings. Those thoughts ran through my head one morning while capturing the moment in which numerous lifeless bodies were piled up along the shore of a beach on the Tarifan coastline. That day, the desolate souls who had crossed the waters of the Strait in search of a dream were devoured, trapped between two shores, two continents.

So it's inevitable that when I look through the viewfinder of a camera, I am hit by a wave of endless questions. . . . Why are there borders? Why can't each one of us live where we want to live, where it's best for us? Who has the right to prohibit the entrance of a person into a country? Definitively, who and why did they put doors on the world?

Andres Carrasco—Barcelona, Spain.

In one of the photographs in the exhibition, there is a woman whose tears silently run down her face until they hit the ground or disappear between her lips. She cried relentlessly because she had lost someone in her family, a brother I believe, who had fallen into the water. In her raft there had been close to 60 people along with her. What a price she paid for the trip!

How did they live in their countries of origin? How can desperation force a person to risk his or her life in this way? The goal is to live in a better world. A world with borders. If they didn't exist they wouldn't have to look for a different, better place, and they wouldn't risk their lives in such a desperate way. They shouldn't have to lose their lives in 14 kilometers. In a dark abysm. In the Strait.

From my humble place as a photojournalist, I would like my images to be used as a call to governments to stop locking up so many places in the world, which become scattered with the dead. The deaf voice of these images is a shout for equality, so that those who have made invisible barriers stop trying to separate different worlds, trying to hide a latent problem.

For a world without border limits.

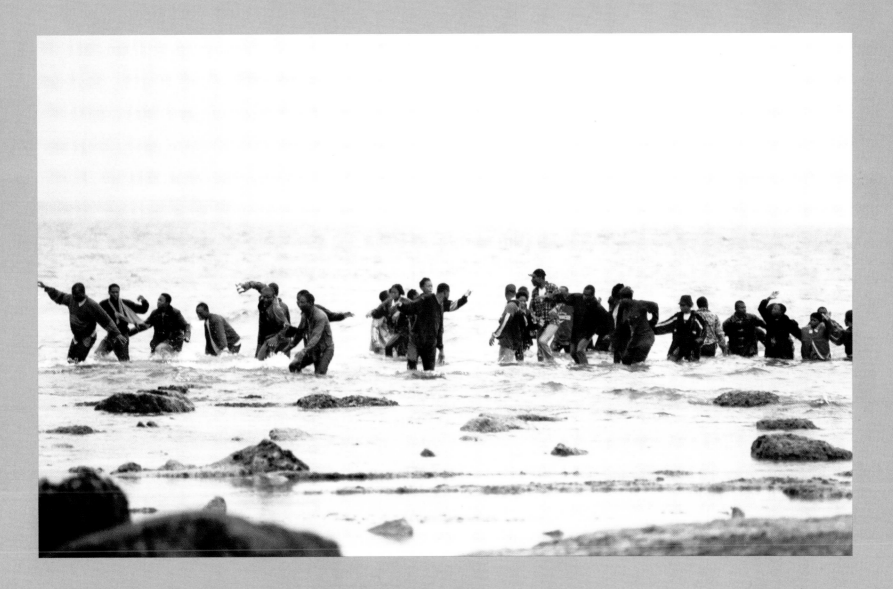

Landing, Paloma Point, Tarifa, Southern Spain.

The following photographs capture four moments in the landing of a small Zodiac inflatable boat at Paloma Point in Tarifa, southern Spain. Tarifa is the closest point to the African continent.

As the Africans neared the shore some of them began singing. Some sang joyously, others painfully. At one point I noticed four people left in the Zodiac boat. One, a woman, was pregnant and two of her fellow travelers were attempting to get her off the boat. Soon they were all scampering up the sand dunes in an attempt to reach the roadside.

Unfortunately, the immigration authorities soon captured the boat people. They offered no resistance because they knew they could not be repatriated as they refuse to reveal their country of origin. Only Moroccans are repatriated. The following day they were released with a notice (that they would ignore) stating they had to leave Spain within 15 days.

August 13, 2000. ©Andres Carrasco.

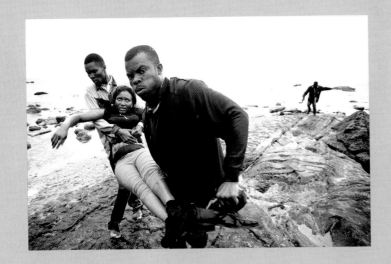

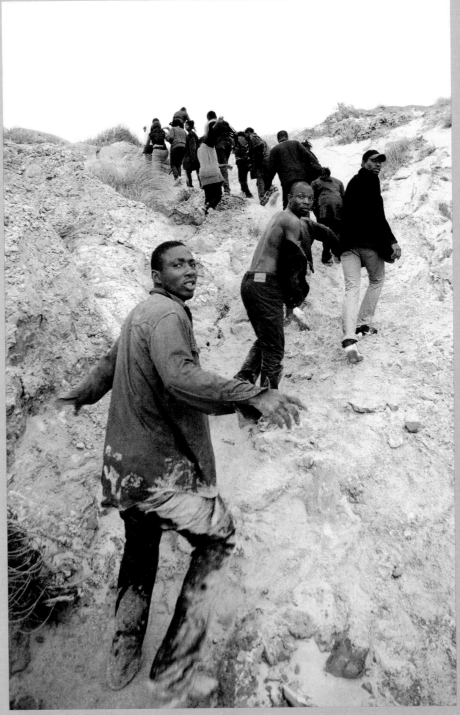

ABOVE: Rescued, Paloma Point, Tarifa, southern Spain.
RIGHT: The Escape, Paloma Point, Tarifa, southern Spain.
AUGUST 13, 2000. ©ANDRES CARRASCO.

The Escape, Paloma Point, Tarifa, southern Spain. AUGUST 13, 2000. ©ANDRES CARRASCO.

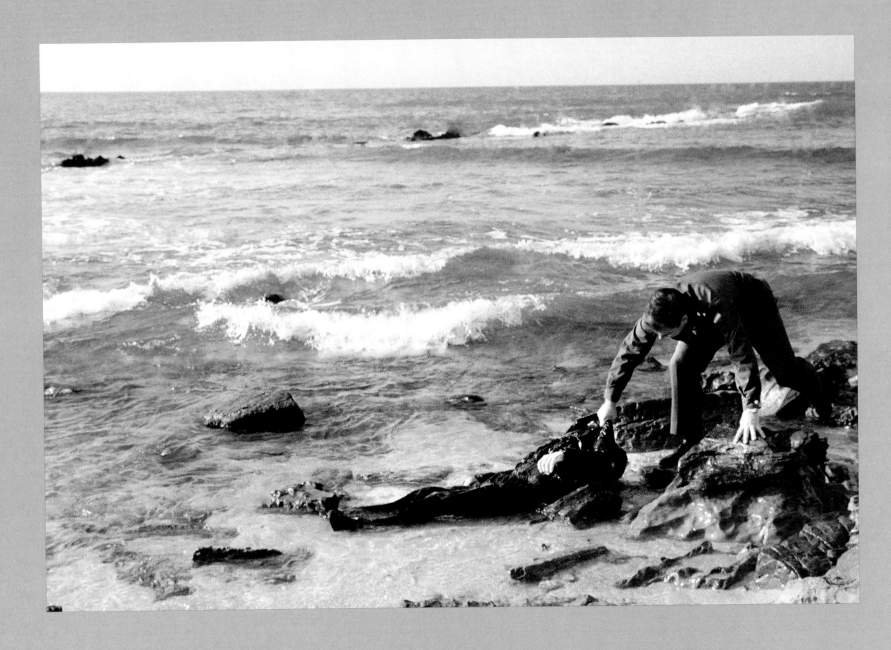

The Drowned. Bolonia Beach, Tarifa.

The following photographs were taken on Bolonia beach in the town of Tarifa. On this day 12 Moroccans drowned. These illegal immigrants attempt to make boat landings on beaches that are extremely rocky and dangerous. The area is un-approachable by car and this gives the Moroccans a better chance of not getting caught by the authorities. Unfortunately, their boat crashed on one of those very rocks that should have made their dangerous landing successful. Not knowing how to swim the Moroccans drowned. This had to be one of the most difficult days for me as a photographer.

MAY 2, 2001. ©ANDRES CARRASCO.

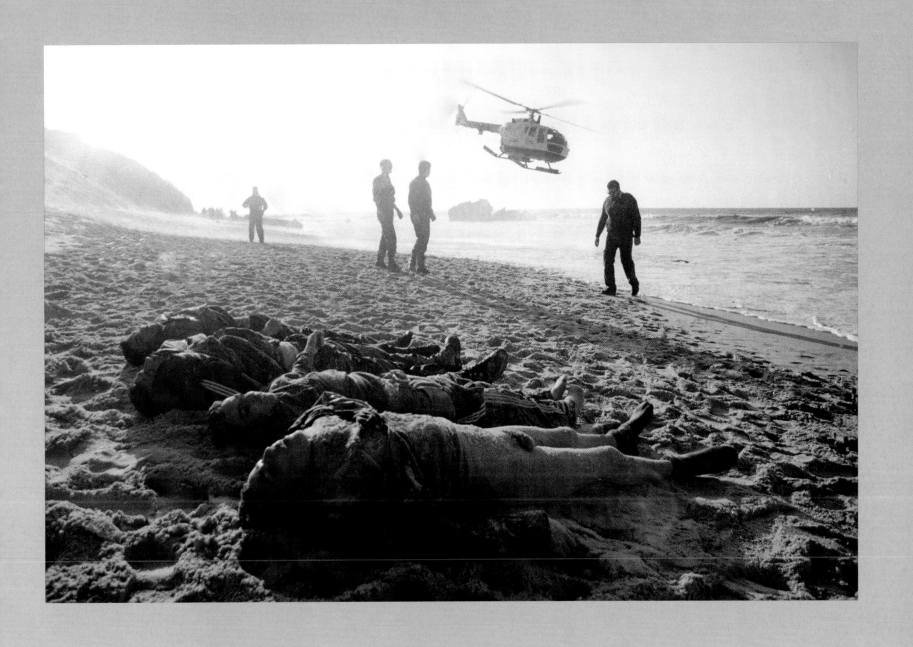

Journey's End. Bolonia Beach, Tarifa. MAY 2, 2001. ©ANDRES CARRASCO.

ENCARNA MOZAS **dream home**

BROKEN DREAMS

This photojournalism project was made with the support of a FotoPres '01 grant from the Fundación la Caixa in Barcelona, Spain. The photographs were taken in 2000 and 2001 in the town of El Ejido, located in the province of Almería, Spain, and in Khenifra, Morocco.

This project began as a result of the events that took place in El Ejido in February 2000, where an angry, raging battle began between Moroccan immigrants and the local residents. It lasted around a week, observed by thousands of policemen on every type of transportation imaginable. They were not authorized by the government to break up the fighting and the demonstrations. Instead, they dodged rocks thrown by both sides in the conflict and watched as farms were burned. As a result of this conflict and the ensuing media coverage, the citizens of El Ejido were labelled as racist and the Arab workers were labelled *los sin papeles*, those without legal papers to work.

I established a friendship with a group of Moroccan immigrants in El Ejido. Mohamed and his friends allowed me into their dwellings in El Ejido and I documented the conditions in which they lived as they shared their friends, their belongings, and their dreams with me. Most poignantly, they also shared what they left behind in Khenifra when they embarked on a dream that was never to happen.

Encarna Mozas—Barcelona, Spain.

Family home, Khenifra, Morocco.
2001. ©Encarna Mozas.

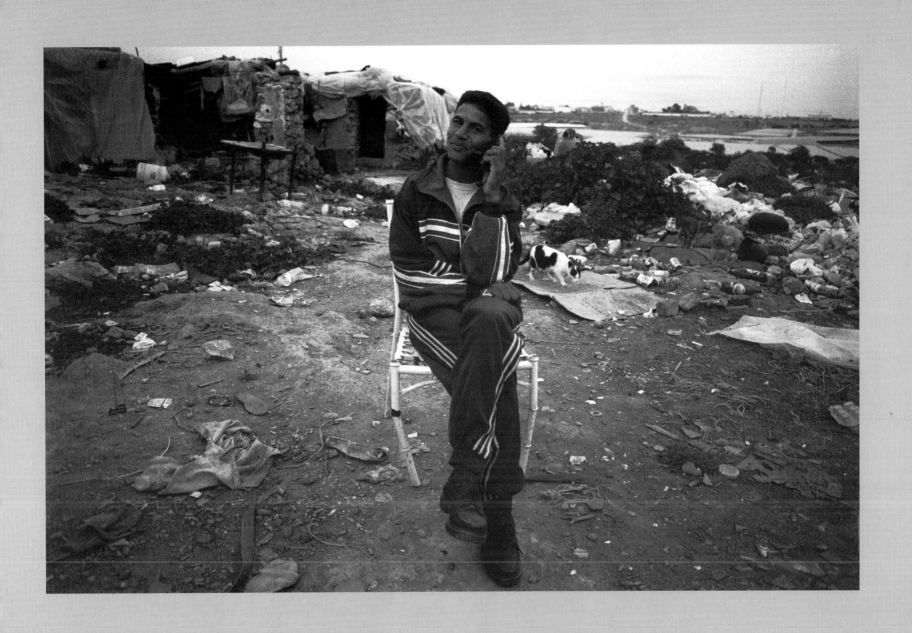

Moroccan Immigrants to Spain, El Ejido, Almería, Spain. 2000. © Encarna Mozas.

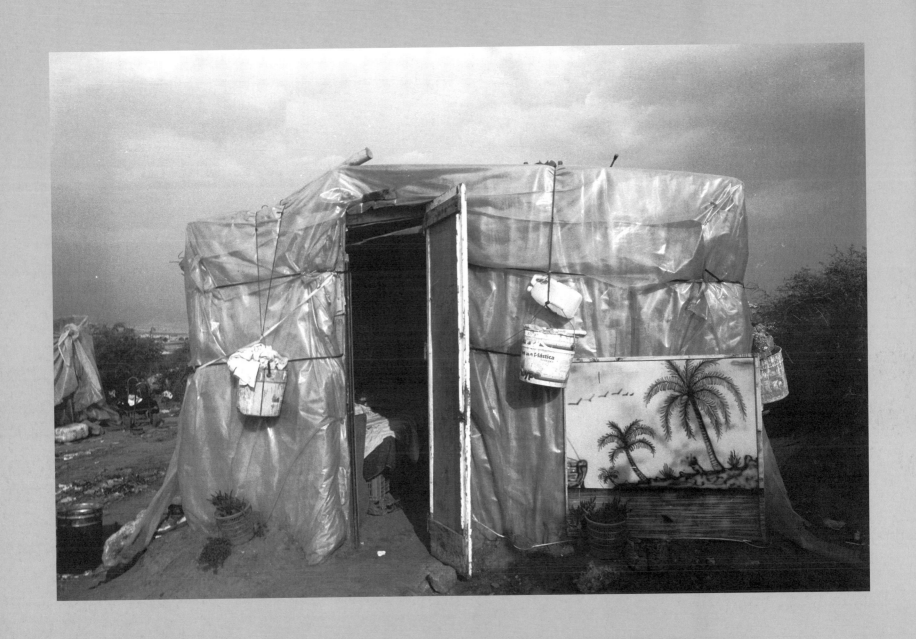

Moroccan Immigrants to Spain, El Ejido, Almería, Spain. 2000. © Encarna Mozas.

Moroccan Immigrants to Spain, El Ejido, Almería, Spain. 2000. © ENCARNA MOZAS.

Moroccan Immigrants to Spain, El Ejido, Almería, Spain. 2000. © Encarna Mozas.

Moroccan Immigrants to Spain, El Ejido, Almería, Spain.
2000. ©Encarna Mozas.

VISITED LAST SUNDAY. IT WAS THE HEART OF DARKNESS jay murphy

"Visited last Sunday. It was the heart of darkness."[1]

Before any talk of the "disaster" or "catastrophe president" there was a series of emergencies. At some point in that series it became a dim continuum—"trouble every day." The malaise is visible, even if often there are not words for it. Novelist Francine Prose illustrates it this way: comparing her and her friends' alarmed and daily email chatter to sound engineers sharing notes on strange, squealing engine noises as the plane crashes to the ground. A friend tells of her brother watching the news on Mexican TV, which freely shows the men, women, and children of Fallujah stacked like cordwood. For domestic consumption, even American flag-draped coffins have been hidden from view; and as for civilian Iraqis, you have to go count the dead yourself. The English journalist Robert Fisk, did just that, finding 26 dead by midday in just one mortuary, and discovered official figures giving a total of 1,100 violent deaths for the month of July in Baghdad alone.[2] It's one of the running threads or questions of this composite exhibition, with its title that echoes ancient biblical injunctions of caring for one's neighbor—when do images matter? When do people matter? When are we dispensable? And how do we become indispensable?

* * *

Susan Sontag, who left us last year, was forced to revise her earlier assumption that people simply become inured to photographic depictions of atrocity and war and disaster. Rather, "there are pictures whose power does not abate, in part because one cannot look at them often," they remain "the indelible sample."[3] This is true even when they present horror in an inevitable chain-link—the 1992 Serbian death camp in Omarska, Bosnia, resembling nothing so much as the 1945 Nazi death camps, or the piles of skulls in mass graves in Lebanon, Cambodia, Bosnia, El Salvador, Guatemala, or Afghanistan and Iraq where the bones eventually become indecipherable in a *le rond* of extermination. Sontag felt the unphotographed atrocities were bound to remain more remote, memories more difficult to claim and

care for, although we still know they happened. But even given the constant stream of images on the worldwide web, relaying suffering and combat from the farthest points of the globe, the "global citizen" prophecies of cyberspace haven't aged so well. With the rapid-fire chain-link of incident comes the danger of getting lost in the interval. This even applies to those one would think it inapplicable: A Palestinian writer in East Jerusalem whose family has lived there since the fourth century, battered by permits and permissions coming and going, in a surround of strife, still feels the peculiar disconnect or disabling of the media. Typing away in a loft off New Gate in the Old City, the incident or atrocity is there on the screen, and then it's gone, replaced by a more palatable tragedy, or fun and games—"Is a 3-D King Kong in the Works?": "Kirstie Alley no longer a fat actress." As columnist Bob Herbert put it after more of the revelations about secret CIA-run gulags, "black sites" often using the actual compounds in Eastern Europe of the Soviet predecessors, "Worse stories are still to come. . . . We'll watch them unfold the way people watch the aftermath of terrible accidents."[4]

We are continually stunned. The cloak on images that often cover the worst in Iraq, has been broken sporadically by the handicam parade of Abu Ghraib, which Sontag suggested was itself a sort of symptom of digital desensitization,[5] and Gabriele Zampirini's documentary for Italian television on the use of white phosphorus and other chemical agents on the population of Fallujah, so graphic many found it difficult to watch.[6] Quite in contrast, the floods that ravaged New Orleans, one of America's oldest and most culturally prized cities, that truly a one-of-a-kind metropolis, were accompanied by a flood of imagery that found it incapable of concealing the worst. There were some whites, to be sure, like the man who gamely swam across Lake Ponchartrain to find a highway out, but most of the faces calling for help on rooftops, or floating facedown in the tidewaters, were unmistakably black. That "other America" that decades ago had once inspired a massive government intervention called a "war on poverty" was unmistakably revealed, still in place, in full

force, unleashed in our midst. And the official response showed the chaos and instability prescribed for the Middle East—the World Bank in 1995 called for a "shakedown period" in the region preparatory to "democracy"—a stance reaffirmed by Secretary of State Condoleezza Rice in the spring of '05 during the warm-up to the "elections" in Egypt, when she advised that a little chaos is a salutary thing, is a feature of domestic life as well. The outside and inside of the American "empire" have become a moebius strip, so to speak. Now America is becoming the site of the same rumblings as Iraqi street talk, that Americans can't be "*that* incompetent," or the conspiratorial conjuring of what the Haitians, recently counseled by Rice concerning who they could and could not elect, term the "plan Amerikan."

Eerily reminiscent of the Iraq adventure, now already in year four, the accusations of irresponsibility in the fiasco of disaster management that followed Hurricane Katrina, of what did they know and when did they know it, centered around "incompetence." There was incompetence, that is incontrovertible, but it was often a result of policy. Not only had the Federal Emergency Management Agency (FEMA) been downsized, removed from cabinet status, and three-quarters of its budget devoted to flood, storm, and natural disaster protection reallocated to counter-terrorism schemes, but director Michael Brown's last day job was as head of the International Arabian Horses Association, a post he left under a cloud. FEMA's previous director under President Bush, Joseph Albaugh, characterized disaster assistance as "an oversized entitlement program."[7] Those who supported, in President of Americans for Tax Reform Grover Norquist's phrase, drowning the government like a "baby in the bathtub" were responsible this time for some real drowning.

> We found all the food that we could and we cooked and we fed people. But then, things started getting really bad.
>
> By the second day, the people that were there, that we were feeding and everything, we had no more food and no water. We had nothing,

and other people were coming in our neighborhood. We were watching the helicopters going across the bridge and airlift other people out, but they would hover over us and tell us "Hi!" and that would be all. They wouldn't drop us any food or any water, or nothing. . . .

And I want people to realize that we did not stay in the city so we could steal and loot and commit crimes. A lot of those young men lost their minds because the helicopters would fly over us and they wouldn't stop. We would make SOS on the flashlights, we'd do everything, and it really did come to a point, where these young men were so frustrated that they did start shooting. They weren't trying to hit the helicopters, they figured maybe they weren't seeing. Maybe if they hear this gunfire they will stop then. But that didn't help us. Nothing like that helped us.[8]

With Hurricane Katrina, as with Operation Iraqi Freedom, we need to look at what Middle East scholar Mark LeVine calls the "three circles" of incompetence. There is a circle, indeed, of sheer stupidity and ignorance (Richard Perle's essays on the Arab world that could in no way pass any Arab History 101), but it is surrounded and carried by circles of military and corporate suasion where the "incompetence" left in their wake is more to a point, more of what LeVine terms "sponsored chaos," or what Colgate University Professor Nancy Mies, referring to the Iraqi occupation, calls "planned chaos." In the wake of the "shock therapy" globalization initiatives often driven by the U.S. abroad, there is a new international vocabulary for it. In Kazakhstan and many of the republics of the former Soviet Union, it's *bardok*. The Palestinians call it *fawda*. Italians visiting or working in these lands speak of it in the specialized phrase or sense of *è un casinoi*, where anyone or anything is for sale, usually with direct reference to the brothels and sexual trafficking "globalization" that has vastly expanded wherever it has gone, including now into pious Shiite Iraq.[9] It is the fearsome maelstrom of what in more polite company is commonly called "privatization."

In the refugee camp I just left, on the I-10 freeway near Causeway, thousands of people (at least 90% black and poor) stood and squatted in mud and trash behind metal barricades, under an unforgiving sun, with heavily armed soldiers standing guard over them. When a bus would come through, it would stop at a random spot, state police would open a gap in one of the barricades, and people would rush for the bus, with no information given about where the bus was going. Once inside (we were told) evacuees would be told where the bus was taking them—Baton Rouge, Houston, Arkansas, Dallas, or other locations. I was told that if you boarded a bus bound for Arkansas (for example), even people with family and a place to stay in Baton Rouge would not be allowed to get out of the bus as it passed through Baton Rouge. You had no choice but to go to the shelter in Arkansas. If you had people willing to come to New Orleans to pick you up, they could not come within 17 miles of the camp.[10]

Such chaos can be lethal for those who cannot climb into their SUVs or helicopters to move on to their other address, who are condemned to the frightening disorder of the convention center, or trapped in makeshift camps surrounded by soldiers who treat them as the enemy. This terrible juggernaut was present before, but Katrina revealed it in all its inane glory. It even moved Senator John Kerry to characterize the Gulf Coast reconstruction plans as an attempt to turn "the region into a vast laboratory for right-wing ideological experiments."[11] Before FEMA had anyone on the scene, Joseph Albaugh and other hucksters were already getting contracts signed for Halliburton, the Blackwater mercenaries, the Shaw Group, and like leagues, to visit upon New Orleans the neocon utopia that had formerly been the Coalition Provisional Authority's *mission de civilisation* in Baghdad. The "incompetence" was so striking that it is confusing to figure which of the three circles to consign it to. House speaker Dennis Hastert's exclamation that nature had finally bulldozed the Ninth Ward, what policies had failed to do, at least had the virtue of honesty.

Columnist David Brooks of *The New York Times* proposed to scatter the denizens of the city across the country, "to integrate people who lack middle-class skills into neighborhoods with people who possess these skills and who insist on certain standards of behavior." While the black and poor are to be "culturally integrated," Brooks urged the white middle class to move back into the center city they had generally fled decades earlier, "even knowing that their blocks will include a certain number of poor people."[12] Brooks provokes what theorist Avital Ronell has called "traumatic stupidity,"[13] but the stupidity or stupor here is not so much Brooks's (whose characterization of New Orleans's poor as a "blank slate" smacked of a leaf from Chairman Mao's playbook), as blind, cloistered (and contradictory, for one who decries "grandiose . . . failed" social initiatives, the stereotyped "social engineering" of the '60s like the "war on poverty") as he appears to be, as it is ours, that such a breathtaking column could appear in a mainstream, "newspaper of record" American newspaper. Brooks was far from alone in heralding Hurricane Katrina's act of ethnic cleansing: effective population transfer as an answer to the disorders of economic and racial apartheid.

> Just restored email capabilities after two weeks. Went into Jeff Parish last week, and it is a total war zone: military copters overhead, checkpoints, curfews. We'd go to [the] civic center to get daily ration of ice, H2O and MREs. This is the kinda stuff that Clash-Jam-Pistols sang about, but it's real.[14]

In our "staying with the stupor of unaccountable excess and regressive brutality"[15] it is difficult for us to see which catastrophe gives rise to the "emergency state" and which is provoked by it. Yet it is certainly the "crisis state" or "state of exception" that steps in to cast a military solution for each calamity, whether it be the avian flu or a category 4 hurricane. The president professed to have no knowledge that the Louisiana levees could break although it had been a topic of discussion for many decades and named a number one priority/possibility by his own federal disaster

agencies, even as the ongoing construction on them was radically de-funded (hurricane prevention projects around Lake Pontchartrain were slashed by 79 percent in the year 2005 alone; flood prevention projects were cut 53 percent). He was quick, however, to call for a curfew and "zero tolerance" for looters, which the rest of the nation who watched television (the president claims his main source of "news" is his own court) could see were desperately scavenging for food and supplies. The BBC would later show the Afghan and Iraq veterans ramming down doors for the New Orleans stay-at-homes not too differently than they had weeks previously in Ramadi or Najaf. Increasingly any social symptom or emergency reveals this frightening degeneration of "public governance" or "public interest" into naked force and obsession with control. It is not a question of the foibles or "incompetence" of one American administration, however odious it may seem. At the time of this writing the governments of Argentina and France alike are using the police to suppress exploding social and political discontent expressed in day after day of rioting.[16] It could well illustrate a more generalized crisis of governance, as in the argument of Italian philosopher Giorgio Agamben, who maintains the "camp" has replaced the city-state as the paradigm of our politics.[17]

Agamben is continuing the explorations in the late work of philosopher Michel Foucault, where he examined the meaning of "biopower," the need, as he saw it, for contemporary regimes to exercise control over hitherto unimaginable realms of life and death.[18] For Foucault the transition from the ancien régime to more modern capitalist forms of power involved inducing "disciplinary" regimes, especially regarding the body and the biological. The transition from those "disciplinary" states (associated by Foucault with his analysis of "confinement" in the 18th and 19th centuries through the beginning of the 20th) to our contemporary "societies of control," signal forms of domestication operating not from the conventional "outside" but rather from "inside" the body politic, constituting it in fact, and completely cutting across social relations of all sorts, making previous forms of control look static and partial,

with simpler relations of opposition. Foucault wrote, "Life has now become . . . an object of power."[19] If the origin of Western politics and metaphysics demanded a separation of "natural" or "bare life" from properly political existence, the modern era seamlessly melded them. As Foucault explained, "For millennia, man remained what he was for Aristotle: a living animal with the additional capacity for political existence; modern man is an animal whose politics calls his existence as a living being into question."[20]

One reason for the continuing fascination with the regime of Nazi Germany has to be due to its eminently biopolitical nature. As modern and contemporary politics bring about a "symbiosis" with "bare" or "natural life" (hence the critical debates on euthanasia, abortion, cloning, Terry Schiavo, the death penalty, torture) the classical modes of understanding politics lose their relevancy. As Agamben puts it so succinctly, "Only because politics in our age had been entirely transformed into biopolitics was it possible for politics to be constituted as totalitarian politics to a degree hitherto unknown."[21] Although for many theorists this history creates a clear dividing line between "liberal democracies" on the one hand and the "totalitarian" states on the other, for Agamben it is the basis for their "contiguity." He argues:

> only because biological life and its needs had become the politically decisive fact is it possible to understand the otherwise incomprehensible rapidity with which twentieth century parliamentary democracies were able to turn into totalitarian states and with which this century's totalitarian states were able to be converted, almost without interruption, into parliamentary democracies. In both cases, the transformations were produced in a context in which for some time politics had already turned into biopolitics, and in which the only real question to be decided was which form of organization would be best suited to the task of assuring the care, control, and use of bare life.[22]

Nazi Germany remains exemplary here, since for Agamben in this instance the difference between the terms police and politics disappears, and "the care of life coincides with the fight against the enemy."[23] It is here one can find the "full sense" of the attempted extermination of the Jewish people—that police and politics, eugenics and ideology, health, and complete defeat of the foe—are all calls and missions that merge indistinguishably.

> In a sort of cliché way, this is an edifying experience. One is rapidly focused away from the transient and material to the bare necessities of life. It has been challenging to me to learn how to be a primary care physician. We are under martial law so return to our homes is impossible. I don't know how long it will be and this is my greatest fear.[24]

Perhaps that's why the Nazi experience is still so stubbornly resistant to our understanding,[25] it is even now too close to us, and our threatening, booming, ever more complex biopolitical field. What Agamben calls the "zone of indistinction" between politics and "bare life" is precisely that no-man's land where the "state of exception" comes into play and finds its role: think Guantanamo Bay detentions; "secret renditions"; the suspension of habeas corpus, the 1679 writ often heralded as the basis for modern democratic rights; open, governmental defense of torture; dismissal of the Geneva Conventions, instituted, lest we forget, as an international response to Nazi crimes, as "quaint." The San Francisco poet Kevin Killian riffed on these lawless liminal spaces as exemplified by the airport duty-free shop, but he did so in the late last century before they so frightfully accelerated and careened past the powers of satire. The sight of "bare life" crosses a zone of life and death and is often incommensurable for that reason: the poignantly moving sight, by all accounts, of Guantanamo hunger strikers in the tropical sun; Ninth Warders waving for aid; or "Chechen war victims"; "Afghani refugees"; the human stuff deformed by Agent Orange. Sometimes it is in the simplicity that they exist: Ethiopian Jewry; a *guajiro* in Cuba. Indelible evidence. It appears linked to Agamben's claim for "the refugee" as "perhaps the only thinkable figure for the people of our time and the only category in which one may see today . . . the forms and limits of a coming political community."[26] It was an extremely prescient moment in the thinking of political theorist Hannah Arendt, Agamben reminds us, when she wrote of how the "refugees driven from country to country represent the vanguard of their peoples."[27] Refugees have often lost all possession and relation except their simple status as human. Simply human: impossible to integrate in the old order, receding from us at lightening speed.

* * *

This essay was written on November 2, 2005, the 40th anniversary of the martyrdom of Norman Morrison. Although, according to many, consciousness of the Vietnam war in America in 1965 was still very limited, a marked escalation was in progress, and news stories were already reporting U.S. napalm raids in "the land of the burning children." Morrison, a longtime Quaker activist, on the day of his action, sitting on a wooden stool, had calmly asked his wife during lunch "What more can we do?" Later that afternoon, Morrison sat down cross-legged at the Pentagon, and, releasing his daughter Emily at the last moment, set himself on fire. He was almost directly under the front window of Secretary of Defense Robert McNamara. The next day his wife received in the mail Morrison's goodbye note:

> Dearest Anne,
>
> Please don't condemn me. . . . For weeks, even months, I have been praying only that I be shown what I must do. This morning with no warning I was shown, as clearly as I was shown that Friday night in August 1955 that you would be my wife . . . at least I shall not plan to go without my child, as Abraham did. Know that I love thee but must act for the children in the priest's village.
>
> —Norman

A November 1 newspaper article titled "A Priest Tells How Our Bombers Razed His Church and Killed His People" had moved Morrison. That year nearly another dozen Americans followed his example, and of the Buddhist monks in Vietnam who had earlier protested the Diem regime with their flaming bodies.

In an era where the "state of exception" wields such seemingly absolute power, from monopoly of weapons of mass destruction, dramatized especially by the nuclear option, to the shaping of society and media apparently detached from any accountability or responsibility, it can be forgotten that even such power needs its subjects. Morrison's extreme suicidal gesture robbed the American state of its power over life and death, asserting the autonomy of the body through its freely chosen destruction. In that, it shares a continuum with its opposite polarity of the suicide bomber.[28] Even if it has an ancient pedigree (Israeli sociologist Baruch Kimmerling describes the story of Samson pulling down the temple as a similar impulse), this similarly extreme move appears the new weapon of choice from Sri Lanka to Palestine, from Chechnya to New York, Barcelona, and London. Often a response to a hopeless asymmetry in military power, the suicide bomber likewise through terrorist sacrifice eliminates the state's absolute decision it has claimed over death.

Yet there is another martyrdom option, tantalizingly raised but not really delineated in the grand synthetic work of Michael Hardt and Antonio Negri's *Multitude*, and that is "the republican martyr . . . from the heroes of Plutarch to Martin Luther," the martyr "as a kind of testimony—testimony not so much to the injustices of power but to the possibility of a new world, an alternative not only to that specific destructive power but to every such power."[29] In this tentative, the martyr is indeed struck down by the "violence of the powerful," but that is not his or her project. It would be absurd to seek such a fate, rather it is "only a by-product of real political action and the reactions of sovereignty against it."[30] We realize that acting in concert, realizing the commons, in this most gregarious and compulsively communicating of societies, is often a crime. It is tempting to see the recent reconsideration of a figure like John Brown carried out in David S. Reynolds's study,[31] quite apart from the portraits of the "fanatic" we are used to in Stephen B. Oates, Robert Boyer, or even Russell Banks, as an attempt to rethink or reimagine such martyrdom. Hardt and Negri evoke the specter of Lysistrata and the "biopolitical strike," claiming "A one-week biopolitical strike would block any war."[32] There are numerous ways to jam the gears, beyond the older dialectics of nonviolence and violence. As activist Mario Savo exclaimed at the beginning of another era of often complete and unavoidable risk over 40 years ago, we must invent new ways and means of throwing "your bodies upon the gears and upon the wheels, upon the levers, upon all the apparatus. . . . And you've got to indicate to the people who run it, to the people who own it, that unless you're free, the machine will be prevented from working at all!" In short, there are plentiful ways to become indispensable.

Jay Murphy—November, 2005.

Jay Murphy resides in New York City, USA and is Director and Founder of the internet site Soul City (http://www.thing.net/~soulcity/top.html).

NOTES

1 Caroline Senter: Personal communication. September 22, 2005.

2 Robert Fisk, "War is the Total Failure of the Human Spirit," www.democracynow.org/article.pl?sid=05/10/20/1411211&mode=thread&tid=25.

3 Susan Sontag, *Regarding the Pain of Others* (New York: Farrar, Straus, & Giroux, 2003), pp. 83-84.

4 Bob Herbert, "Secrets and Shame," *The New York Times*, November 3, 2005, p. A27.

5 Susan Sontag, "Abu Ghraib Is Us," *The New York Times Magazine*, May 24, 2004.

6 Zampirini's documentary *La strage nascosta* (The hidden massacre) can be found at www.rainews24.rai.it/ran24/inchiesta/body.asp. The French newscast, Le Journal, reported that the film has been banned from the U.S. news media.

7 Mike Davis, "The Predators of New Orleans," October 25, 2005, *Le Monde Diplomatique*, (English version) http://mondediplo.com/2005/10/02Katrina.

8 Charmaine Neville, "How We Survived the Flood," September 7, 2005, www.counterpunch.org.

9 See Mark LeVine, "Where Chaos is King," October 25, 2005,www.tomdispatch.com/index.mhtml?emx=x&pid=30881; also LeVine's 2004 column "Whose Chaos Is This Anyway?", www.tomdispatch.com/index.mhtml?pid=1396 and his "Echoes of Oslo," *In These Times*, September 19, 2005.

10 Jordan Flaherty, "Notes from Inside New Orleans," September 2, 2005. Retrieved from worldwide web.

11 John Kerry's September 19, 2005, speech can be found at www.johnkerry.com/pressroom/speeches/spc_2005_09_19.html.

12 David Brooks, "Katrina's Silver Lining," *The New York Times*, September 8, 2005, A29.

13 Avital Ronell, *The Test Drive* (Urbana: University of Illinois Press, 2005) p. 108.

14 David Rivé: Personal communication. September 14, 2005.

15 Ronell, ibid.

16 For France, see "9 Nights of Rage." www.truthout.org/docs_2005/110505Y.shtml.The disturbances continued for over 13 days. In Argentina at Mar del Plata demonstrators trashed shops, fought with police, and burned a bank in protest of the neoliberal policies promulgated at the Summit of the Americas conference, where Bush administration attempts to win Latin America over to its version of "free trade" largely collapsed.

17 Agamben develops this line of thought in a projected four-volume series, of which three have been published: *Homo Sacer*. Trans. Daniel Heller-Roazen. Stanford: Stanford University Press, 1998; *Remnants of Auschwitz*. Trans. Daniel Heller-Roazen. New York: Zone Books, 1999; *State of Exception*. Trans. Kevin Attel. Chicago: University of Chicago Press, 2005. A collection of his political essays is *Means Without End: Notes on Politics*. Trans. Vincenzo Binetti and Cesare Cesarino. Minneapolis/London: University of Minnesota Press, 2000. A well-taken critique of Agamben is Malcolm Bull's "States don't really mind their citizens dying (provided they don't do it all at once): they just don't like anyone else to kill them," *London Review of Books* (December 16, 2004): 3-6.

18 Foucault broached some of these issues in volume one of his *The History of Sexuality*, (Trans. Robert Hurley. New York: Vintage, 1978), as well as *Power/Knowledge*. Ed. Colin Gordon (New York: Pantheon, 1980). Yet the notion of "biopower" was rarely developed explicitly as far by him as by Agamben, Gilles Deleuze and Felix Guattari, Michael Hardt, and Antonio Negri, to cite only the better known examples.

19 Michel Foucault. "Les mailles du pouvoir," *Dits et ecrits*. Vol. 4. Paris: Gallimard, 1994, p. 194. An analysis of the transition from disciplinary to control societies is provided in Gilles Deleuze's "Postscript on Control Societies," in *Negotiations*. Trans. Martin Joughin. New York: Columbia University Press, 1995.

20 Foucault. *The History of Sexuality*, p. 188.

21 Agamben, *Homo Sacer*, p. 120.

22 Ibid., p. 122.

23 Ibid., p. 147.

24 Greg Henderson, "Letter from New Orleans," September 1, 2005. Retrieved from worldwide web.

25 One thinks of Jacques Derrida's caution that we know what we are referring to when we say "Nazism," or Jean-Luc Nancy's alluding to its "revolutionary" nature—"I know that Fascism and Nazism were also revolutions; as were Leninism and Stalinism. It is therefore a question of revolutionizing revolutions." Jean-Luc Nancy, *The Experience of Freedom*. Trans. Bridget McDonald. (Stanford: Stanford University Press, 1993), p. 164.

26 Agamben, *Means Without End*, p. 16.

27 Arendt, quoted ibid.

28 However offensive to both parties, there is a strong common relationship in terms of spectacle and representational politics, between pacifist civil disobedience and forms of terrorist action. See the analysis in Michael Hardt and Antonio Negri, *Labor of Dionysus* (Minneapolis/London: University of Minnesota Press, 1994).

29 Michael Hardt and Antonio Negri, *Multitude* (New York: Penguin Books, 2004), p. 346.

30 Ibid. p. 347. Hardt and Negri delight in limning the eccentric figure of resistance. In their earlier *Empire* they discuss St. Francis of Assisi in practically the same breath with the Wobblies as an ideal "militant . . . in opposition to nascent capitalism." See *Empire* (Cambridge/London: Harvard University Press, 2000), p. 413.

31 David S. Reynolds, *John Brown, Abolitionist* (New York: Knopf, 2005).

32 Hardt and Negri, *Multitude*, p. 347.

LATIN AMERICA AT THE DAWN OF THE 21ST CENTURY richard gott

Political explosions of popular unrest have been taking place all over in the Andes in recent years, almost on a monthly basis. Largely unnoticed by the foreign media, they represent a sea change in the atmosphere in Latin America, a two-headed phenomenon of major significance. The indigenous peoples, the heirs to the age-old civilizations of the continent, have begun stirring themselves politically, moving to center stage in several countries for the first time since the great Indian rebellions of the 18th century. They have grown strong enough to overthrow governments.

During the same period, this predominantly Catholic region has sheered off in a new and unexpected direction, embracing evangelical Protestantism on a hitherto unprecedented scale, creating new social actors, and presenting a serious problem for the Roman Church that is high on the new pope's agenda. Pentecostal churches have sprung up like dragon's teeth, almost without human agency, in the remotest and poorest areas of the continent. When Pope John Paul II denounced liberation theology, forcing radical Catholic priests to abandon their flocks in the shantytowns, the evangelicals moved seamlessly to fill the vacuum.

These developments have multiple and specific causes in each country, but they have arisen to prominence chiefly as a result of the free-market economic programs that have been implemented throughout the continent since the 1980s. These promised untold riches, the increase of national wealth through economic growth, yet in practice they brought large price increases, the cheap sell-off of state enterprises, and a drastic curtailment of services once provided by the government—including health, education, and credit to agricultural workers. In many countries, the great majority of the population found themselves worse off, with no education or medical services of any kind available. This, with the consequent acceleration in the rate of movement from country to town, left people with little to sustain themselves but the self-help communities established by evangelical religion and the ever-expanding networks of cultural nationalism and indigenous mobilization.

In the Andean countries, especially, with memories of a pre-Columbian civilization kept alive over the centuries, this has proved a potent mix. The cultural resurgence of groups reclaiming their Indian/indigenous identity, and the organic growth of the Pentecostal churches, can be detected almost everywhere, from Argentina to Chile, from Brazil and Mexico. The disastrous displacement of indigenous peoples from the countryside, driven out by oil prospectors, logging companies, and coca eradication programs, has produced immense new indigenous cities often invisible to the white middle class. Lima in Peru has become a Quechua city, Santiago in Chile is peopled with Mapuches, driven out of their reservations in the south, Quito in Ecuador has doubled in size, and El Alto, the new Aymara city in Bolivia, threatens to overwhelm La Paz. These urban conglomerations, thanks to modern methods of communication, remain in constant touch with their rural roots.

These epoch-defining developments, chiefly affecting the poorer (and majority) sectors of the population, are beginning to redefine the familiar image of Latin America. Most outsiders still imagine a continent of confident white settlers from Europe, living in a society made secure by the authoritarian military traditions of Spain and the narrow ideology and morality of Rome. The new movements of indigenous peoples and evangelicals are changing this picture, and already causing concern within the existing conservative political establishments in Latin America. Debates within the once powerful leftist movements have also been affected. Gender issues and liberation theology had been taken on board in the last decades of the 20th century, but most people on the left have been unprepared for questions associated with culture, race, and popular religion.

Few have recognized that Latin America is on the brink of an entirely new era, comparable to that of the early 19th century, when Simón Bolívar, a revolutionary from Venezuela, fought for independence from Spain and brought the radical ideas of the French Revolution to replace those of Spanish absolutism. New political actors

have come to the fore all over the continent, with the aim of redressing the wrongs visited on the indigenous peoples, and of redrawing Bolívar's postindependence map. They are also calling for an end to the privileges of the old white settler elite and of its Church, both in the name of the continent's original inhabitants and in that of a renewed "Bolívarianism"—the vision and ambition of Bolívar to unite the countries of the former Spanish empire.

The leadership of this movement belongs to Hugo Chávez, the mercurial and charismatic ruler of Venezuela over the past seven years, who has set out single-handedly to revive Latin America's sense of its own history and culture. He is not alone. Many people in the Andean countries of Peru, Ecuador, and Bolivia are demanding a return to Tahuantinsuyo, the "four states" of the old Inca empire of 500 years ago, stretching from Pasto in Colombia to the River Maule in Chile, and to Tucumán in Argentina. Their aim, in the words of one Peruvian observer, is "to realize the Bolivian dream with an Inca base."

These developments have some elements in common with comparable phenomena in other parts of the world. The revival of local and indigenous cultures across borders, threatening the frontiers established in colonial times, has become familiar in Africa in recent years, while the self-help solidarity of the evangelicals is not unlike that provided by the social and cultural movements associated with the revival of Islam. Even the United States has seen a significant revival of indigenous activism, which has not gone unremarked further to the south, and the spread of evangelical religion, although now local and autonomous, started as a U.S. export.

Yet the experience of Latin America, different though in some ways similar to developments elsewhere, is rarely bracketed together with the others, nor has there been much discussion or analysis in the media. Latin America is no longer a beacon, or even a topic of discussion, for the left. In the 15 years since the collapse of Communism, the defeat of the Sandinistas in Nicaragua, and the almost universal acceptance of neoliberal hegemony, political interest in the continent's future has waned. Latin America has effectively disappeared from the screen. Newspaper coverage has been reduced to reports from the specialist correspondents of the financial press, providing the kind of information that only the business community wishes to hear. Television programs consist of travelers' accounts of whitewater rafting, or the lifespan of the condor and the llama.

Yet while no one has been looking, dramatic developments have been taking place. The new era began in February 1989 with an event in Venezuela known as the *Caracazo*, an explosion of political rage by the underclass in Caracas against a program of free-market reforms. For two days the city degenerated into violence of a kind not seen there since the 19th century, sparked off by an increase in bus fares, but reflecting a much wider political discontent. A thousand people, perhaps more, were killed in the subsequent repression.

The *Caracazo* was as significant for Latin America as the fall of the Berlin Wall, in November the same year, was for Europe. It marked the first occasion when the free-market agenda, universally adopted in the 1980s, was dramatically rejected by a popular uprising. Comparable rebellions occurred subsequently in other countries, but Venezuela led the way. It was the first to suffer from serious government corruption, and the first to react against the effects of globalization and neoliberalism—the economic recipe enshrined in the "Washington consensus."

The *Caracazo* had an important impact on the soldiers who were called on to repress it, and it led inexorably to a military coup attempt in1992 led by Colonel Chávez. The subsequent creation of a powerful current of popular opinion in favor of this remarkable officer was to sweep him into power at elections in 1998. The Chávez government, still popular in its eighth year, was the first (after Cuba) to experiment with an original program of antiglobalization. Chávez draws his inspiration from the nationalist struggles of the 19th century. His heroes are Bolívar, who

sought to liberate the continent, Simón Rodríguez, Bolívar's tutor, who opposed European migration and sought to educate the indigenous peoples, and Ezequiel Zamora, a general who championed the peasants against the landlords.

With a strategy of securing the country's oil rents, embracing land reform, and empowering the poor, the blacks, and the indigenous groups, Chávez has become an icon for the other popular, often indigenous movements that have emerged further south. His "Bolívarian" agenda has found a ready audience in the Andean countries.

Chávez has also had an influence on young officers in several countries, reviving the military tradition of left-wing nationalism espoused by General Juan Velasco Alvarado in Peru in the 1970s and by General Omar Torríjos in Panama in the same period. He also keeps alight the flame of the Cuban Revolution, regularly seeking assistance and advice from Fidel Castro, the continent's aging political rock star.

In the years since the first Chávez election victory in 1998, the crisis of neoliberalism has affected the entire continent. New and more radical presidents have been elected, put there by popular pressure, although not themselves always able to escape from the neoliberal straitjacket. A new leftist president took office in Brazil in 2003, the candidate of the Workers' Party with a long track record of hostility to globalization. Luiz Inacio da Silva (Lula) aroused many people's hopes, but when he took the route of neoliberalism, he lost soon lost his initial popularity and his regime degenerated into the familiar pool of corruption that has longed defined the politics of Brazil. Some leftist critics have described him as a Brazilian Lech Walesa, the Polish trade union leader who ended up on the right.

Unprecedented scenes of revolt occurred in the early years of the 21st century in Argentina, in which even the impoverished middle class was mobilized. The normally sober citizens of Buenos Aires were seen banging on the doors of defaulting banks, and the underclass became increasingly active all over the country. Elections in 2003,

with a dour cast of political rejects competing for the presidency with no popular support, led to the emergence of President Nestor Kirchner, a supporter of the left-wing Peronist Youth in the 1970s, and widely perceived as a different and new broom.

In neighboring Uruguay, Tabaré Vásquez was elected president in October 2004 as the socialist leader of the Frente Amplio, the heirs to the Tupamaros, the left-wing urban guerrilla movement of the 1970s. In Colombia, the civil war waged since the 1950s endlessly rolls on, its impact exacerbated by the government's economic policies and by the continuing American military intervention, enshrined in "Plan Colombia." Substantial areas of the country remain out of the control of the central government, as they have been for much of the past 500 years.

Few countries have been exempt from these winds of change. The *Caracazo* was followed by a comparable explosion in Ecuador the following year. A hundred Indian activists occupied the Santo Domingo cathedral in Quito in May 1990, demanding action from the government to resolve the land disputes in the Sierra, and sparking off an insurrection throughout the country. The government was obliged to negotiate and to recognize CONAIE, the Confederation of Indigenous Nationalities, first established in 1986 by the 11 principal indigenous nationalities in the country, as the legitimate voice of the Indian majority community. Land conflicts and the increasing involvement of the indigenous movements in politics continued throughout the 1990s, with the formation in 1995 of Pachakutik (the Movement of Plurinational Unity), the first indigenous political party.

In January 2000, thousands of Indians seized the Congress in Quito, shouting the three demands of their movement, "*ama sua, ama llulla, ama kjella*"—no thievery, no lying, no idleness. They were supported by a group of young army officers, led by Colonel Lucio Gutiérrez, and they brought down the government that had dollarized the economy. Three years later Colonel Gutiérrez was elected president with the support of Pachakutik. The coalition of the military and the Indians was to last

for less than a year. It fell apart over the colonel's support for the neoliberal policies of his predecessors, and his retention of the U.S. dollar as the national currency. The result was a division within the indigenous organizations, and uncertainty about their future moves. Yet in 2005 they were able to unite to remove Gutiérrez.

Next in line for dramatic political intervention by indigenous movements was Bolivia, where the attempt to privatize the water supply provoked demonstrations in Cochabamba in April 2000, leading to the cancellation of the contract with the U.S. firm Bechtel. At presidential elections in June 2002, Evo Morales, the indigenous leader of the Movement to Socialism, came a close second to Gonzalo Sánchez de Losada, a right-wing millionaire. A year later, in October 2003, this businessman-president had to be rescued from his palace in La Paz by an ambulance, while the city was given over to rioters protesting against privatization and the imposition of fresh taxes. The police force, itself on strike, confronted armed soldiers, while Indians poured down from the hills to trash U.S. fast-food outlets and supermarkets. President Sánchez fled to the United States.

Early in January 2005, the scene was repeated. Tens of thousands of Indians demonstrated in El Alto, the vast city of Indian rural migrants on the plateau above La Paz, protesting against the increase in the petrol price, and about the profits and inadequate reach of yet another foreign water company—the French Lyonnaise des Eaux that had been operating there since privatization in 1997. Hundreds of thousands joined the protest a day later in the eastern metropolis of Santa Cruz, and President Carlos Mesa, himself the product of the rebellion against Sánchez Losada, declared that he would resign if the demonstrations turned violent. The French water contract was cancelled, but further popular mobilizations in June led to Mesa's resignation. Elections were held in December 2005 and the left-wing Morales won with more than 50 percent of the vote, inaugurating a new revolutionary era in the history of Bolivia.

A similar story has been unfolding in Peru, hitherto less exposed to indigenous politics than the other Andean countries. On New Year's Day 2005 the Andean town of Andahuaylas was occupied by a group of 200 former soldiers demanding the resignation of Peru's unpopular, right-wing president, Alejandro Toledo. Led by Antauro Humala, a retired officer of indigenous extraction, the group's action was enthusiastically supported by thousands of local Indians who flocked to the main square to show their solidarity. Their national indigenous movement, the first of its kind in Peru, has hopes of resurrecting the empire of the Incas. The rebels held out for four days, but were dislodged after President Toledo declared a state of emergency and sent a small army to remove them.

Antauro Humala had staged a similar coup in 2000 with his brother Ollanta, an unsuccessful action that helped, nevertheless, to accelerate the end of the corrupt, ten-year regime of Alberto Fujimori. In subsequent years, the Humala brothers devised a countrywide organization with a nationalist, indigenous agenda. Their "Ethno-Cácerist Movement" has sought to restore the government and geographical space of the Inca empire. Ethno-Cácerism, the formulation of their father, Isaac Humala, invokes the memory of a 19th-century Peruvian president, Marshal Andrés Cáceres, who waged a guerrilla war against the Chilean occupation during the Pacific War between 1879 and 1883.

The organization's magazine, *Ollanta*, sells more than 60,000 copies every fortnight, and campaigns against globalization, against the free-market system adopted by successive governments, and against privatization. It also sustains a steady diet of articles hostile to Chile, to Israel (a prominent backer of Toledo), and to homosexuality (a preoccupation of many Andean Indians). As in Bolivia, they have concentrated on the privatization of the municipal water companies, something particularly offensive to indigenous opinion. Popular demonstrations in Arequipa in June 2002 prevented the local companies from being sold off to a Belgian firm, and led to the resignation

of the economy minister, Pedro Pablo Kucynski, the architect of the privatization program. "Everywhere you look," he said ruefully, "people say 'the guys follow the model, and they're in the soup. So obviously the model does not work.'" Ollanta Humala is a candidate in the presidential elections to be held in April 2006.

Ollanta's message goes down well in a country where more than half the population are Quechua or Aymara Indians, and it is echoed throughout the Andean region. Peru's white elite, of course, has been virulently hostile to the emergence of this and other indigenous movements in the Andes. Mario Vargas Llosa, the novelist and former right-wing presidential candidate (he is now a citizen of Spain), is an outspoken critic, accusing them of generating "real political and social disorder." Society faces a choice, he says, between civilization and barbarism.

Richard Gott—December 2005.

This is the age-old cry of Latin America's white settlers, indicating an unwillingness to come to terms with the indigenous peoples whose continent they have usurped. It is too early even to guess what will be the effect of these new phenomena. But the prevalence of the free market, once thought to presage "the end of history," has certainly thrown up some intriguing items in the democratic marketplace. The 70 million evangelicals in the continent today (there were less than 20 million in 1980) will not easily be wished out of existence, and the indigenous movements are clearly here to stay. The Pentecostal churches endlessly divide and quarrel, and the indigenous movements do the same. Each ethnic group, and they are legion, has its own leader. They still perform better in opposition than in government. Yet their presence on the continental stage is permanent, and worth watching. Latin America deserves more attention than it has received in recent years.

Richard Gott is the former Latin-American correspondent of London's *Guardian* newspaper. He is the author of *Cuba: A New History* (Yale University Press, 2004) and *Hugo Chávez and the Bolivarian Revolution* (Verso, 2005).